KU-131-240

Abdelkebir Khatibi
Mohammed Sijelmassi

THE SPLENDOUR OF ISLAMIC CALLIGRAPHY

READING BOROUGH COUNCIL

with 232 illustrations, 98 in colour

Thames & Hudson

Frontispiece
Detail of a page from a Qur'ān in Karmatian script,
an ornamental version of Eastern Kufic.

Any copy of this book issued by the publisher as a paperback is sold subject to
the condition that it shall not by way of trade or otherwise be lent, resold, hired
out or otherwise circulated without the publisher's prior consent in any form
of binding or cover other than that in which it is published and without a similar
condition including these words being imposed on a subsequent purchaser.

First published in the United Kingdom in 1976 by Thames & Hudson Ltd,
181A High Holborn, London WC1V 7QX

Revised and Expanded edition published 1996

This edition published in the United States of America in hardcover in 1996 by
Thames & Hudson Inc., 500 Fifth Avenue, New York, New York 10110

First paperback edition 2001

© 1976 and 1995 Thames & Hudson Ltd, London
Original edition © 1994 Editions Gallimard, Paris

All Rights Reserved. No part of this publication may be reproduced
or transmitted in any form or by any means, electronic or mechanical,
including photocopy, recording or any other information storage and
retrieval system, without prior permission in writing from the publisher.

British Library Cataloguing-in-Publication Data
A catalogue record for this book is available from the British Library

Library of Congress Catalog Card Number 95-78912

ISBN 0-500-28294-3

Printed and bound in Italy

ling 0118 901595
8 901510

THE SPLENDOUR OF
ISLAMIC CALLIGRAPHY

WITHDRAWN

Reading Borough Libraries

34126000252430

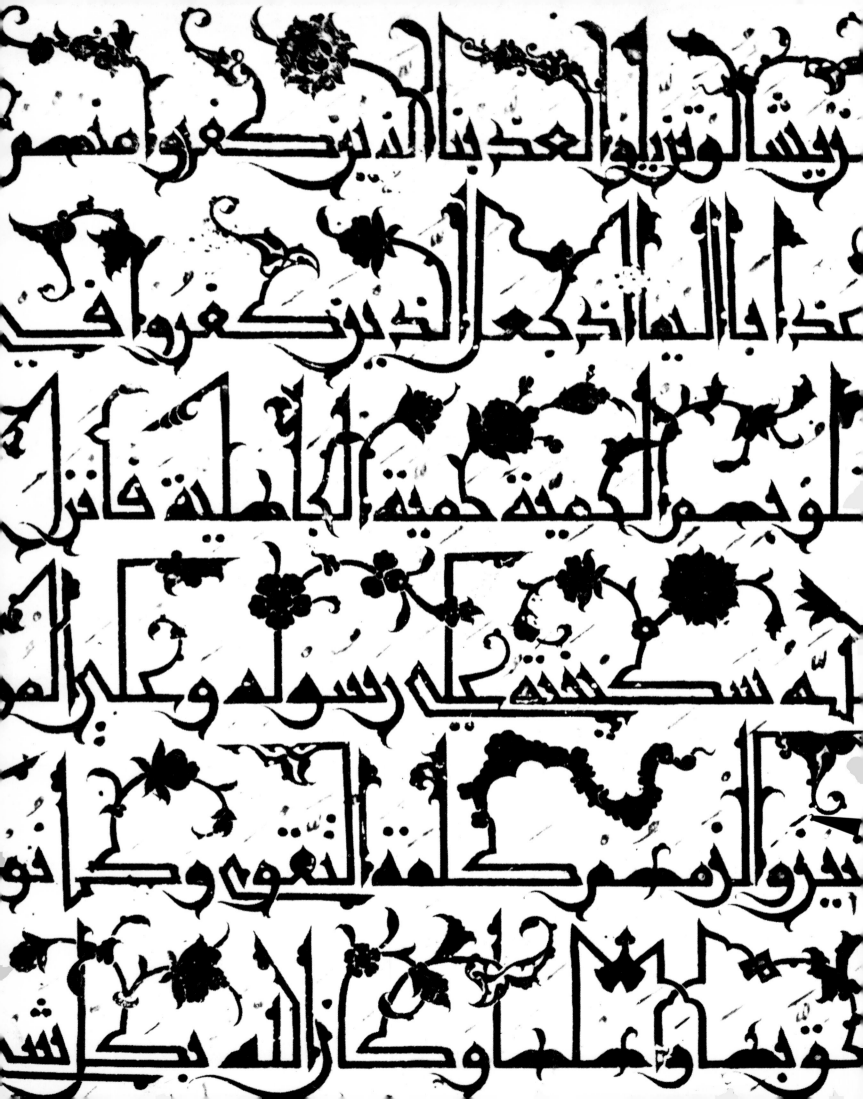

إذ جعل الذين كفروا في قلوبهم الحمية حمية الجاهلية فأنزل الله سكينته على رسوله وعلى المؤمنين وألزمهم كلمة التقوى وكانوا أحق بها وأهلها وكان الله بكل

CONTENTS

SYMBOL OF CIVILIZATION

Every text, whether sacred or secular, carries within it a desire to imagine the reader who approaches it. Therein lies its dream of eternity. What is the nature of the imagined reader within the ambit of Arab calligraphy? Recall the first words revealed to the Prophet Muhammad, 'Read, recite.' Does not the word Qur'ān also mean the act of reading and recitation? Read the world and the heavens as a table of signs. You are first and foremost a reader, then a believer.

Calligraphy is the art of the linear graphic; it restructures one's visualization of a language and its topography. In this sense, calligraphy in the Arabic language is constructed on a simple spatial principle: the Arabic alphabet is written in the interplay of a horizontal base line and the vertical lines of its consonants. It is read from right to left, with the addition of vowels, diacriticals and loops which are positioned variously above and below the base line. The originality of this written form, which in some respects has no equal, is created by the architecture and rhythm of the letters: here we recognize the force of the 'arabesque' as a plastic form.

Calligraphy can be seen as a reading and a writing in the second degree. It obeys a geometry of the spirit that is created in the opening of a space between the statement contained in a phrase and its realization as a work of art. This happens within the heart of every word, every phoneme, right down to the noiseless musical quality of the text as a whole, rendered by the calligrapher's art in the form of light and shade, the readable and the elusive, the impression of what one sees and the presence of the voice.

Calligraphy reveals the plastic scenography of a text: that of a letter turned into image, caught in the physical act of creating a line which is animated and led onwards by an inner rhythm. This art works by taking a text as a score consisting of strokes created by the graphic artist. For the language which practises it, and which thereby gains beauty, the calligraphic art constitutes a laboratory of signs. As in

Ta'liq script. *The letter 'm' in its final form, a calligram in itself.*

the case of Chinese and Japanese writing, the Arabic script derives from a civilization of signs. By 'sign' we mean in this context a conventional mark, arbitrary in relation to the thing designated, which serves to convey the sound of the spoken language.

What calligraphy does is to take the written sign and alter its form and decorative style by changing the treatment of line. This plastic form simultaneously serves both the meaning of the actual statement and the composition of images, of letters that are recreated as image. The actual meaning of the statement here becomes secondary, so that the imagined reader is like a dreamer awakened, whose vision is woven within a context of art. Take a close look at any page of fine calligraphy and you find a delicate balance between matter (the ink and its supporting medium), colour and signs.

The characteristic aspect of this Islamic cultivation of signs and symbols is the pre-eminence of the art of ornamentation, and in this the book has pride of place. We should remember that during the classical Arab era (the ninth and tenth centuries AD) the visual arts embraced the arts of the book (illumination, fine bindings and calligraphy itself), architecture (mosques, religious schools known as *madrasas*, mausoleums, palaces . . .) and the everyday applied arts such as ceramics, carpet-weaving, mosaics and leatherwork. Thus in Persia it would fall to the court calligrapher to design the preliminary sketches for the finest carpets, giving us marvellous prayer mats where the artist, in collaboration with artisans, introduces us to an imagery of Paradise, literally woven into the words of Allah.

Graphic systems may be more or less beautiful in their conception. And, as in every art, calligraphy may be arrived at by skill or by serendipity and improvisation. As indicated above, the Arabic system of writing is created from a range of signs and their variants, combining elements of the vertical and the horizontal. it also features diacritical marks, the loops which make up the bodies of letters, and the connecting links between them. Letters may be joined together or they may stand alone.

Given that this calligraphy derives from an ancient Semitic alphabet, it is no surprise to find that it still retains pictographic remnants such as ع (*'ayn*) representing the eye, and ج representing the camel. However, the alphabet has evolved greatly since the early manuscripts of the Qur'ān. It has embraced many forms of ornamentation and decoration, so that the letter recreated as image has become an essential paradigm of the arabesque. Initially an art confined to books, Arabic calligraphy has gone on to adapt itself wonderfully to other media: stone, stucco, mosaics, ceramics . . . This iconic transformation has only been possible thanks to the nature of this system of writing – as a highly flexible mutual adaptation between the sign and the image, between the sign and the act of writing it.

Calligraphy thus has its own sculptural autonomy as an art which is extremely abstract, and within which one can discern (as certain researchers have done) a geometry, even a mathematical quality, of the sign. For example, the simple dot (.), which signified nought among the Arabs of ancient times who invented it, came to serve as the means of indicating the diacriticals which distinguish various letters that have the same shape, such as ب (b) and ت (t), or س (s) and ش (sh). We shall see shortly how professional calligraphers adopted the dot as a module in developing different calligraphic styles.

The letter recreated as image follows three rules of composition: phonetic, semantic and plastic. Calligraphers create their compositions by joining letters together, and by adding vowels and diacriticals. Thus they give supplementary form to the meaning of the text which one is reading. Such is the ground that we shall be covering in our survey of the calligrapher's art.

Thuluth script *by Shah
Mahmūd Nisabūri
(16th century).*

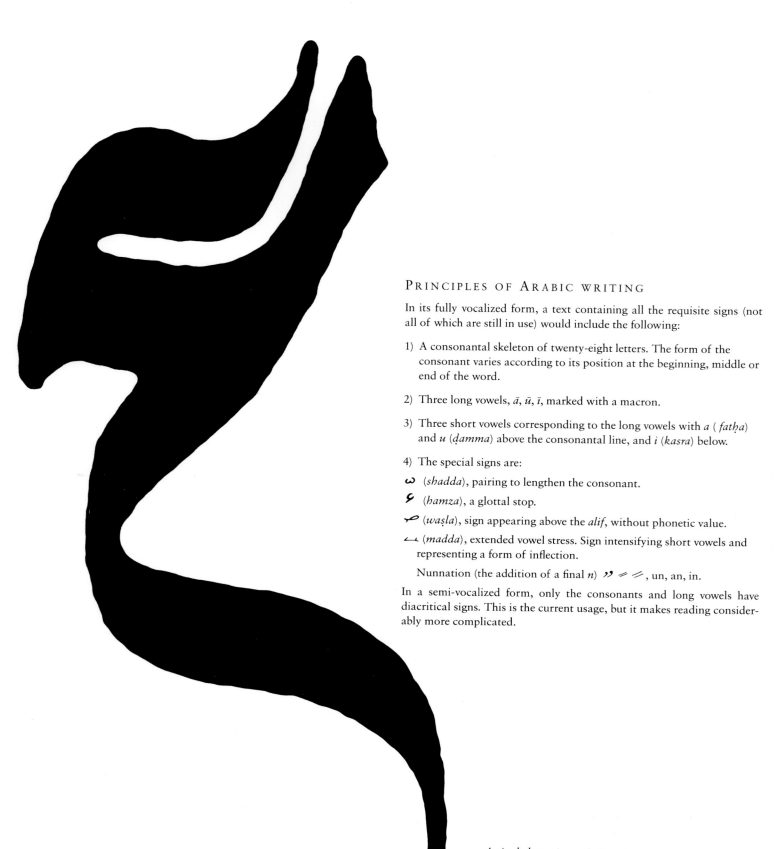

PRINCIPLES OF ARABIC WRITING

In its fully vocalized form, a text containing all the requisite signs (not all of which are still in use) would include the following:

1) A consonantal skeleton of twenty-eight letters. The form of the consonant varies according to its position at the beginning, middle or end of the word.

2) Three long vowels, *ā*, *ū*, *ī*, marked with a macron.

3) Three short vowels corresponding to the long vowels with *a* (*fatḥa*) and *u* (*ḍamma*) above the consonantal line, and *i* (*kasra*) below.

4) The special signs are:

ω (*shadda*), pairing to lengthen the consonant.

ؤ (*hamza*), a glottal stop.

ٮ (*waṣla*), sign appearing above the *alif*, without phonetic value.

�← (*madda*), extended vowel stress. Sign intensifying short vowels and representing a form of inflection.

Nunnation (the addition of a final *n*) ‟ ⁒ ⁒ , un, an, in.

In a semi-vocalized form, only the consonants and long vowels have diacritical signs. This is the current usage, but it makes reading considerably more complicated.

A single letter in **sumbuli** *script.*

SYSTEM OF TRANSLITERATION

In the transliteration of Arabic characters we have used a much simplified system, but one which enables Arabic speakers and specialists to re-establish the precise equivalence of the signs.

ء '(hamzah)	ج j	ز z	ظ ẓ	ل l
ا ā	ح ḥ	س s	ع '(ayn)	م m
ى a	خ kh	ش sh	غ gh	ن n
ب b	ذ d	ص ṣ	ف f	ه h
ت t	د dh	ض ḍ	ق q	و w, ū
ث th	ر r	ط ṭ	ك k	ى y, ī

11

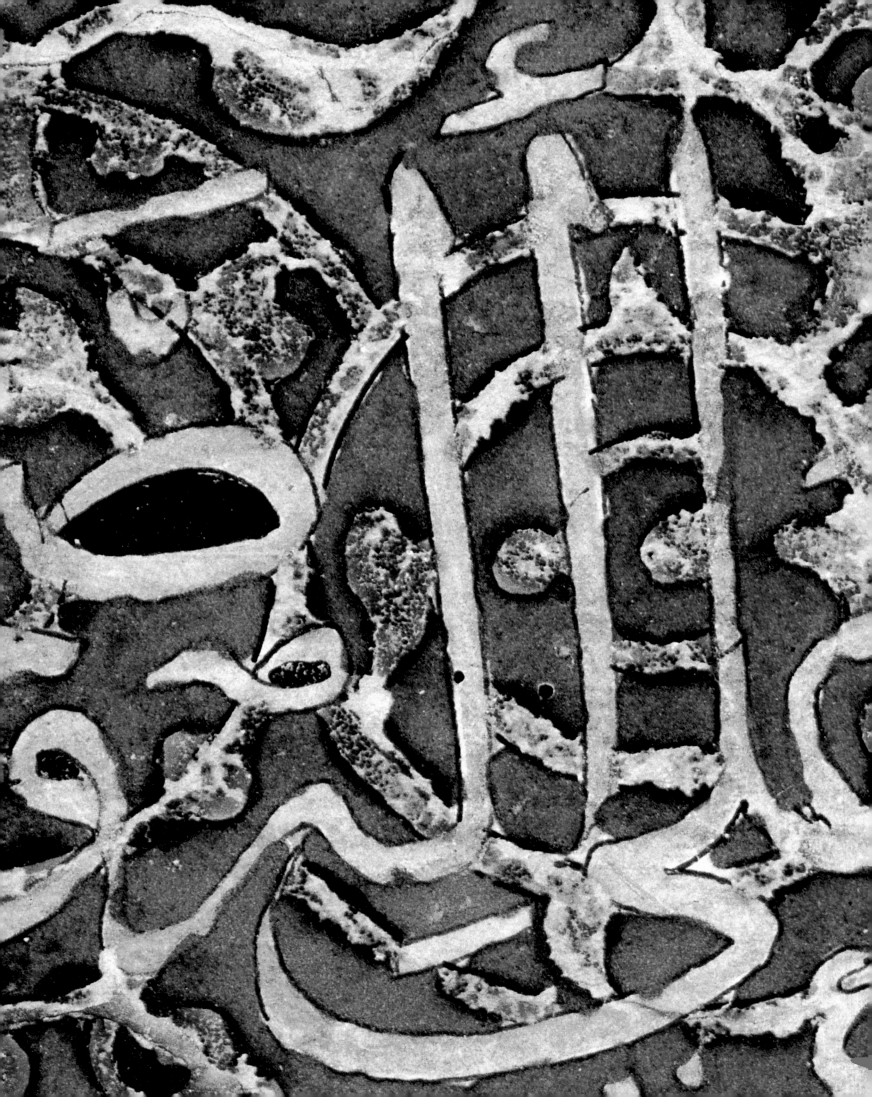

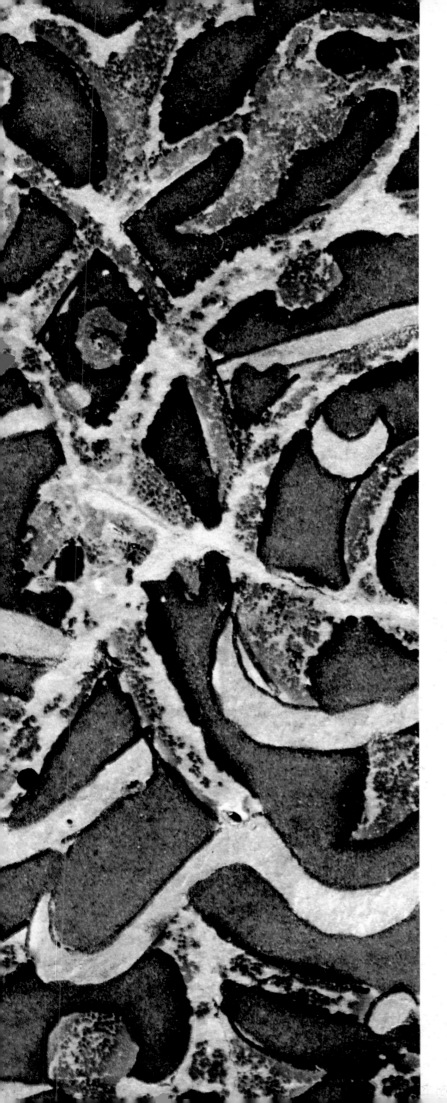

TRACING
THE ORIGINS

Calligraphy means here – in the strict definition of the word – an art which is conscious, founded upon a code of geometric and decorative rules; an art which, in the patterns which it creates, implies a theory of language and of writing. This art starts off as part of the linguistic structure and institutes an alternative set of rules, derived from language but dramatizing and duplicating it by transposing it into visual terms.

The essence of calligraphy lies in its relation to language. Although the aims of the art of the calligrapher and that of the painter who incorporates words or letters into his work may sometimes be the same, the two part company in the way that the written character is given meaning and life.

Calligraphy is here under examination only insofar as calligraphy itself examines the nature of the language in which it resides. Our first concern is the calligrapher's attitude and his approach, which is both emotionally charged and yet rigorously precise. The calligrapher is an artist who copies and the text which he has to copy already exists. At the point where the meaning unfolds, an image appears which enchants language, in the original sense of incantation, that is, it transforms it into a divine (or magical) formula. Later, we shall determine the nature of this delicate image, whose potency and range had induced one calligrapher to declare – in the excitement of creation – that the tip of the pen is what marks the difference between cultures.

Calligraphy is of course the art of writing, but the practice is by no means universal. Many peoples have not developed it in detail, whereas for others it is regarded as a supreme art. The Japanese describe a person as 'having beautiful handwriting' when they mean he is graceful and handsome. The Arab calligraphers considered that their art was the geometry of the soul expressed through the body – a metaphor that can be taken literally and concretely with the literal design of its inspiring spirit. This metaphor refers back to an established language as, so to speak,

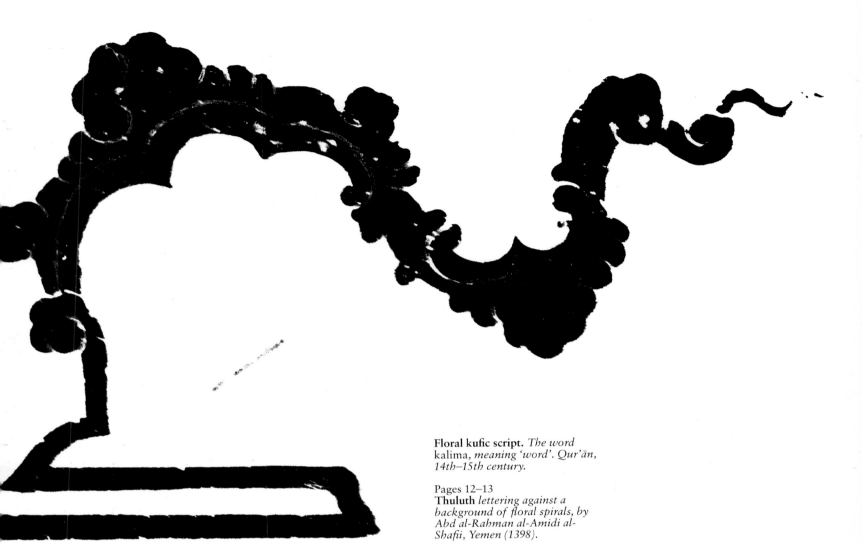

Floral kufic script. *The word* kalima, *meaning 'word'. Qur'ān, 14th–15th century.*

Pages 12–13
Thuluth *lettering against a background of floral spirals, by Abd al-Rahman al-Amidi al-Shafii, Yemen (1398).*

its reflection, its language of love. Among people without a calligraphic tradition beautiful handwriting can of course be found anywhere – in a private letter, for instance. But this comes from an expression of feeling not rooted in a general knowledge and technique of calligraphy. It remains an individual impulse within the totality of a culture. We use the word calligraphy here to denote an all-embracing cultural manifestation which structures the philosophical basis of regular language.

It should be noted here that a codified Arabic calligraphy presupposes the existence of an earlier graphic convention, including diacritical signs and vowels, which was developed gradually both before and after the appearance of Islam, and was applied to the painstaking and laborious task of transcribing the Qur'ān. But calligraphy was the work of a hieratic bureaucracy, who were keen to impose on society a political order inspired by the Qur'ān. The new discipline was established by Ibn Muqla, a man who, according to legend, was thrice Vezir, thrice went on a holy war, and whose

remains were thrice interred: first in the prison where he died, second in his house, and third in the cemetery. He will reappear in our story in a less legendary form, a pen in his right hand – the hand that the Caliph Rādi billāh ordered to be cut off.

As a historical phenomenon Arabic calligraphy dates, in its codified form, from Ibn Muqla (ninth century AD), and its decline coincides with the spread of printing. More than ten centuries of calligraphic tradition are represented in this growth and decline of Arabic culture.

It is to be understood that our concern here is not to compile a catalogue, large or small, of this art, but simply to honour it. Such a catalogue would be virtually impossible in any case, since it would have to cover ten centuries of history and a vast geographic area embracing the Muslim world. Indeed, Persian and Swahili, and Urdu too, are written in Arabic characters, as was Turkish before the drastic reforms of Kemal Atatürk after the fall of the Ottoman Empire.

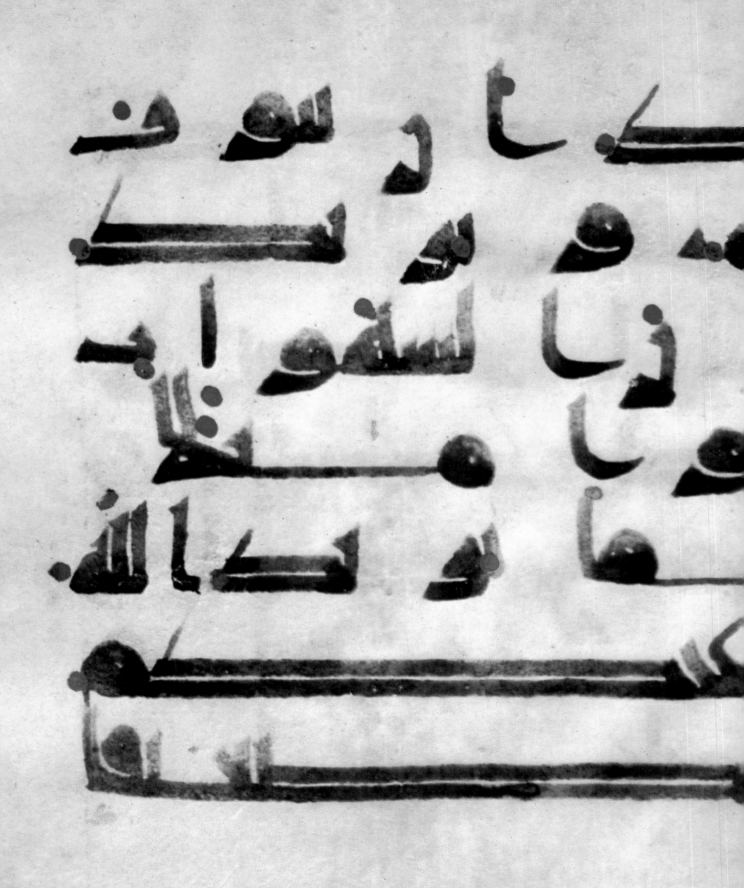

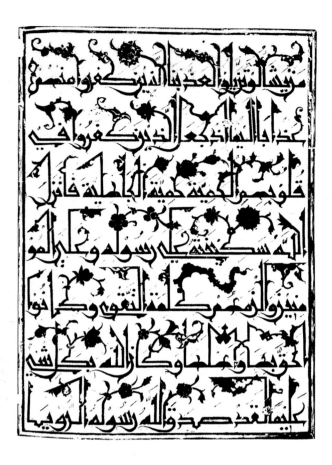

Karmatian kufic script.
Page from a Qur'ān.

Right. Ḳarmatian kufic script.

Pages 16–17
Archaic Kufic script *on parchment (9th century).*

LEGEND AND EPIGRAPHY

Present throughout Islam, calligraphy raises the question of writing at its original source in religious belief. The Prophet Muhammad said that the Qur'ān was revealed to him in 'pure Arabic'. What can we wager on knowing the 'agency' of this written sign?

First of all we must rid ourselves of the idea that calligraphy developed as compensation for the prohibition placed by Islam on the representation of the human or divine form. As the religion of an invisible god, early Islam had to compete with the pre-existing totemistic religions, which encouraged figural representation; it had to eradicate and blot out the memory of such established practices. But this prohibition, which has incidentally been little elaborated, conceals another approach, no less influential, which fits absolutely into a fundamental theory of the divine origin of writing: the human body is a progression in four stages: death (the inanimate), life, death again, and finally life in the beyond, be it in Paradise or Hell. The Qur'ān is the site of this migratory separation. And Allah speaks Arabic first: so the Qur'ān is not seen as a gospel to be revealed in any language. Hence the belief that the Arabic language, occurring in the Qur'ān, is to be considered as a miracle. How can a miraculous language be transcribed without giving the lie to its implicit perfection? And since all revelation enjoins silence and hushed voices, the scribe's sublime task is beset with grave problems. From the inception of Islam conflicts broke out over different recensions of the Qur'ān, which did not acquire its definitive form until after the death of the Prophet. The recensions themselves were transcribed in an orthographically incomplete form of writing: the system of vowel and diacritical signs – so important in calligraphy – was deficient. This is a major (but not the only) reason for the custom of chanting and reciting the text. It was not until the third Caliph, Uthmān (23/644–35/655) that an 'authorized' version was produced. Calligraphy, though not yet codified, was born at that moment, to establish the miraculous nature of the Qur'ān's origin.

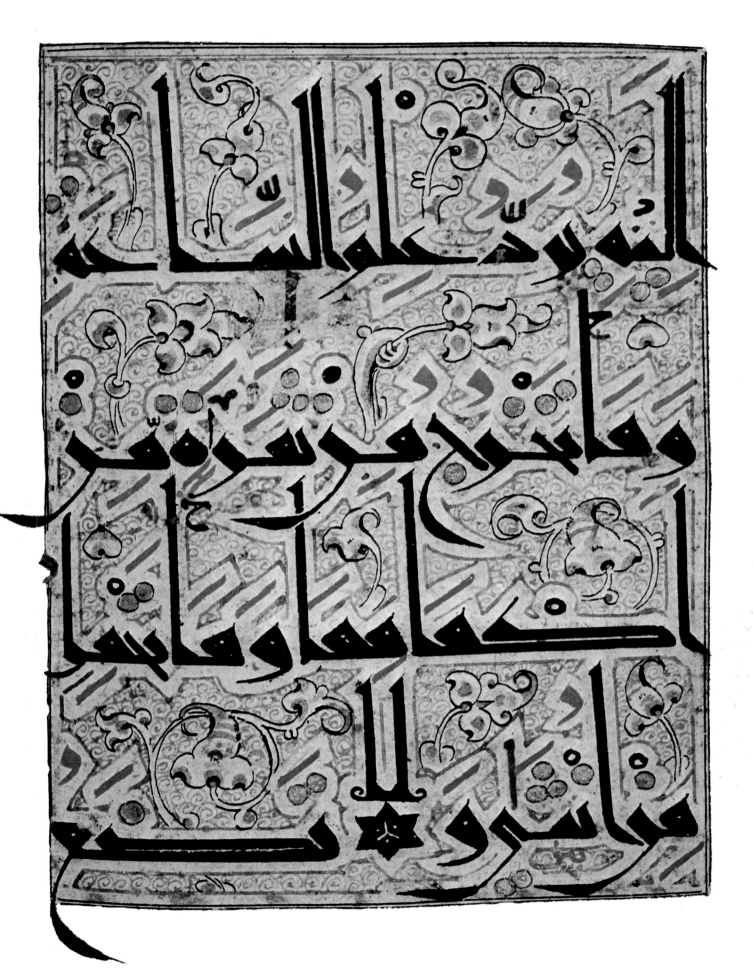

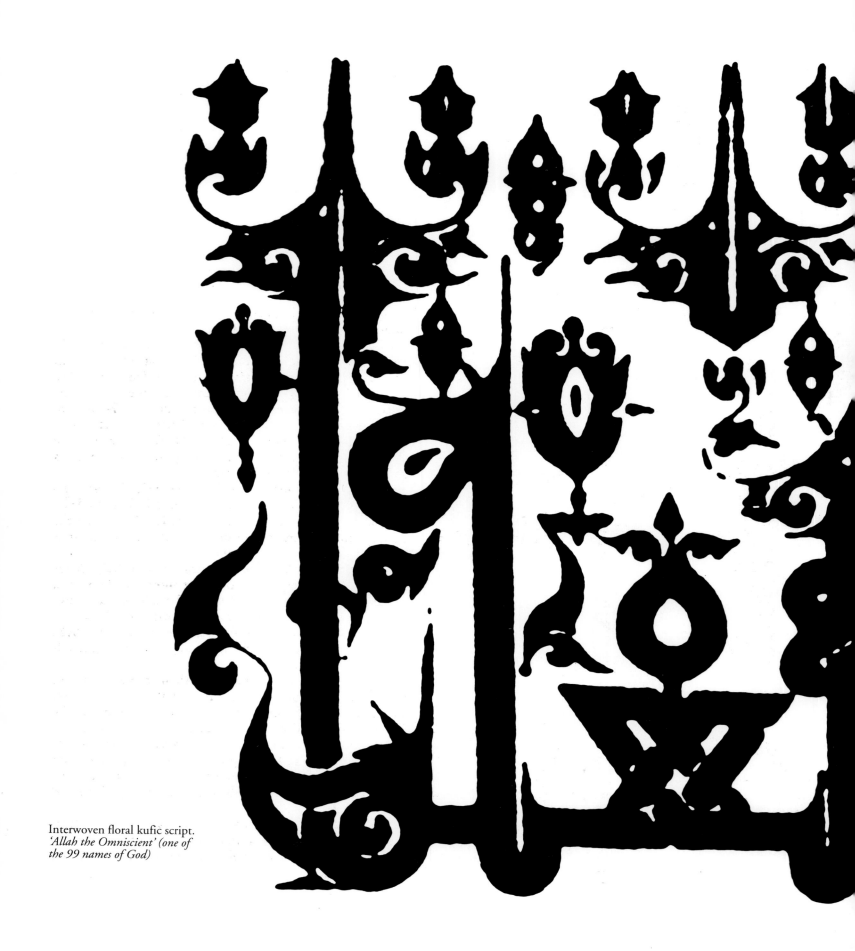

Interwoven floral kufic script.
*'Allah the Omniscient' (one of
the 99 names of God)*

MYTHS
OF ORIGIN

The origin of writing may be explained – or it may be a matter for reverie and meditation.

From the outset the Muslim finds himself mysteriously confused. For while Arabic script is definitely revealed in the Qur'ān as a miracle, we also know – from the other side of the looking-glass, so to speak – that it existed as the successor to Nabato-Aramaic, and therefore to Phoenician, beginning with the first letter *alif*. What can such a discrepancy mean? Is the truth of the Qur'ānic script above and beyond the evidence of its own past, with pre-Islam nothing but its crude semblance?

Further on we shall consider a factual, though perfunctory, explanation offered by some Muslim thinkers, written, as it were, in a clandestine script. Let us for the moment consider the origin of the Arabic language as it occurs in imagination and legend.

According to Abu al-Abbas Ahmed al-Bhūni, letters arose from the light on the pen that inscribed the Grand Destiny on the Sacred Table. Allah had ordained that therein should be recorded the deeds of all creatures, till the Last Judgment. After wandering through the universe, the light became transformed into the letter *alif*, from which developed all the others.

In another variation of the myth, Allah created the angels according to the name and number of the letters, so that they should glorify him with an infinite recitation of the Qur'ān. Allah said to them: 'Praise Me! I am Allah, and there is none other but I.' The letters prostrated themselves before him, and the first to do so was the *alif*, whereupon Allah said 'You have prostrated yourself to glorify My Majesty. I appoint you to be the first letter of My Name and of the alphabet.'

Another myth, which frequently appears in Arabic treatises, connects Adam with the origin of writing. Adam is said to have written a number of books three centuries

before his death. After the Flood, each people discovered the book that was destined for it. The legend describes a dialogue between the Prophet Muhammad and one of his followers, who asked: 'By what sign is a prophet distinguished?'

'By a revealed book,' replied the Prophet.

'O Prophet, what book was revealed to Adam?'

'A, b . . . ' And the Prophet recited the alphabet.

'How many letters?'

'Twenty-nine letters.'

'But, O Prophet, you have counted only twenty-eight.' Muhammad grew angry and his eyes became red.

'O Prophet, does this number include the letter *alif* and the letter *lām*?'

'*Lām-alif* is a single letter . . . he who does not believe in the number of twenty-nine letters shall be cast into Hell for all eternity.'

According to another tradition, the names of six kings of Madyan made up the letters of the Arabic alphabet. In fact, these imaginary names form the *abjād*, a mnemonic device to establish the order of the Arabic alphabet.

Like the Greeks, the Arabs gave a numerical value to each of their letters, classifying them in three series of nine: units from 1 to 9, tens from 10 to 90, hundreds from 100 to 900, and finally 1000. This system is still in use in popular treatises on divination.

Our purpose in providing a reminder of these myths is not to consider their emotive appeal: every culture records this interplay between myth and Logos. Our intention is to ensure that the myths should not be abruptly consigned to the limbo of 'pure illusion', in contrast to science, since the idea of myth, as well as that of science, is involved in the metaphysics of sign and symbol. This approach to the origin of writing is thus a way of setting it down in its metaphysical and theological origin. In Islam, writing is an absolute, *the* Absolute, the *Sanctum Sanctorum*. True, there may also be discerned in it the Greek theory of writing, formulated differently, that writing is the fine garment which clothes meaning, but the status of writing is nevertheless given a sacred character, and in a fundamental way. When writing is seen as an aspect of the Absolute, then scientific thought itself partakes of and prolongs the nature of revelation. Beyrūni wrote: 'As surprising for a science to be considered eternal as for a camel to be found in the channel of the Ka'ba.' Islam builds up science and philosophy from the basis of the Qur'ān and its miraculous rhetoric.

Interwoven floral kufic script. *Qur'ān, Afghanistan (18th century).*

Aristotelianism was to come to Islam and then depart from it, but its descendants, the schools of scientific materialism, have never ceased to plague us since the nineteenth century. And now technology once again presents a challenge to the foundations of religion.

We are not directly concerned here with analyzing the interdependence (in Arabic script) between the different usages of religion, philosophy and science. But we must define, however briefly, the question of calligraphy in the field of a language which claims to be revealed by God. In such an investigation we cannot allow facts and images to fall into the province of punditry or aesthetics. Instead of analyzing Arab culture and its linguistic base, this type of image-making leads to ignorance. At best it is as lifeless as a photograph album – or a corpse embalmed in preparation for burial.

It has been well said that what will remain of the Arabs in the end is to be found, firstly, in the Qur'ān, secondly, in pre-Islamic poetry and, finally, in calligraphy and architecture. There remains the question of the Arabs themselves and their body of knowledge, past and present.

A consideration of calligraphy without further development of these philosophic issues limits our range. But at least there is no question of composing an obituary for the corpse of Arabic thought. Students of oriental sensualism, and Muslim exponents of nostalgia, have already done this better than we can.

Calligraphic art, operating at the edge of language, makes systematic use of the laws of rhetoric and in particular the *al-Adab*, a very subtle concept which acts upon the whole range of the Arabic language and its linguistic theory. *Al-Adab* combines the logical and the imaginative approach – two methods which should never have been separated – and rejects the primacy of any single system, summoning, instead, a whole range of disciplines (science, literature, education, legend, etc.). Thus the text becomes parenthetical, stylized by its calligraphy (as we shall try to show) in some well-known phrase or sentence, taken from the Qur'ān, with its forcefulness delicately veiled for our greater enjoyment.

To return to the beginning, the concept of the Qur'ān as a miracle has been marginally disputed by some Muslims, and perhaps even by the great al-Ma'arri (973–1057); but in its basic sense it has affected the whole process of writing. Rhetoric (al-Bayān) has emphasized the unique character of the Qur'ān and the nature of its composition, which ensures

that certain elements remain permanently obscure. Hence those isolated and mysterious letters which preface some of the Suras. Allah speaks through the Prophet. The Qur'ān has revealed its message in Arabic characters. If the Qur'ān has been revealed in 'pure Arabic', what are the presuppositions and the effects of this theory?

With or without a mystic formulation, the question of the origin of writing is that of the origin of language itself. Our synthesis of the subject has confined the Qur'ānic structure to a simplified theocentric discussion. There remains, in fact, a series of questions on the divinely created character – or otherwise – of the Qur'ān. Classical Arabic learning, especially in its grammar and philology, has been deeply influenced by it, particularly with the rationalistic Mu'tazila which, in the reign of the Caliph al-Mamūn (d. 218/833), accepted the thesis. Nazzām (d. 231/845) has even written, 'The structure of the Qur'ān and the beauty of its prose are not a miracle of the Prophet, nor proof of the truth of his mission. But what proves the truth of his mission is the fact that the Qur'ān contains the revelation of hidden things. As for the beauty of its language, men are capable of producing works of similar, and even superior, composition.'[1]

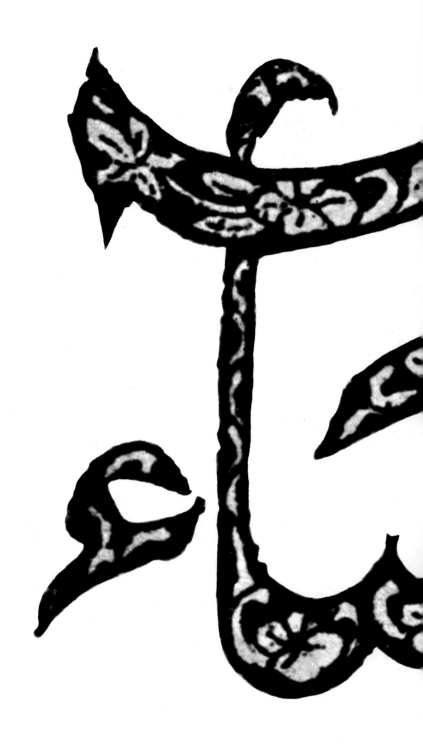

The word 'women' from a lithographed Arabic Qur'ān, with translation into Urdu. Probably mid-19th century.

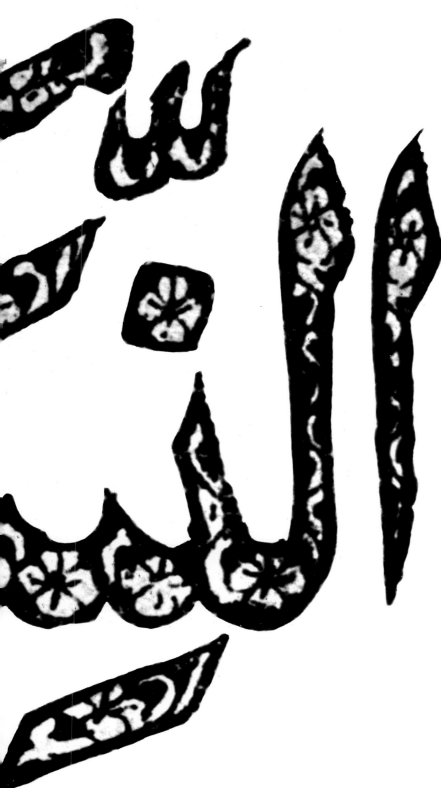

This crucial point is decisive as regards the issue of writing. Let us consider, in outline, some questions arising from it: on the one hand, if God speaks Arabic in the absolute sense, what is the value of pre-Islamic Arabic? How can non-Arabs appreciate the inimitable beauty of the Qur'ān? What is to be said about the diffusion of all the other languages? We would suggest that Arabic may remain in a sense 'dormant' in all language, including that of other monotheistic cultures. But how can the 'dormant' or 'awakened' condition of a miraculously inspired grammar be evaluated? Ibn 'Askari has written: 'The language of Adam in the Garden of Eden was Arabic. After his disobedience he was deprived of it and spoke Syriac. Then, after Adam's repentance, God restored Arabic to him once more.'[2] Thus Arabic is seen as the prelapsarian language, which human sinfulness has caused to become latent in all other tongues – even here, in this text.

On the other hand, if the Qur'ān was transmitted to Muhammad by Allah, the terms of the process by which it came into existence need to be specified, and the importance of the human word in relation to the divine voice. How is the human origin of language and writing to be justified without departing from the theological framework?

25

Archaic kufic script. *Variants of letters (from a Qur'ān incorrectly attributed to the Caliph Uthmān).*

Andalusian maghribi script. *A typical example.*

قل لعبدى البسمه

اوليك لهم عقبى

الدار جنت عدن

يدخلونها ومن

صلح من ابايهم

TAWQĪF
AND IṢṬILLĀḤ

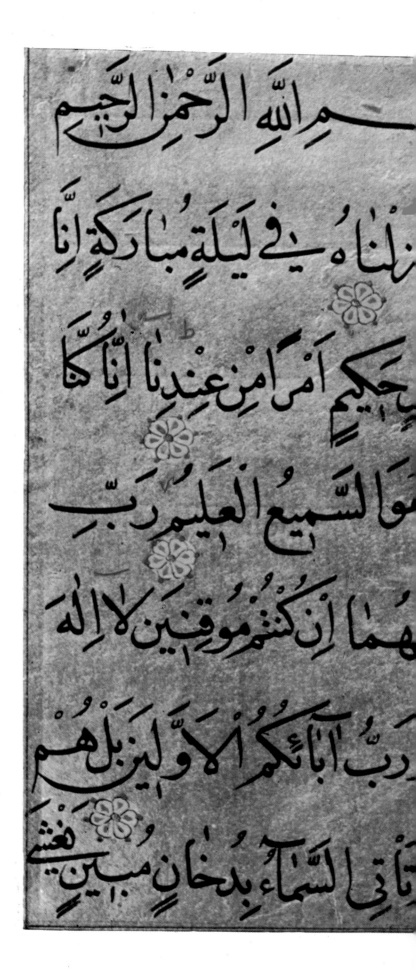

Leaving aside the question of the divine utterance, the two sides of this debate straddle the twin concepts of *tawqīf* and *iṣṭilāḥ*, the theory of a language established by God and that of a language fixed by a convention among humans, and specifically in writing.

Tawqīf, from the verb *waqqafa*, (root, WQF) means to stop, to make a halt, to stand up, to put in restraint. H. Loucel has suggested 'a revealed confirmation' for *tawqīf*,[3] a translation which we accept with some reservations. The concept, which is both active, passive and between the two, of determining, being determined, standing up, and stopping, implies a delicate configuration of meanings in its written form. Some Arabic authors use, instead of *tawqīf*, the words *waḥy* and *ilhām*, which are usually translated as 'divine inspiration'. *Waḥa* (root, WH) means to insinuate, suggest, inspire, reveal, write. *Ilhām* comes from *alhama* (root, LHM), which means to inspire.

The word *iṣṭilāḥ* (from the verb *iṣṭalaḥa*) signifies agreement or accord between men, and, in this context, between the human institution of language and literature.

The contrast between these two concepts is not comparable to that between natural and conventional.[4] The concept of nature does not apply here, as it does in the Greek *physis*. No Muslim theologian would try to suggest, for example, that birds sing in Arabic. However, popular mythology in Islamic countries, unaware of this kind of debate, maintains that it is in Arabic that the dove coos its five daily prayers.

Arab thinkers reject the idea of a usage inspired by spontaneous naturalism. And if Ibn Jinni (d. 392/1001) seems to reconcile gods and men, this is not a reference to the Greek notion but a preparation for his theory that the Qur'ān was not divinely created. 'There are some', he writes, 'who claim that the origin of all languages is to be found in sounds heard, such as the whistle of the wind, the

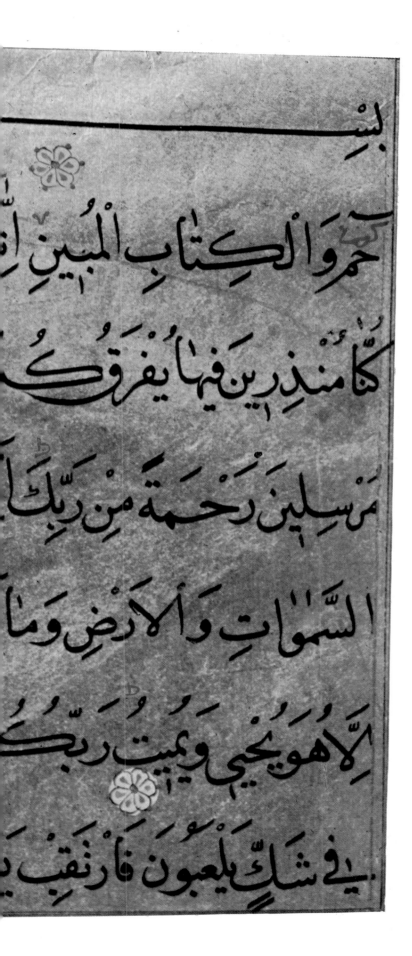

rumble of thunder, the trickling of water, the braying of donkeys, the cawing of crows, the neighing of horses, the belling of gazelles, etc . . . Languages are born from these sounds. In my opinion this view is interesting; it is an acceptable theory.'[5]

Does the origin of language and writing emerge from *tawqīf* or from *iṣṭilāḥ*? Let us synthesize, with A. Badawi, the varying responses of the Mu'tazila, leaving them open-ended and in suspense like an incompletely calligraphed letter: 'The word of Allah has form, that is, it is an articulated voice, and therefore it has been created.'[6]

'The word of Allah is an articulated voice, and human effort consists in reading (and transcribing) it.'

The word of Allah is uttered in several places. The adherents of Mu'ammer 'say that the Qur'ān is an act (an effect) of the place where it is heard. If it is heard from a tree, then it is the act of the tree. Thus, wherever it is heard it is the act of the place where it occurs.'[7] And according to al 'Allāf, the word of Allah is expressed in three places: in the written text of the Qur'ān (Muṣḥaf), in its recital in Arabic, and in the receptive ear, that which hears the voice. The notion of this transmigration of the divine voice, the omnipresent script that is written everywhere, becomes clearer in the doctrine of al 'Allāf: according to al-Ash'ari, 'Abū al-Huṭaīl (that is, al 'Allāf) taught that God created the Qur'ān from the Sacred Table. It exists in three places: the place where it is preserved (or memorized?), the place where it is written, and the place where it is read and heard. The word of God can exist in several places . . . The Qur'ān need not be transferred, or moved, or actually destroyed, yet it exists in a place even as it is written, or read, or preserved. If it is obliterated in one place, it will not for all that be destroyed there. If it is transcribed in one place, it shall not for all that be transferred from another place; likewise, even it it is memorized, read or heard, it may be destroyed. The word of

Naskhi script. *Qur'ān, 16th century.*

ابْيَضَّتْ وُجُوهُهُمْ فَفِى رَحْمَةِ اللهِ هُمْ فِيهَا خَالِدُونَ ۚ تِلْكَ آيَاتُ اللهِ نَتْلُوهَا عَلَيْكَ بِالْحَقِّ ۗ وَمَا اللهُ يُرِيدُ ظُلْمًا لِّلْعَالَمِينَ ۚ وَلِلّٰهِ مَا فِى السَّمَوَاتِ وَمَا فِى الْأَرْضِ ۚ وَإِلَى اللهِ تُرْجَعُ الْأُمُورُ ۚ كُنتُمْ خَيْرَ أُمَّةٍ أُخْرِجَتْ لِلنَّاسِ تَأْمُرُونَ بِالْمَعْرُوفِ وَتَنْهَوْنَ عَنِ الْمُنكَرِ وَتُؤْمِنُونَ بِاللهِ ۗ وَلَوْ آمَنَ أَهْلُ الْكِتَابِ لَكَانَ خَيْرًا لَّهُم ۚ مِّنْهُمُ الْمُؤْمِنُونَ وَأَكْثَرُهُمُ الْفَاسِقُونَ ۚ لَن يَضُرُّوكُمْ إِلَّا أَذًى ۖ وَإِن يُقَاتِلُوكُمْ يُوَلُّوكُمُ الْأَدْبَارَ ثُمَّ لَا يُنصَرُونَ ۚ ضُرِبَتْ عَلَيْهِمُ الذِّلَّةُ أَيْنَ مَا ثُقِفُوا إِلَّا بِحَبْلٍ مِّنَ اللهِ وَحَبْلٍ مِّنَ النَّاسِ وَبَآءُوا بِغَضَبٍ مِّنَ اللهِ وَضُرِبَتْ عَلَيْهِمُ الْمَسْكَنَةُ ۚ ذَٰلِكَ بِأَنَّهُمْ كَانُوا يَكْفُرُونَ بِآيَاتِ اللهِ وَيَقْتُلُونَ الْأَنبِيَاءَ بِغَيْرِ حَقٍّ ۚ ذَٰلِكَ بِمَا عَصَوا وَّكَانُوا يَعْتَدُونَ ۚ لَيْسُوا سَوَاءً ۗ مِّنْ أَهْلِ الْكِتَابِ أُمَّةٌ قَائِمَةٌ يَتْلُونَ آيَاتِ اللهِ آنَاءَ اللَّيْلِ وَهُمْ يَسْجُدُونَ ۚ يُؤْمِنُونَ بِاللهِ وَالْيَوْمِ الْآخِرِ وَيَأْمُرُونَ بِالْمَعْرُوفِ وَيَنْهَوْنَ عَنِ الْمُنكَرِ وَيُسَارِعُونَ فِى الْخَيْرَاتِ وَأُولَٰئِكَ مِنَ الصَّالِحِينَ ۚ وَمَا يَفْعَلُوا مِنْ خَيْرٍ فَلَن يُكْفَرُوهُ ۗ وَاللهُ عَلِيمٌ بِالْمُتَّقِينَ ۚ إِنَّ الَّذِينَ كَفَرُوا لَن تُغْنِىَ عَنْهُمْ أَمْوَالُهُمْ وَلَا أَوْلَادُهُم مِّنَ اللهِ شَيْئًا ۖ وَأُولَٰئِكَ أَصْحَابُ النَّارِ ۚ هُمْ فِيهَا خَالِدُونَ ۚ مَثَلُ مَا يُنفِقُونَ فِى هَٰذِهِ الْحَيَاةِ الدُّنْيَا كَمَثَلِ رِيحٍ فِيهَا صِرٌّ أَصَابَتْ حَرْثَ قَوْمٍ ظَلَمُوا أَنفُسَهُمْ فَأَهْلَكَتْهُ ۚ وَمَا

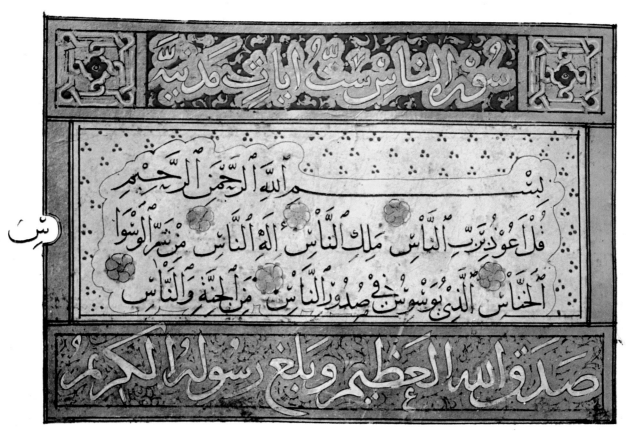

Thuluth and naskhi script.
*Page from a Qur'ān written
by the leading calligrapher
Yaqut al-Musta'simi (d.1298).*

Left. **Oriental naskhi script.**
Qur'ān.

man can also exist in several places according as it is memorized, or imitated (or reported?).'[8] Thus, human speech is regarded as imitation and repetition of the creating force in its movement, the articulation of the voice in memory, reading and transcription. Writing is to be found at this point. Its origin is in fact a form of imitation. But this theory of places is, as we shall see, a compromise between the tenets of the two theories.

Grammarians like Ibn Fāris (d. 390/999), Ibn Jinni (d. 392/1001) and Ibn Ḥazm (384/994–456/1064), are known to have rejected as absurd the very idea of a conventional language. Their grammar is based on the revealed, uncreated nature of the Qur'ān, thus discarding the thesis of Mu'tazila, for major metaphysical reasons.

First, for them, the Qur'ān is co-eternal with God. This explains, they say, the famous verse that has been the subject of passionate discussion throughout the centuries: 'God taught Adam all the names.' What was this language of Adam, the original and principal? If, as Ibn Ḥazm has called it, it is Paradise Lost, then man is to blame for dispersing, diversifying and corrupting such a language. 'We do not know what language Adam spoke at the beginning, but we can definitely state that this was the most perfect of all languages. . . .'[9]

Secondly, to create is to utter, to articulate. Man cannot articulate his bodily senses, for his sight, hearing and speech are delimited by Allah. Language descends upon him, as a revelation. A man's birth is ordained, and occurs in the context of a language already articulated and formed. The infant learns not conventional speech, but the ability to tune itself into the voice of the divine. The infant is potential, like a vibrating atom.

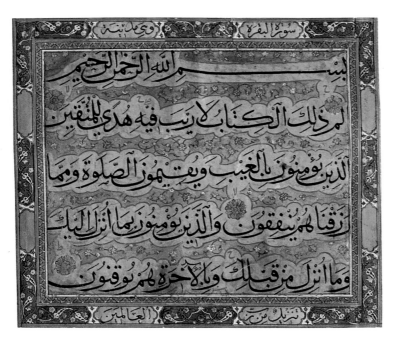

A page from a Qur'ān in **naskhi**: *the opening of the Sūra al-baqarah (the Cow). A stylized variant of naskhi script, with enlarged detail from line 4 above.*

Thirdly, language signifies and presupposes knowledge, and this is accorded by Allah. The concept of science has its origin in the divine voice, insofar as technology is, according to Heidegger, the offspring of metaphysics. The ultimate source (*aṣl*) of language is divine, whereas its later development may be the activity of humans. Every system of thought is thus pervaded by this absolute principle of the origin of language.

Fourthly, diversity of language results from a primary unity, the language of Adam. Ibn Ḥazm maintained that Arabic was spoken by Ismail, Syriac by Abraham, and Hebrew by Isaac. 'Some people', he wrote, 'have supposed their own language to be of superior value to others. But this means nothing because the criteria of superior value are known: they are based only on output and particular attribution. A language, however, does not have output, and we have no revealed text proclaiming the superior value of one language over another, since God has said: 'The Prophet has been sent only to bring enlightenment in the language of his people . . . And God has made it known that he sent down the Qur'ān in Arabic so that it should be understood by his people, and for no other reason.'[10]

Fifthly, the status of writing derives from the Qur'ān, which brings us back to our point of departure. Here we are to understand, with A. Badawi, that Ibn Ḥazm distinguished five elements in the Qur'ān's conceptual field: the word of Allah; the Qur'ān as uttered by the human

voice; the meaning of that which is uttered; the written record (Muṣḥaf); that which is memorized from the Qur'ān.[11]

The word of God is uncreated, whereas the other elements in the Qur'ānic concept are created, as also is writing, in its restricted meaning.

This is not the place to develop this discussion. By establishing the Qur'ān in such a setting we seek to free the art of Islam from certain prejudices and received ideas. These will occur later, too, in the context of the arabesque and the conflict between abstract and concrete, and they are allied to notions of the so-called superiority of Greek phonetics over consonantal language.

In their allusions to the myths of origin (in the form of qīla – 'It is said') some Arab thinkers and historians have given hints of their belief in a human origin of writing. These hints are too isolated and veiled, and their authors could not develop them without considerable fear of the consequences. Al-Ghazāli (d. 505/1111) himself left the question open in his sketchy formulation of a mystic theory of the written word:

'We ourselves think it possible that language could be conventional, in the sense that God acts upon the spirit of a man so that another may understand therein the design of the convention. But it is also possible that languages are fixed by revelation, in the sense that God has established their signs and characters: he who would see them clear might thus grasp their significance.'

This introduction provides food for thought, in view of the great intellectual rigour of this author, who attempted to bring philosophy and mysticism to order by means of a very subtle theology. For al-Ghazāli it was theology itself that was undeniable, not his interest in mysticism. This did not prevent him from writing, in his major work,[12] that language could not express the existence of God, and that language was made by men for men. This was clearly a heretical opinion, which appeared literally to contradict the content of certain verses of the Qur'ān. But it is known that his desire for theological truth made him end his days as a professor teaching – after his interest in mysticism – religious science.

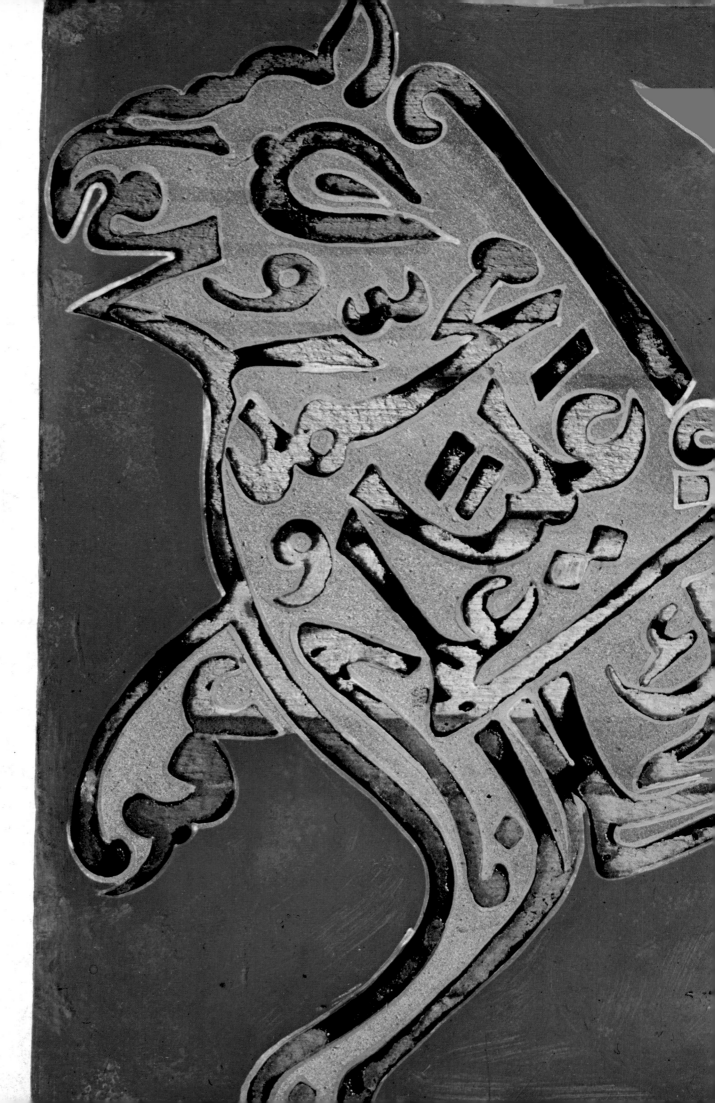

*Calligram in
the form of a tiger.
Artist unknow.*

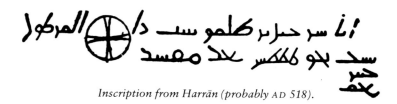

Inscription from Ḥarrān (probably AD *518).*

*Inscription from Zabad in Greek and Arabic (*AD *512).*

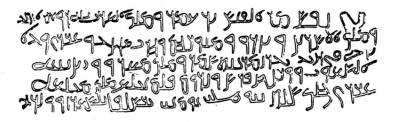

*Funerary inscription from an-Namara (*AD *328), speaking
of the famous pre-Islamic poet Imru l-Qays.*

Inscription from Umm al-Jimāl (between AD *250 and 271)*

EPIGRAPHICAL CONFUSIONS

Let us now consider further evidence relating to a factual approach to the subject. Ibn Khaldūn (1332–1406), that disillusioned rationalist, exhausted by the futility of the chroniclers, has nothing to say on those theories of the origin of writing which relate to Adam, the Prophet, or the angels. He was a philosopher who lived at the time of historic Arab retreat, and he tried to explain the actual nature of the facts. 'The most plausible view', he wrote, 'is that the art of writing was transmitted by the Ḥimayrites to the Tubbā; from them to the people of al Ḥira, and thence finally to the people of the Ḥijāz. . . . The Ḥimayrites had a script known as *musnad* which could only be studied with their assent.'[13]

The assent of another party is common to all writing. But where does this hypothesis lead? In fact it supports the statements of most of the chroniclers, who make Hira and Anbār on the Euphrates pivots for the dissemination of Arabic script. The historical importance of these centres of commerce is well known. But our concern is with the theory of the Syriac origin of writing, which Balāduri summarizes as follows: 'There is the story of three people from T'ay who came together at Baqqa, and constituted the Arabic alphabet *according to the Syriac manner*. From there the language passed to Anbār and Hira, thence to Mecca, and so on.'

This thesis, though of course anecdotal, is partly confirmed by recent epigraphical research, and challenges other theories which will be discussed later. At first sight there is nothing surprising in this conjunction of Western epigraphy and Islamic lore as regards the origins of writing and the metaphysics of symbols. For, in spite of the refinement of its classifications, epigraphy attempts to trace different scripts back to a single source and a common origin. This is an extraordinarily difficult task, where certainty is impossible (and in a sense useless), when one

thinks of the languages and scripts that have been lost for ever, the chain of their connections broken and dispersed among many other languages. How are they to be reconstituted when their most subtle signs and remnants have been scattered beyond recall? To become such an epigrapher one has to be a solitary seeker after the nostalgia of metaphysical beginnings. How can surviving traces of a language found here and there be recomposed, and fragments of phrases inscribed on tombs be rearticulated? However, like the (theological) ant of the philosopher Naẓẓam, which was transported by spiritual power, epigraphy has from its birth learnt to jump. But in our situation the jump will be less dangerous, since the Arabic language is more recent and the earliest known document dates from *c.* AD 328. So, abandoning this laborious and confusing approach, let us analyze the origin of Arabic writing from an epigraphical viewpoint.

This discipline makes use of certain archaeological inscriptions and, on the theoretical level, of linguistics, the history of writing, and so forth. The first fact is that the Semitic script is linked with Phoenician (or possibly proto-Phoenician), and chiefly characterized by the use of consonants, by a systematic combination of roots, and by a graphic line running from right to left. This is of course the case with Arabic. The second fact is the existence of inscriptions at an-Namara, Zabad, Harrān, Umm al Jimāl, and the papyri of Engaddi. The four first inscriptions, which are familiar to specialists, derive from what is generally called the Syro-Palestinian domain.

An-Namara is the site of a funerary inscription referring to the celebrated pre-Islamic bard Imru l-Qays. Dated AD 328, it is written in monumental Nabataean script, but with some signs of Arabic tendency. At Zabad (near Aleppo) there is a bilingual inscription (Greek-Arabic) dating from AD 512. The inscription at Harrān (AD 518) is written in

three languages, Greek, Syriac and Arabic, and that at Umm al Jimāl probably dates from AD 250–271. It should be mentioned that these dates are provisional, and that scholarly opinions are not always in agreement.

Other documents concerned with Arabic script, which have been studied by J. Starkey and J.T. Milik, relate to the papyri of Engaddi from the end of the first century AD and to some inscriptions from the second, third and beginning of the fourth centuries.[14] There is also an incomplete redaction to be found in the important *Répertoire chronologique d'épigraphie arabe*.[15]

Semitic epigraphers have, since the nineteenth century, decided, on the evidence of the inscriptions, on a Nabataean origin for Arabic script, which is usually called Nabataean-Arabic. It is a script derived from cursive Aramaic, which is itself derived, 'in the last resort' (according to J. G. Février), from Phoenician. This transformation must have taken place in the second or third centuries AD, according to B. Moritz.[16]

Could this Nabataean-Arabic script perhaps have been what the Arabs call *musnad*? This was formed of characters usually made up of one or two perpendicular or very oblique strokes, accompanied by an arc, a point or a crochet. We shall return to this later, but will here note that the theory of the origin in *Estranghelo* (a variant of Aramaic) has been generally rejected.

To continue the discussion with a reconsideration of the texts, B. Moritz, a supporter of the Nabataean theory, has compared ancient Nabataean with ancient Arabic characters and has concluded that there was no horizontal base line. Yet horizontality defines the skeleton of Arabic script, above and below which fall the vowel and diacritical signs. Moritz thinks that the introduction of these marks (in the Syriac manner) very probably took place in pre-Islamic times.

This thesis is put forward in the majority of histories of writing. But J. Sourdel-Thomine has attacked its tenuous nature as exemplified in this statement by J.G. Février: 'Around the second century the Nabataean script, a variation of the Aramaic, appeared at El'Ula. A north Semitic script, itself derived from the Phoenician alphabet, is thus substituted for a south Semitic script. The Nabataeans, to judge from their proper names and some other elements, spoke an Arabic dialect, but for their written language employed Aramaic, the chief commercial language of the Ancient East at that time, using an alphabet, called Nabataean, which was merely a cursive variant of Aramaic. After the decline of the Nabataean kingdom in the first century AD, Arabic insertions occur with increasing frequency in the texts . . . '[17] Such 'insertions' would require that Arabic existed in its own ancestral language. However, the experts disagree over the direction of the 'insertions'. But Février, a supporter of nineteenth-century Semitic epigraphy, has raised the question of certain characteristics of archaic Arabic which need answering: since the Nabataean alphabet had twenty-two letters, and the Arabic twenty-eight, the latter must have developed by means of diacritical signs (insertion). The vowels triangle is used in an unsystematic way, and the use of *matrices lectionis* existed before Islam. The Arabic script adopted, from the Nabataean, its method of ligatures connecting the letters.

J. Sourdel-Thomine, in his restatement of the question, supports the hypothesis of J. Starkey,[18] which concurs with that of the Arabs themselves. Starkey writes, 'It will be easier for us if we abandon the theory of the Nabataean origin of the Zaban and Harrān script, and simply say that the archaic Arabic script, being relatively homogeneous, derives entirely from the Syriac as it was written in the Lahmid capital.' He also writes: '. . . the hypothesis of a Syriac origin accounts better for certain Arabic letters and

Naskhi (text) and ta'liq *(marginal notes). The text is set within a border of gold. Qur'ān, 19th century.*

38

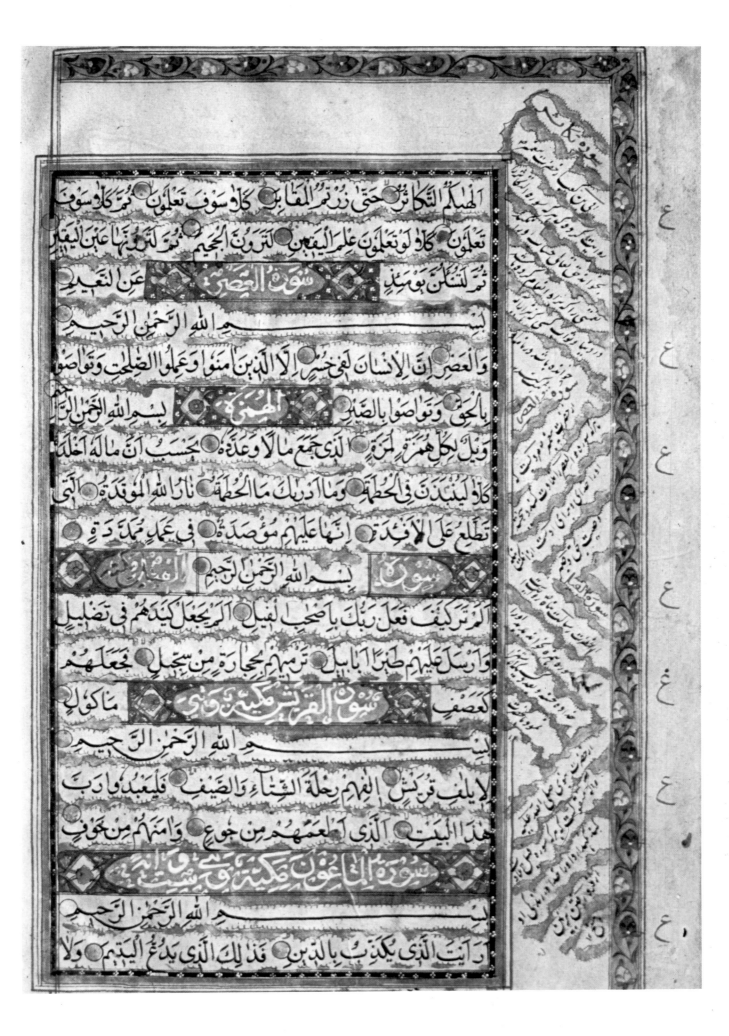

الهٰكُمُ التَّكَاثُرُ ۝ حَتّٰى زُرْتُمُ الْمَقَابِرَ ۝ كَلَّا سَوْفَ تَعْلَمُونَ ۝ ثُمَّ كَلَّا سَوْفَ
تَعْلَمُونَ ۝ كَلَّا لَوْ تَعْلَمُونَ عِلْمَ الْيَقِينِ ۝ لَتَرَوُنَّ الْجَحِيمَ ۝ ثُمَّ لَتَرَوُنَّهَا عَيْنَ الْيَقِينِ ۝
ثُمَّ لَتُسْـَٔلُنَّ يَوْمَئِذٍ عَنِ النَّعِيمِ ۝

سورة العصر

بِسْمِ اللّٰهِ الرَّحْمٰنِ الرَّحِيمِ

وَالْعَصْرِ ۝ إِنَّ الْإِنْسَانَ لَفِي خُسْرٍ ۝ إِلَّا الَّذِينَ اٰمَنُوا وَعَمِلُوا الصّٰلِحٰتِ وَتَوَاصَوْا
بِالْحَقِّ وَتَوَاصَوْا بِالصَّبْرِ ۝

الهمزة بِسْمِ اللّٰهِ الرَّحْمٰنِ الرَّ

وَيْلٌ لِكُلِّ هُمَزَةٍ لُمَزَةٍ ۝ الَّذِي جَمَعَ مَالًا وَعَدَّدَهُ ۝ يَحْسَبُ أَنَّ مَالَهُ أَخْلَدَهُ ۝
كَلَّا لَيُنْبَذَنَّ فِي الْحُطَمَةِ ۝ وَمَا أَدْرَاكَ مَا الْحُطَمَةُ ۝ نَارُ اللّٰهِ الْمُوقَدَةُ ۝ الَّتِي
تَطَّلِعُ عَلَى الْأَفْئِدَةِ ۝ إِنَّهَا عَلَيْهِمْ مُؤْصَدَةٌ ۝ فِي عَمَدٍ مُمَدَّدَةٍ ۝

سورة الفيل بِسْمِ اللّٰهِ الرَّحْمٰنِ الرَّحِيمِ

أَلَمْ تَرَ كَيْفَ فَعَلَ رَبُّكَ بِأَصْحَابِ الْفِيلِ ۝ أَلَمْ يَجْعَلْ كَيْدَهُمْ فِي تَضْلِيلٍ ۝
وَأَرْسَلَ عَلَيْهِمْ طَيْرًا أَبَابِيلَ ۝ تَرْمِيهِمْ بِحِجَارَةٍ مِنْ سِجِّيلٍ ۝ فَجَعَلَهُمْ
كَعَصْفٍ مَأْكُولٍ ۝ **سورة قريش مكية وهي**

بِسْمِ اللّٰهِ الرَّحْمٰنِ الرَّحِيمِ

لِإِيلَافِ قُرَيْشٍ ۝ إِيلَافِهِمْ رِحْلَةَ الشِّتَاءِ وَالصَّيْفِ ۝ فَلْيَعْبُدُوا رَبَّ
هٰذَا الْبَيْتِ ۝ الَّذِي أَطْعَمَهُمْ مِنْ جُوعٍ ۝ وَاٰمَنَهُمْ مِنْ خَوْفٍ ۝

سورة الماعون مكية وهي ست اٰيات

بِسْمِ اللّٰهِ الرَّحْمٰنِ الرَّحِيمِ

أَرَأَيْتَ الَّذِي يُكَذِّبُ بِالدِّينِ ۝ فَذٰلِكَ الَّذِي يَدُعُّ الْيَتِيمَ ۝ وَلَا

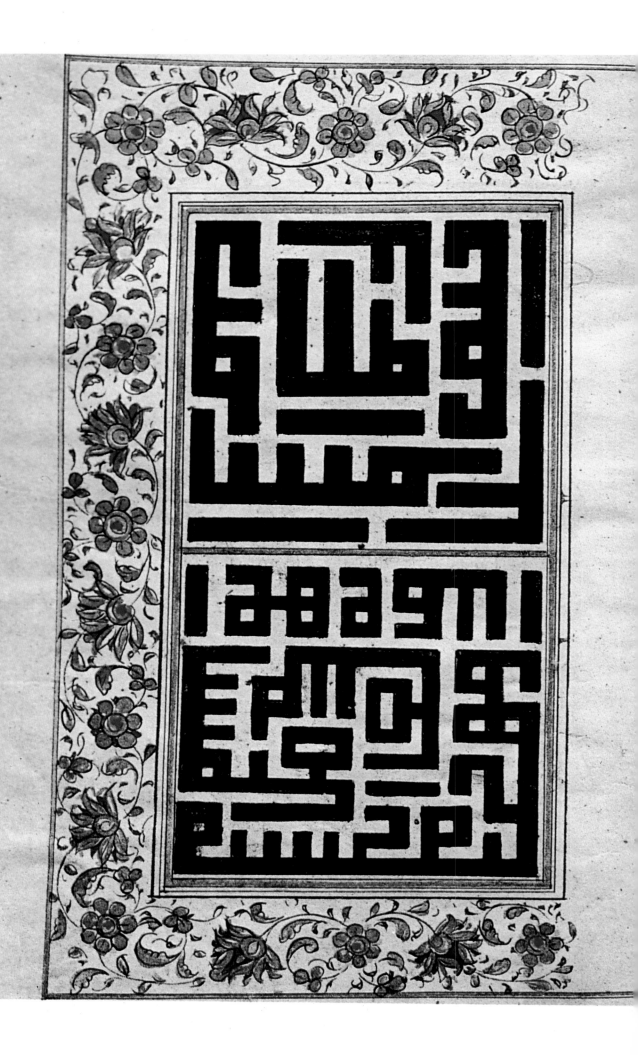

Square kufic *with a maze-like quality, and a page of text in* interwoven floral kufic.

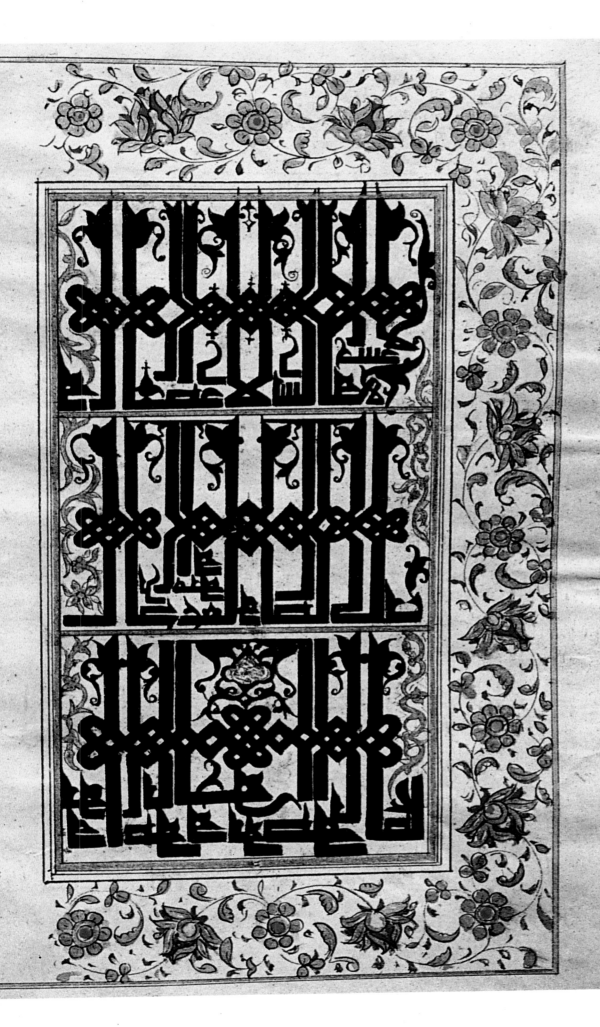

for the fact that, taken as a whole, Arabic script is *placed* along the length of the line, exactly as in Syriac script, while the succession of Nabataean letters is *suspended from this same line.*'

For his part, the Iraqi scholar Zayn al-Din Nāji[19] has tried to justify the theory of the *musnad* by means of Western epigraphy. In Arabic texts *musnad* and *jazm* are equally often suggested as the earliest Arabic scripts. This authority considers that *jazm* is merely a derivative of *musnad* and therefore there is no contradiction. In fact, what he calls *musnad* is called 'proto-Arabic script' in epigraphy. It is a script whose best known variants are *Safaitic, Tamoudian* and *Lihyanite*, and is characterized by the following: each pair of lines is separated by a stroke, in order to preserve the horizontality. And the line runs either from right to left, or left to right, or in *boustrophedon* (turning from one direction to the other, like the marks left when ploughing with oxen).

But all these theories are beset by fundamental contradictions. To attempt to recreate a prototype of Arabic by such methods is clearly to waver between a theory of resemblances on the one hand and a genealogical derivation on the other.

We have turned up some facts in the course of this critique. But we might do better, perhaps, when epigraphy and palaeography reconsider their ideas on the origin of Arabic script, and think of it as, in a sense, a dead body of symbol without name or feature.

Classical Arab philosophy turned to God to establish the inaccessible, indefinable origin, forever veiled from human understanding. It simultaneously made use of an insight into the past, the dawn's reflection, as it were, falling on consciousness in a shaft of metaphoric light, and, in the world of men, an inexorable call to start again. In his heart, of course, man had by no means lost awareness of those divine intimations lying, as it were, midway between the word of God and the human form, but the course of his development assumed a finality which sealed the signs of nature in their enigmatic opacity. The Qur'ān is presented as simultaneously revealed and concealed, absent and present, veiled – but by a celestial hand. And if man in his unsteady progress could express this transcendent order, where would he find a place if not in the ebb and flow of such a rhythmic transparency? Calligraphy was to be the flowing plainsong of the divine.

Epigraphy and palaeography no doubt progress at a diagonal to the metaphysical axis. Deriving from the eighteenth-century rationalism of the West, they too have kept to a limited concept of the origin. But both Islam and this rationalist discipline work towards an irreducible metaphysic, seeking the point of creation so as to assign to it the majesty of the beginning. And if, as modern thought repeats, the origin is nowhere, has no 'place', and never has had, except within something which far exceeds it, displacing it both at the level of the atom and in the lightning flash of cosmic movement, destroying its identity; if, then, the imagined dawn of writing can be realized only in sacred song, calligraphy too has its place in this voyage of discovery and, in the sense that script is sacramental, repeats its origin in the absolute line of the artist.

قاذن نمام ما يشتمل من الذات على امور مختلفة ولا بدان يكون نمام حقيقتها المشترك جنس
تلك المختلفة وكل واحد من تلك المختلفة نوع لذا اذا لا يختلف حقيقة المشتركات في ذاك الا اذا في غير
فيكون حقيقة بجموع الجنس والفصل هذا و قد يطلق ‏ شرح ‏ غدم

وكذلك اولا اذا في مشتركا بينها الا هو او ما هو و اختلف به
نقول لكم وجز بها المشترك بجرور معطوف على ما بينه
اى نمام جزئها المشترك فلا بد من فصول الاجناس و اما ان
لا يكون نمام المشترك فيكون حيزا لها في بجلة عاعدا ها
وهو الفصل قوله فاذن فرغه على ما تقدم تنبيها على اعتبا
قيدى النام والذات في فلا ينقض بفصول الاجناس
واما عارض العامة وآعنرض بقوله ولا بد ان يكون نما
حقيقها المشترك بين المبتدأ و جزوه اشارة الى كونه
مغولا في جزء ما هو على تلك الامور المختلفة بالحقيقة
نحب لشركة الحقيقة ليتحقق من بحنبه فلا بد ان
يكون جزء الكل واحد منها وآ ر يد بمختلفة بالحقيقة كما هنا
المختلفة بالحقيقة كما يشعر به في الكلامه فكل منها
نوع لذلك الجنس ولا ا انتقاض بالاشخاص و نما
واما اخراجها با عتبار ان الجنس يقول على تلك المختلفة
قولا بالذات فغير ما لا دلالة عليه في العبارة
ولا هو مطابق للواقع فان الاجناس العالية انما
نوع على انواع السافلة قولا بالواسطة مع انها الوقع

Shikesté script. *Triple overlapping of the letter 'kh'.*

Ta'liq script. *Text and marginal text.*

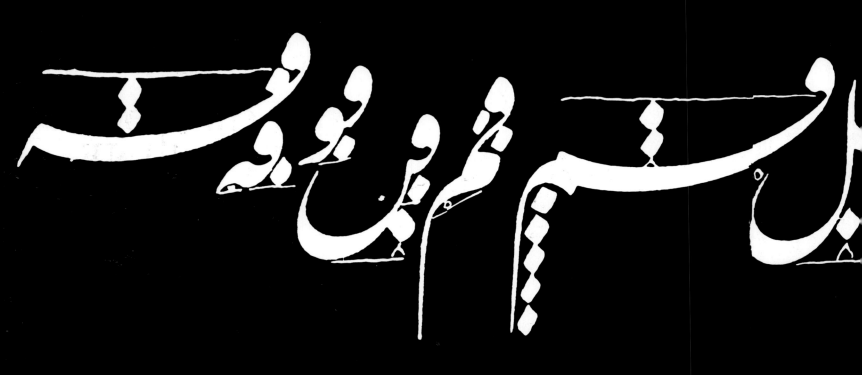

THE
PROPORTIONS
OF THE LINE

THE ALIF MODULE

The letter alif, *the first in the Arabic alphabet, is used as a module. Its length is determined by the dimensions of the nib of the reed pen. The rounded parts of the rest of the characters are made to fit within a circle, of which the alif serves as the diameter, its length being determined by the particular style adopted.*

We noted at the beginning that calligraphy constitutes a secondary code, related to language, and that it is based on geometric and decorative rules. Let us consider these rules in isolation, in order to understand better the composition of the character.

Clearly we do not want to reduce calligraphy to mere geometry. But we maintain that the proportioning of the characters, for example, plays a part in calligraphic designs in the same way that rhythm articulates music. The calligraphers had specified the elements of proportion, both in respect to the Arabic alphabet and to the interrelationship of the letters themselves. According to the most probable hypothesis, these geometric rules were invented by Ibn Muqla and afterwards perfected by numerous calligraphers. The principal points are described below.

The legibility of a text and the beauty of its line require rules of proportion. According to Arab calligraphers, the proportions of the characters always remain in a constant relationship: they all refer back to the size of *alif*, the first letter of the alphabet.

Alif is taken as the module of every Arabic calligraphic system; this choice and method are due to religious and mystical concepts, to which we will return. The length of the alif varies according to the writer, but all agree on using the dot as the universal unit of proportion. This is a square (rhombic) impression formed by pressing the tip of the pen onto the paper. The dimensions of each side of this square dot thus depend on the way in which the pen has been cut, and on the pressure exerted by the fingers. This pressure had to be sufficiently delicate and precise to separate the two sides of the nib.

What is meant by an Arabic dot and its measurement? The history of units of measurement is a very difficult subject, for these units change their names and designations from region to region, and thus make systematization impossible. In calligraphy, the dot is the craftsman's working unit. Al-Qalqashandi has shown that the standard pen was the official type used by the Abbasid Caliphs for signatures or initials. This pen, known as a *tomar*, consisted of twenty-four hairs of a donkey (or the equivalent), properly arranged and set.

Each calligrapher cut his pen in accordance with his own usage and that of his native land, and also in accordance with the kind of text he was to transcribe. In this sense, styles of script are definable by the pen and the width of the nib. In the thuluth style the width is equal to one-third of the *tomar*, and therefore the dot used for thuluth is also one-third.

The height of an *alif* varied from three to twelve dots depending on the author and the style of the script, its

Pages 44–5
Ta'liq script. *A stylistic exercise*

width then being equivalent to one dot. The important thing was to establish the height for each text. Once the calligrapher had chosen his alif module, he would draw it in the same way throughout the text. This was the general geometric principle, although in practice the calligrapher introduced variations. The arrangement of these variations is of great interest.

Alif was also used to measure the diameter of an imaginary circle within which all Arabic letters could be written. The calligrapher composed the characters, and therefore proportioned them according to the dot width, the size of the *alif*, and the diameter of the circle. These three elements were chosen by him.

For example, in naskhi script the *alif* is five dots high, and the letter *ba* (b) is seven dots wide and two dots for each of its serifs. In thuluth script the *alif* measures nine dots and the top of the character has a crochet of three dots. The length of the *ba* is either fifteen or eleven dots according to the two ways in which it can be written. When a letter is partly curved, it must be based on the arc of a circle of a given dimension, which is predetermined by the diameter of the *alif* standard. Thus, in thuluth the curve of the letters *'ayn, ra* (ع, ل) measures half a circle, which establishes the size.

It should be noted that the line of certain letters may determine one or two areas. This is the case, for example, with the letters *ṣad* (ص), *ḍād* (ض), *'ayn* (ع), etc. The area is established by the standard measure. In naskhi, for instance, the height of the curve of *sīn* (س) is four dots and its width five. The height of the curve of *ha* is six dots and its width five.

These examples reveal the general principle. The calligrapher establishes the dimensions of lines and areas for each letter and must ensure a consistency and a graphic symmetry throughout the text. In short, the size of the character must take account of a standard based on three measures: the dot, the *alif* module, whose size is equal to a fixed number of dots, and finally the circle, whose diameter is equal to the height of the *alif* module.

What is the interrelationship of letters themselves, as regards their reciprocal position, their direction, and their intervals? Let us place ourselves in the position of the reader, looking through the eyes of someone who neither speaks nor reads Arabic. What do we see? From this viewpoint, surveying a whole page of calligraphic script, we see within the margins an interplay of curves and uprights articulating the words, vowels and points; we also see floral or geometric designs and, finally, colours distributed sometimes over the whole or a part of the text.

Examination of the single character, the fundamental element in writing, reveals a head, a body, and finally a tail. With *'ayn*, for instance, the head is necessary for its recognition, providing the information by which it is determined. The secondary part of the character finally serves as a liaison, but its form and development require a style of ligatures.

The calligrapher wrote from right to left, along a horizontal line. On either side of the line, above or below, he inscribed the rectilinear or curvilinear elements of certain letters. Where the elements intersect the horizontal section of a letter they form an angle. We shall see later (pp. 230, 231) how the painter Boullata derives from this geometry the principles of Islamic art.

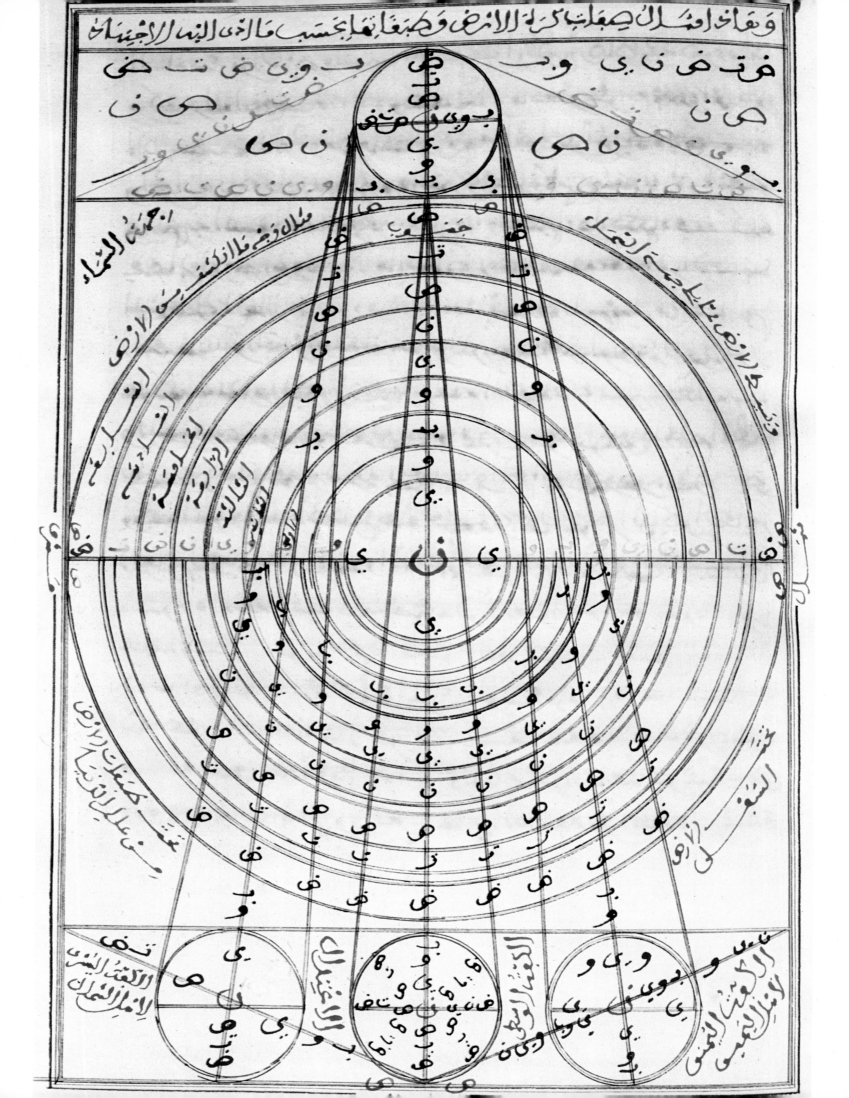

THE GEOMETRIC INTERPLAY

Let us now consider a whole page of calligraphy. The angles made by the appendices and their intersections with the horizontal section of the letter are each equal to one another – whether acute, obtuse, or, naturally, right-angled. All the acute angles on a page lie at about 40°, and the obtuse angles at 100°. When the appendices are curved, these curves are of the same size, since they refer to the same standard circle.

The regularity of the line, based on the three co-ordinates (*alif*, dot, circle) chosen by the calligrapher, lead to a spatial distribution of the appendicular elements of the letter, forming parallel groups, perceived or imagined by the eye. By arbitrarily extending the ends of the appendices, a grid pattern is formed over the whole page. From this new surfaces emerge, overlapping those of the characters, and the planes thus formed are arranged like the facets of a crystal. This, then, becomes a script in three dimensions.

These lines, angles, planes and formal shapes, though subject to geometric rules, achieve life and movement through volutes, contrasted characters, interlocking and intertwined letters, and clear breaks.

A page of calligraphy at once invokes a feeling of movement and rhythm. In the present context, however, we cannot explore further the relationship between music and calligraphy – a relationship which, while not precisely homologous in kinetic terms, reveals something in common, for both arts share a dynamic which separates logic from its rationality and its rhetoric.

In calligraphy, the rhythmic intervals afford rest to the reader's eye as it runs over the text, providing a subtle pause between the forward movement of the line, a kinetic design emphasized by several elements: alteration of the characters' vertical sections; juxtaposition of unequal spaces; groupings of words in sequence or in insertion so as to create, outside the bounds of their assigned space, asymmetry and rhythmic breaks in the reading.

Other formative elements share in the process, including: elongation and cursive linkings of letters above and below their axes; serpentine lines between certain letters; cursives containing the next word within their decorative flourishes; stately and delicate positioning of letters so as to establish a subordinate relationship in form and meaning; and finally, the spiral.

Add to these a distribution of the major masses of text: down-strokes and up-strokes, open spaces, diacritical signs, vowel accents, floral and geometric motifs, and there results a cadence of arabesques which impresses itself upon the space/time continuum, by a process of artistic selection within the hand itself of the calligrapher and in the nerve endings of his fingers.

Let us make our way delicately through this field of symbols, changing our position according to the mood of the figure: first, the monumental characters, suggestive of the architecture of a mosque; then, a labyrinth in which the calligraphy itself seems entrapped; finally, slash marks which seem to have been traced with a warrior's sword.

Square kufic.
Above. 'Al hamdu lillah' ('*God be praised*'). *The interlaced design of the central medallion is formed by the long uprights of the letters* alif *(a) and* lām *(1).*
Left. The name Mahmūd Yazir *rotating around a central letter* mim *(m). (After M.B. Yazir; see bibliography).*

Facing page. Astrological treatise in the maghribi style.

Above. A calligraphic exercise by Muhammad Shāfiq (1874).

Right. **Thuluth script.** *A stylistic exercise in which the letters of the alphabet are accompanied by dots as proportional indicators. Hāj Hassan Rida (1900).*

COLOUR

Before trying to bring out the chromatic scale of the calligrapher's art, the origin of which cannot easily be determined, some introductory remarks are in order. The range of colours used by calligraphers is extremely rich and varied. Black was the basic ink, though not invariably so. In the Maghreb it was prepared from wool taken from the abdomen of a sheep. The tufts were shredded into an earthenware container which was placed over a fire to scorch the wool. Then it was pulverized with a stone and, after water had been added, the mixture was heated afresh. A paste was thus obtained which, after cooling, became hard and homogeneous. A piece could then be taken when needed and dissolved in water. A black or brown ink resulted, according to the degree of dilution.

The colours, which included gold, silver, blue, green, orange, violet, yellow, etc., were prepared from vegetable and mineral sources. Like certain painters, individual calligraphers would prepare their own inks, using secret formulas which were sometimes lost to posterity when their inventors died.

Colours are not automatically a feature of manuscripts.

Their employment indicates the writer's special care and the exceptional value that he placed on the work. They may be varied and rich in every sense of the word, beginning with the complementary colours of the spectrum – red, blue and green; then yellow or gold with violet. The colours were applied separately, but their juxtaposition makes them appear even more vivid and warm, somehow like velvet.

Pastel colours, washes, and colour combinations giving a cool impression were used only rarely. It is the marriage of gold with other colours which gives both miniatures and scripts their elegant character. The skill of the calligrapher lay in his control of them, combining them with an exceptional sense of chromatic balance that may too easily be regarded as principally functional or decorative. But the meaning of such virtuosity, which gives life to miniature, arabesque and text, deserves closer scrutiny. By 'text' we mean a manuscript written in part or in its entirety using colours other than black or brown, these last two being widely used in calligraphy. Naturally, both arabesques and miniatures often serve to frame written passages.

Above. **Maghribi script.** *A marginal motif indicating the end of a Qur'ānic verse (1560).*

Right. **Polychrome maghribi script.** *Extract from the* Dakhira, *a text of the Sharqāwa religious sect (Morocco).*

اللَّهُمَّ صَلِّ وَسَلِّمْ عَلَى سَيِّدِنَا وَمَوْلَانَا مُحَمَّدٍ
وَعَلَى آلِ سَيِّدِنَا مُحَمَّدٍ

حَبِيبِكَ الدَّاعِ أَنْ أَرَى أَلِ إِلَى بَعْضِهِمْ وَبَرَاسُو وَشَامَ مَا مِنْعَتَمَ مَوْلَا مِنْ
إِجْمَاعٍ عَلَى أَسْرَارِ الْغُيُوبِ وَمُحِبَّانِ السِّمَاءِ فَقَالَ مَعَنَا وَاللَّهِ مَعَازُ السَّلَامِ
وَالسَّلَامُ وَدَلِيلِ الْبَايِنِ وَالنَّاسِ وَمَلَاحُ مَآثِمُ أَهْلِ الْحِجَابِ وَالْكِتَابِ

اللَّهُمَّ صَلِّ وَسَلِّمْ عَلَى سَيِّدِنَا وَمَوْلَانَا مُحَمَّدٍ
وَعَلَى آلِ سَيِّدِنَا مُحَمَّدٍ

حَبِيبِكَ أَنْ أَرَى أَلِ إِلَى بَعْضِهِمْ سَارَسَ وَشَامَ مَا مِنَ اللَّهِ مِنْ أَحَادِيثَ النُّسُوِّ
وَالْمَسَاجِدِ وَالْمَرَازِنِ فَقَالَ مَعَنَا وَالنَّجِيِّ كَذَا الْآرِبِعِ وَالْغَارِشِ شَمِيمَهُ لِعَافِظٍ
وَالْخَارِشِ وَحِمَايَةٍ أَنَّهُ أَجَلِ الْغَارِشِ وَمَبِيدٍ مِثْلُ أَنُوشِهِرَاءَ وَكِسْرَى وَقَارِشِ

أبو الفتح أحمد
رحمه الله تعالى

وبتوفيقه نستنجح المطلب والمرام

قال الشيخ الإمام
أبي محمد الغافر

حمد الله تستفتح الك

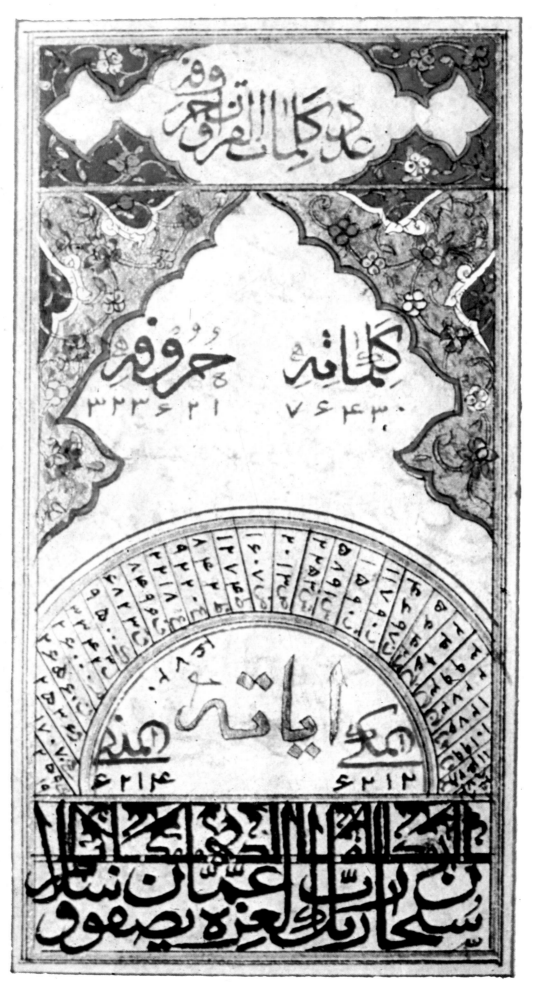

Left. Closing page of a Qur'ān, indicating the number of letters, words and verses contained therein.

Right. **Maghribi script.** *The verses are divided by motifs in gold, while diacriticals and vocalization are highlighted with the use of colour. Qur'ān (1560).*

Preceding pages. Homage to the lineage of the Prophet Muhammad. Al-Qandūsi (1828).

اولم يسيروا في الارض فينظروا

الذين من قبلهم كانوا هم

الارض وخربوها واخذهم الله بذنوبهم

ذلك بانهم كانت تاتيهم

وكفروا فاخذهم الله انه قوي شديد

موسى باياتنا وسلطان مبين الربع

كذاب فلما جاءهم

اقتلوا ابناء الذين امنوا معه واستحيوا

الكافرين الا في ضلال

وليدع ربه اني اخاف ان يبدل دينكم

وقال موسى اني عذت بربي وربكم

Maghribi script. *A medallion.*

Right. **Maghribi script.** *A page written by al-Qandūsi. In the central section the colours used for the consonants and for the vowels and diacriticals respectively are reversed.*

وضع يد بلاعزل

عن مشاهدتك

ومحبتك

ومثلا على السنة

والجملة على

والشوق الى

لقاك يا غا

لجلال والإكرام

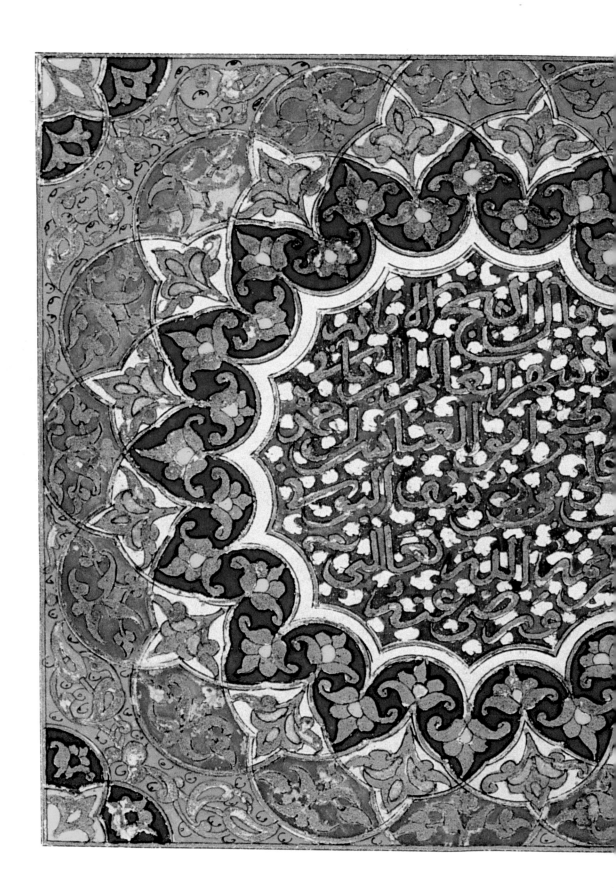

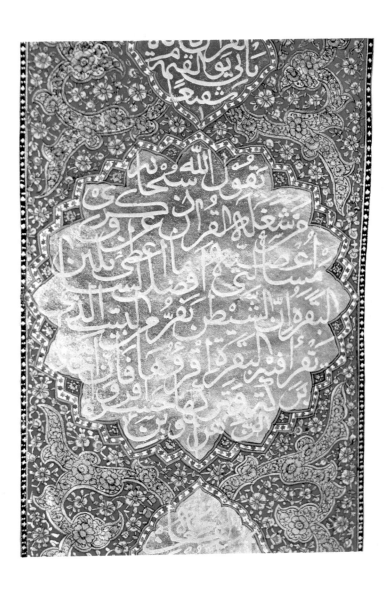

Oriental **thuluth script.** *A Qur'ān copied by Abdul-Salam Hindi (18th century).*

Overleaf. Homage to the lineage of the Prophet Muhammad. Al-Qandūsi (1828).

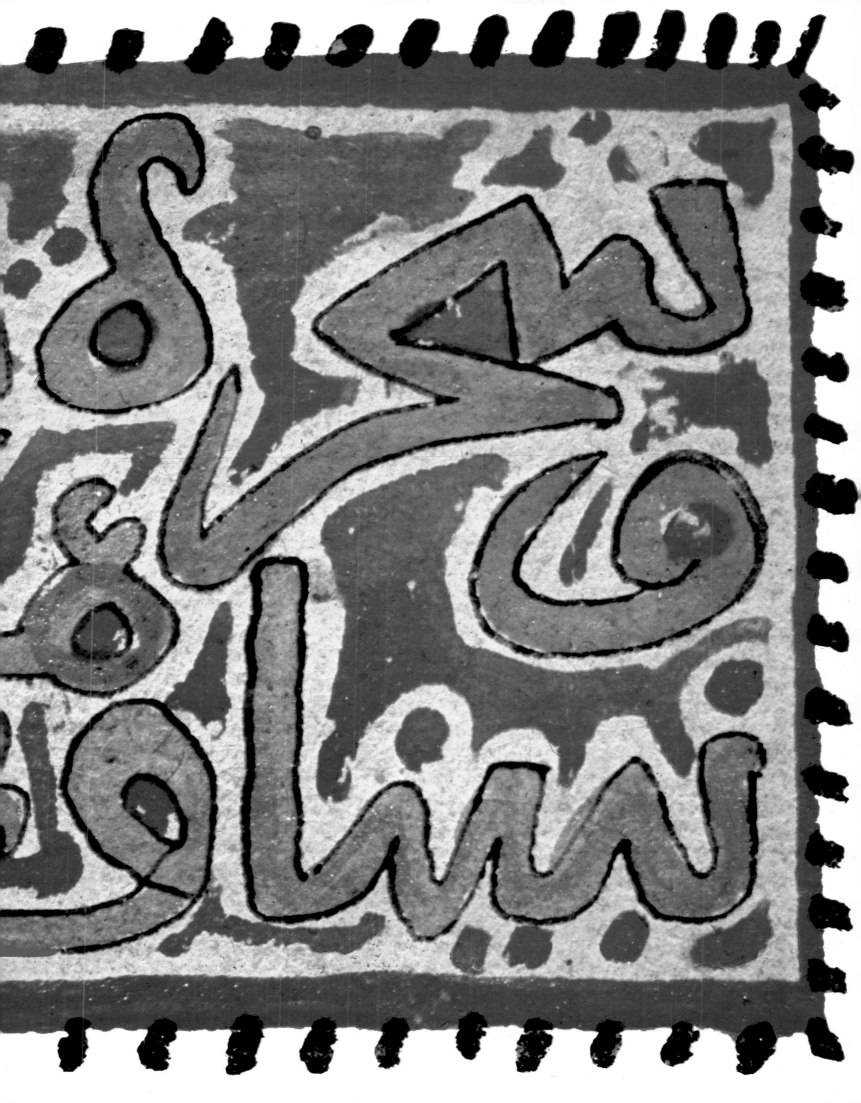

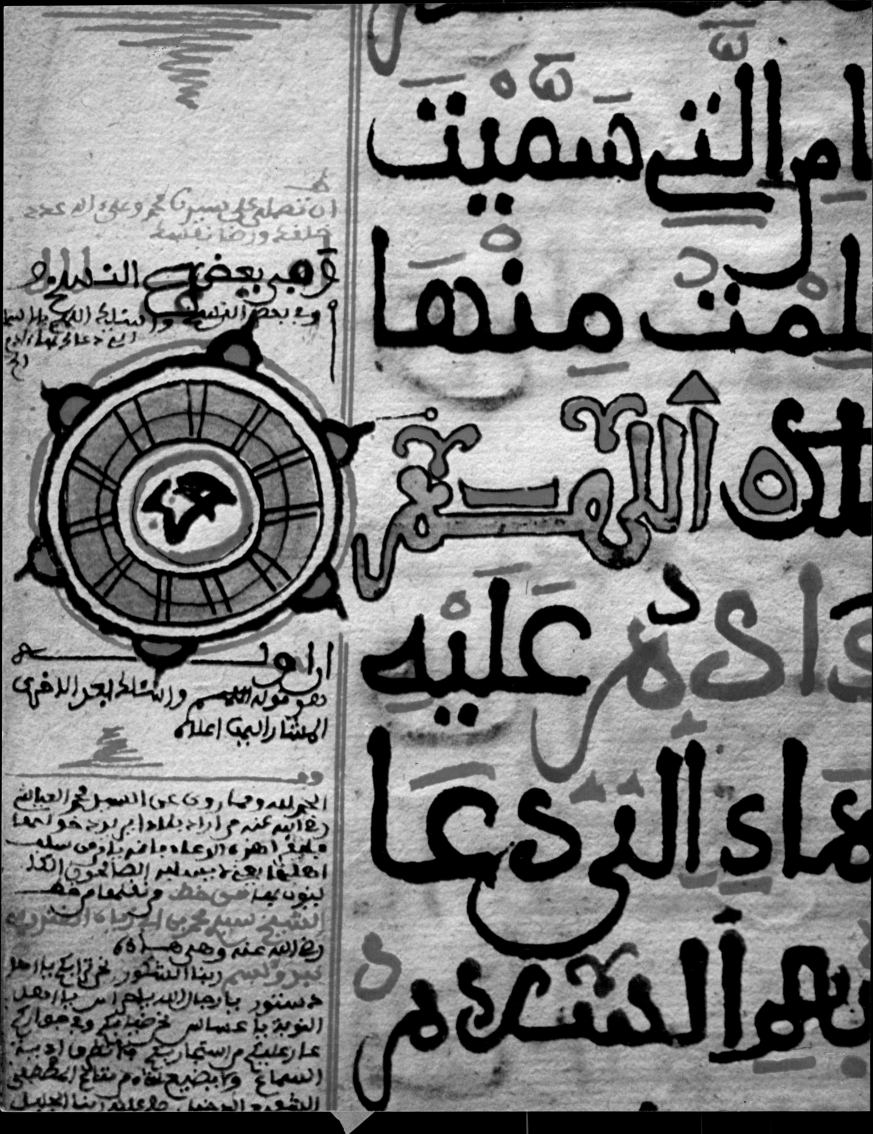

ام التي سميت

لمنت منها

ك الاوهم

عليه

ماء التي عا

هو الخدم

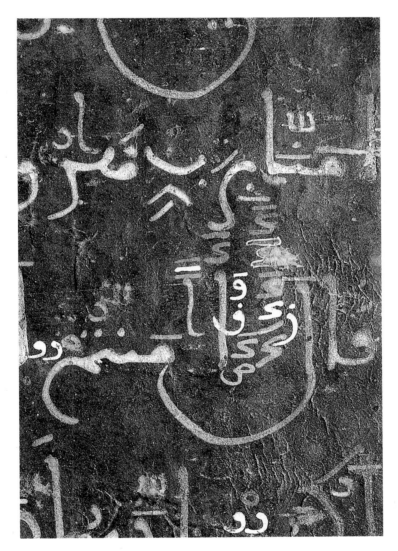

Andalusian maghribi script.
Fragment of a page from the Qur'ān, copied on coloured silk.

Left. Detail of a page with marginal annotations in **cursive maghribi script.**

Preceding pages. A freely flowing text written by al-Qandūsi (1828) in a style suggestive of modern abstract art.

Andalusian maghribi script. *Detail from a Qur'ān copied on coloured silk.*

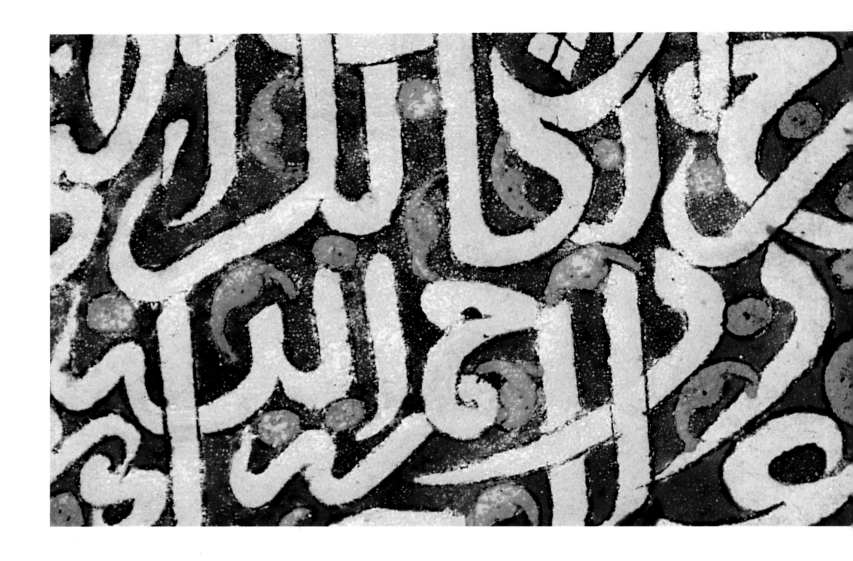

MINIATURE AND ARABESQUE

Maghribi script. *Title page of a work on culture and literature, with reference to the Hellenistic tradition (detail). Edited by the historian al-Baghdadi, 17th century. Bibliothèque Royale, Rabat.*

In this context the miniature owes its origin and impact to the art of Persia, where it first took form, derived from wall-paintings. It later migrated to countries such as Turkey, Iraq and Syria, but is rather seldom found in the remainder of the Arab world.

What, from our point of view, is the relation between calligraphic texts and page decoration? Those marvellous scenes filled with historical or legendary figures are widely known. The world of animals and of plants, generally covering the whole page, is drawn in minute detail, in contours that are clear, well defined and highly stylized. Sometimes flat washes of colour seem to flood into the compartments drawn by the artist, but usually the palette is dominated by intense colours, intensely sumptuous – gold and silver which emphasize a spiritual glory pervaded by sanctity. Qur'ānic verses, poems, or mystical and magical formulas rest in the depths of expanses of colour, or embell-ish them to accentuate the contrasts. Multicoloured floral

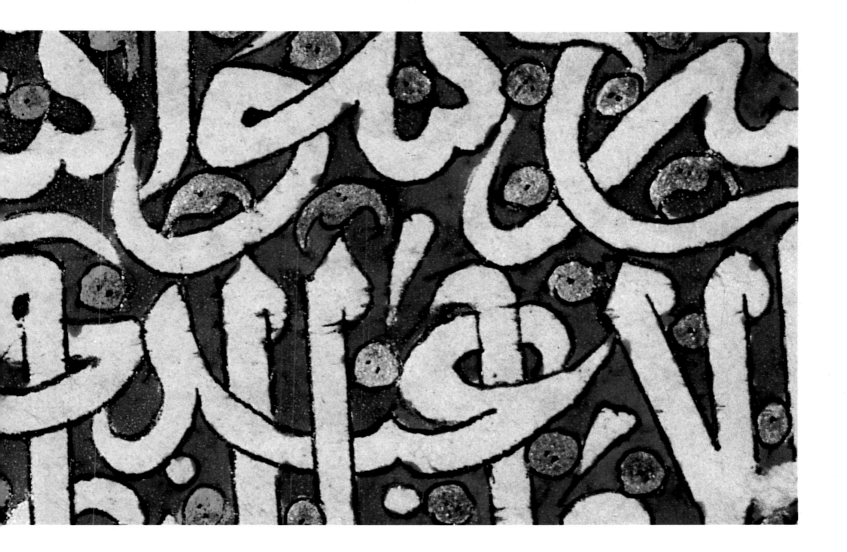

designs accompany blank spaces and give the work a feeling of completeness and order.

In contrast to the miniature, the arabesque has spread throughout the Muslim world. Originally an architectural feature, it found a privileged place in the written word. The miniaturization of floral and geometric designs, the skilful use of the pen in tracing them, the opportunity to apply colour and, above all, the superlatively creative style of the calligrapher, inspired a transfiguration in Arabic art comparable to the mystical tradition of self-transcendence.

The purely decorative designs of the arabesque are too familiar to require a detailed survey. Let us consider, however, besides the widely distributed geometric and floral decoration, certain areas of detail: the architectural motifs of famous mosques, and particularly the Ka'ba and the tomb of Muhammad in Mecca. These motifs reappear in manuscripts, sometimes traced with outstanding elegance. In these general views, which are usually to be found on the opening pages, the calligrapher provides information of a historic kind. In the body of the manuscript, ribbons of arabesques mark the openings of chapters, while other motifs, in the margin, mark the divisions of the verses of the Qur'ān.

In the arabesque, gold is constantly used. Its marriage – 'the golden ecstasy' – with other colours – silver, blue, green, yellow, white – is a subject for contemplation. The range is established with a richness and a harmonious contrast of tones which shine like the colours of a stained-glass window.

The artist took particular care with the design and colour of the medallions in the margins, which marked the chapters of a text or the subdivisions of the Qur'ān. The inscription set in its frame – *rubu'* = ¼, *thumun* = ⅛ of the *ḥizb* (plural *aḥzab*; the Qur'ān is divided into 60 *aḥzāb*) – are often written in kufic script while the actual text of the manuscript is written in, say, thuluth or maghribi. The colours are uniform, filling the areas marked out by the written line.

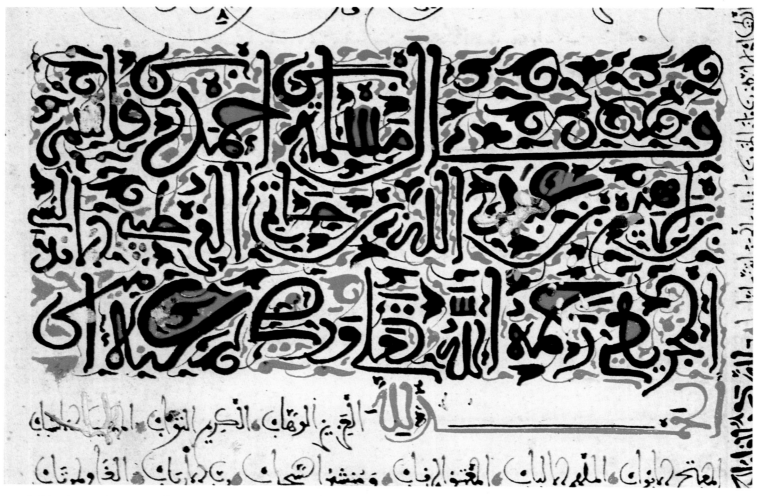

Maghribi script, *with improvised ornamentation.*

The chromatic profusion found in the arabesque is very powerful in certain manuscripts – power and delicacy sharing a sublime coexistence. Contrasting touches, the colours of diacritical signs and vowels, words or phrases given special emphasis by the calligrapher, all evoke the divine presence.

Thus the names of Allah or Muhammad, or words referring to them, recur like a leitmotif. They are drawn in green, blue or red ink, or in any other chromatic style likely to seize the attention, as if the calligrapher were inducing a mystical trance in the wink of an eye.

If the graphic composition follows an order imposed by the text, the colour will, as it were, challenge this order so as to draw from the text a fitful harmony. As a general rule, the colours are arranged in accordance with certain conventions – blue, green, red and so on – superimposed on each other and shaped according to the line of the words. This arrangement of black and coloured areas of script provides a dual colour level for the reader's eye to follow: the letters in black furnish the ground of the page, while the diacritical signs, vowels, and coloured words stand out. As the eye shifts from one plane to the other, a sensation of movement is created: the pictorial divide causes the page to move, with unexpected colour combinations and an effect of brilliance. One can sense in it the calligrapher's intention, concentrated in his fingertips, to catch on the point of his pen the unlooked-for moment of his rhythmic essence: unlooked-for, in the sense of its materialization through form on the mundane level.

Ta'liq and thuluth script,
with decoration of angels.

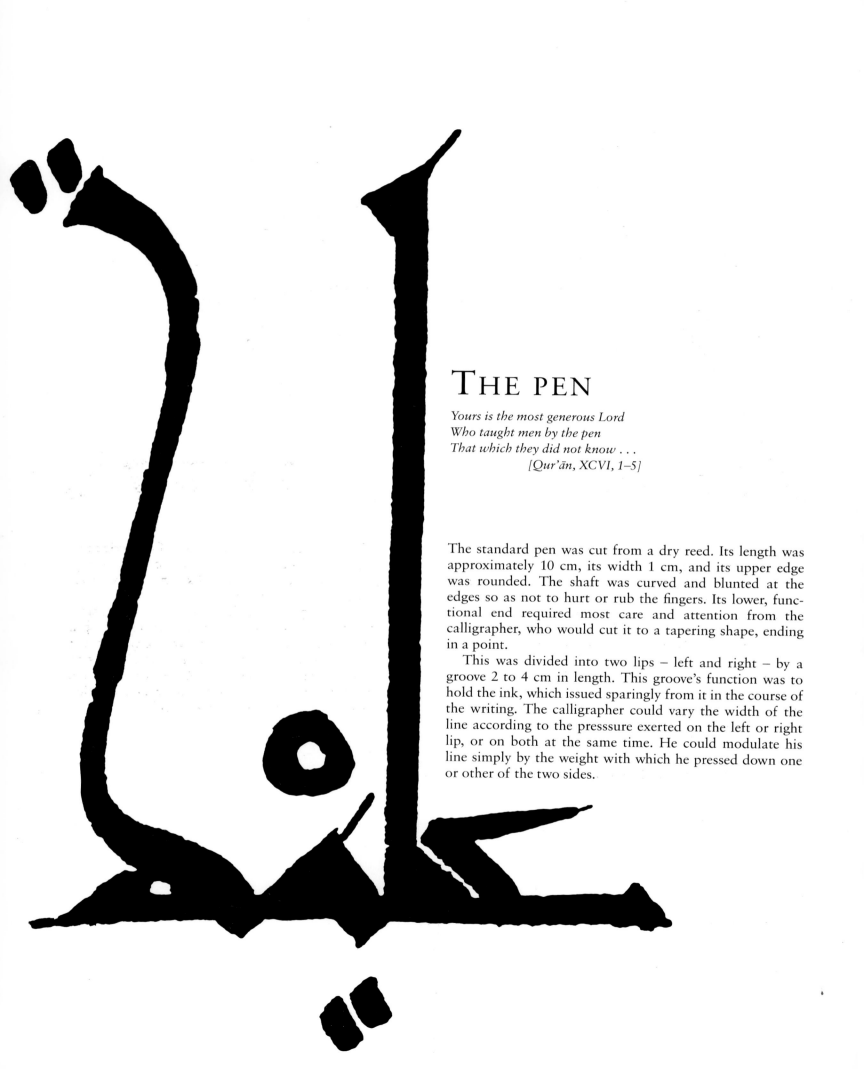

THE PEN

Yours is the most generous Lord
Who taught men by the pen
That which they did not know . . .
 [Qur'ān, XCVI, 1–5]

The standard pen was cut from a dry reed. Its length was approximately 10 cm, its width 1 cm, and its upper edge was rounded. The shaft was curved and blunted at the edges so as not to hurt or rub the fingers. Its lower, functional end required most care and attention from the calligrapher, who would cut it to a tapering shape, ending in a point.

This was divided into two lips – left and right – by a groove 2 to 4 cm in length. This groove's function was to hold the ink, which issued sparingly from it in the course of the writing. The calligrapher could vary the width of the line according to the presssure exerted on the left or right lip, or on both at the same time. He could modulate his line simply by the weight with which he pressed down one or other of the two sides.

As already noted, the width of the nib was important in determining the *alif* module. In fact, the width of the dot decided the unit of proportion of the *alif* and, in consequence, that of all the other letters of the alphabet. It was therefore essential for the calligrapher to cut the point with precision and in accordance with the rules of the selected system of script. Thus there were pens suitable for the naskhi script, others for thuluth, and so on. In the application of colour, each required a particular pen. In order to write the *bismillah*, too, a specific pen was needed. This was also true of signatures (*ṭughras*) and of certain words in a text which were to be emphasized.

The point of the pen could be cut either straight or bevelled. The first gave regular lines of a well-proportioned thickness, the second was fine-pointed with up-strokes and down-strokes. The evenness and elegance of the script also depended on the way that the pen was angled to the surface of the paper. Thus the calligrapher, like an artist with his brushes, used a number of pens.

The materials required for the making of the pen were popularly endowed with symbols. To seal a marriage, a pen of red copper was to be used, with the writing on wax, not paper. To celebrate a friendship, a pen made of silver or from a stork's beak was employed. A pen cut from the branch of a pomegranate tree was used for communication with an enemy, as if to counteract an evil spell.

Above. **Ḳarmatian kufic:** *the letter 'k'.*

Left. **Ḳarmatian kufic** *(detail).*

SCHOOLS
AND STYLES

TYPOLOGY

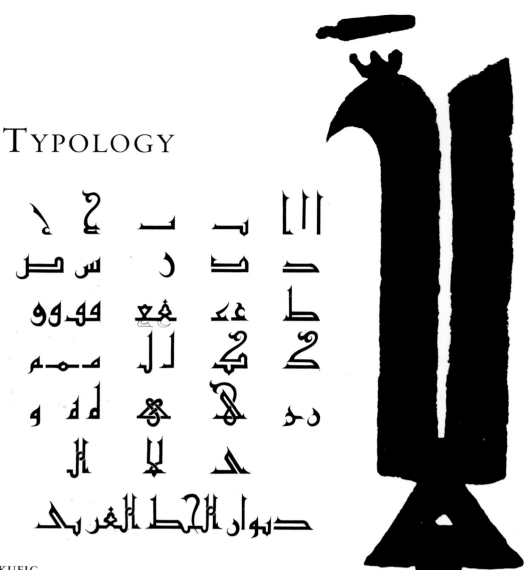

KUFIC

Kufic script. *The double letter* lām *(l) and* alif *(a).*

Pages 76–7
Tughra *(signature) of the Ottoman Sultan Maḥmūd Khan II (reigned 1808–39).*

How is one to determine the precise number of different calligraphic styles and definitive models? The compilations of historiography provide a mass of information, but little qualitative elaboration. Muslim historiography is basically genealogical in its approach to classification. These historians and chroniclers display in daunting detail the genealogy of the calligraphers for every style, providing a mass of information, though without any synthesis. No doubt there still exists innumerable treatises on calligraphy, but they constitute the backing for an orally transmitted teaching, and this reduces their actual scope. Some styles have changed their names or have merged with others no longer in existence. From one country to another, from one epoch to another, typologies and nomenclatures undergo transformations which baffle the contemporary researcher. So let us try to establish a major typology, based on seven styles, and reveal a noteworthy continuity. These are: kufic, thuluth, naskhi, Andalusian maghribi, riq'a, diwani, ta'liq (or fārisi). There is no doubt that they possess cultural coherence and have an extremely widespread geographical distribution.

We have several times pointed out that, from the beginning of Islam, *kufic* was the dominant priestly script, and was certainly reproduced according to a craftsman's procedure. The early texts do not record any code for its transcription, in spite of its importance and the variety of its regional forms.

Archaic kufic was particularly difficult to decipher since it lacked a vowel system, and tended not to give the various letters systematically differentiated forms.

Kufic and naskhi influenced each other. Thus, in the middle of the fourth/tenth century a slanting version of kufic appeared, but prior to that date all the manuscripts of the Qur'ān were written in old kufic.

It is an irrepressible style, lending itself to the most testing transformations. Its magnificent geometrical construction, based on angular elements, could be adapted to any space and to any material, from a simple silk square to

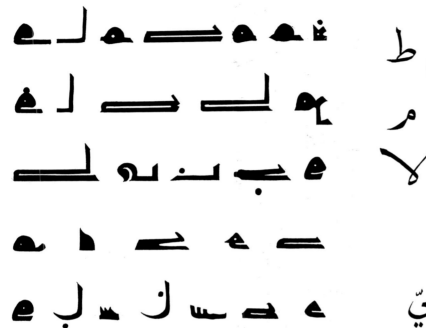

ARCHAIC KUFIC

NASKHI

ديوَانُ الخَطِّ العَرَبِيِّ

the fabulous architectural monuments left by Timur at Samarqand.

Naskhi is an essentially cursive script. During the great epoch of the Abbasid Dynasty, it served equally well for the transcription of texts translated from Syriac, Greek, Persian or Indian languages. It was thus of central importance in the elaboration of classical knowledge and in the administrative work of the bureaucracy. Naskhi absorbed a wide range of disciplines, and influenced the styles of Turkish and Persian scripts. In our opinion it is the common denominator (but not the origin) of thuluth, riḥāni and muḥaqqaq. The complex structure of thuluth has an inaugural liturgical value, for it is used for the headings of the Suras and features prominently in architectural arabesques.

The *Andalusian maghribi* style is less familiar, having been overlaid by the Turks, the Persians, and the eastern Arabs. We use this name to refer to all the styles of script which were current in North Africa, Spain (al-Andalus) and parts of Black Africa. The importance of Qayrawan (founded in 670) in the history of the Arabic East is well known, as is the role played by the Aghlabid dynasty (800–909). The rapid advance to autonomy in the West was indicated by an original culture which reached its apogee in al-Andalus. The style of this script is rounded and easily recognizable:

1 The line of the up-stroke is less sharp – almost wavering – than that of, say, naskhi.

2 The '*f*' is indicated by a point below the letter (ڢ) and the point of the '*q*' is above (ڧ).

3 Certain end letters take a lengthened form, for example س, ص.

4 The diacritical signs are often eliminated from the final letters: ن, ڢ, ق, ى. This feature is associated particularly with the Marīnid dynasty (1190–1468) in Morocco.

5 In some Qur'āns there are still the old divisions of the Suras in groups of five (*khamisa*) and ten (*'achira*), as with the Qur'ān of Ibn al-Bawwāb.

ا ب بٽ ج ذ ز ش ش ض ظ ظ ا ل ي ر ش ع م د ر س ش

غ ف و ق ك ل م ن و ص ط ع ف ق ق و ك ا ل

هه بة ة لاى م ه ق و و هه لاى

ديوان الخط العربي ديوان الخط العربي

Our research involving more than one hundred manuscripts has convinced us of the splendour of some of the true maghribi texts. Ibn Khaldūn contrasted the refinement of the Andalusian with the barbarism of the Maghrebi peoples. But this was the viewpoint of an aristocrat unresponsive to popular art, the subtle force of which requires a different approach. The earlier prejudice was reasserted by the orientalist D. Houdas in 1886, but today one would have to be blind not to appreciate the brilliance of the Moroccan calligrapher Muhammad bnū abi al-Qāsim al Qandūsi (d. 1278/1861). In this book he is accorded a place of honour without in any way detracting from the reputations of other important calligraphers of al-Andalus or the Maghreb.

Though it severed itself politically from the East, al-Andalus nonetheless reproduced the Abbasid system. The court of Abderrahman an-Nāsir (fourth/tenth century) used the same bodies of scribes, illuminators and decorators. The art of calligraphy developed further to the north

as well as in al-Andalus, at Cordoba, Toledo, Granada and Murcia.

Andalusian script is distinguished by a compact projection along the horizontal line, with only narrow spaces between words.

The old script of Qayrawan is in a cursive style akin to naskhi. Here final letters bear diacritical marks. According to Ibn Khaldūn, the script disappeared at the time of the Almohads (1130–1269), to be replaced by the regular Andalusian script.

The style of Fez (*fasi*) is recognizable by the remarkable size of the vertical strokes and the absence of diacritical signs and terminal letters. It is hard to differentiate between the scripts of Algeria (Oran/Tlemcen) and those of Morocco, unless possibly by the greater thickness of the Algerian stroke. Sudanese writing has the general appearance of old kufic script. Since it was little used, it has undergone little change.

The Ottoman Turks invented several styles, stamped by

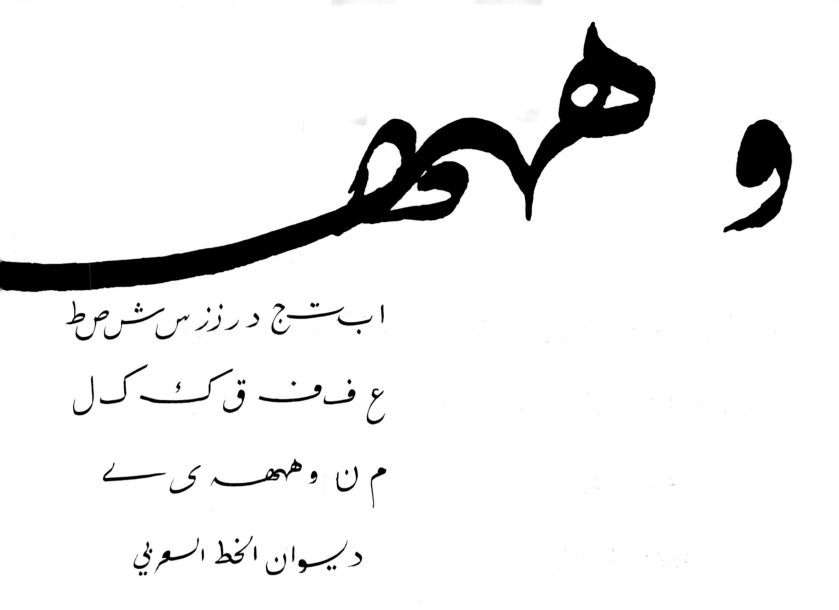

اب ت ج د ر ز ز س ش ص ط

ع ف ف ق ك ك ل

م ن و هه ه ى ے

ديـوان الخط السعربي

TA'LIQ (*with enlarged detail above*)

the Imperial Seal. First is the famous *diwāni* – a Persian term from which two very different words in modern use are derived: divan and douane (custom-house). The diwāni style made its appearance after 857/1453 and was codified at that period by Ibrahim Munīf. It was above all the style of the executive department and its official power. It is distinguished by a lively cursive flow accentuated by an oblique point of balance (from top to bottom and right to left), but slightly looser to the right at the ends of words and phrases. This style blends into an important ornamented variant, *jilli diwāni*, in use from the tenth/seventeenth century. This writing is smaller and more compact, and the intervals between letters is systematically filled by decorative details and strong flourishes.

Riq'a is the other great Turkish script, the use of which expanded as Ottoman dominance grew, with the earliest known examples dating from 886/1481. A stout, thick script, it is arranged, apart from the vertical lines, entirely along a lightly marked horizontal line from which the up-strokes rise stiffly. It is also characterized by rounded hooks at the level of the tail and/or the head of the letter. The time required to read this script is therefore greater.

Sayaqit script has existed since the time of the Turkoman Seljuqs of Asia Minor. It has reference more to cryptography, and was designed to be read by officials of the same department, communicating top-secret political information; it therefore combined complexity of line with a secret code of meanings and ciphers.

The *tughra* script was of the same type, and was used in the signatures of political potentates. Theoretically, it was supposed to be impossible to imitate. It was probably of Tartar origin, and the name itself was kept a secret. This style made its official appearance after the capture of Constantinople by the Ottoman Sultan Muhammad al-Fātih (857/1453).

Persian script superimposed itself on the Arabic language with all the delicacy of choreography. *Pahlavi* is associated with a different linguistic system, and it was

BEDR EL KEMAL

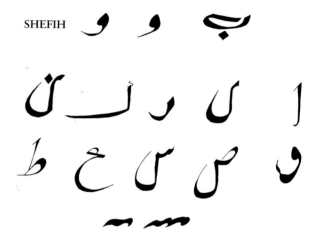

ANDALUSIAN MAGHRIBI

SHEFIH

SHIKESTÉ

necesssary to adapt it by adding, for example, diacritical signs to certain letters in order to complete the Persian alphabet (such as پ for *p*). Ta'liq is the brilliant result of this adaptation, particularly powerful in the *shikesté* (broken) style, which is distinguished by an absence of diacritical signs and an interplay of conjoined ligatures.

There are two kinds of shikesté script: in one the characters are very close together, interlaced, while in the other they are widely spaced and individualized. In the *shefih* script, which is derived from ta'liq, the letters interlock in a kind of lovers' embrace.

Ta'liq is less demanding: it glides over the breaks with a winged grace. The same letter may display a thicker or a thinner line, and some terminal letters are greatly extended. It also tends to go up and down and from right to left without returning to the right.

Riḥani, a variant of naskhi, is characterized by a line in which the letters start with a thick stroke and taper to a thin point at the end. The script follows a horizontal course which may not be broken by strokes below the line, except for the letter *j*.

Finally, we should mention some particular scripts of either a highly eccentric nature or else used for secret and subtle communication: *ghobar*, for instance, is a very delicate script requiring the help of a magnifying glass for decipherment. It was used in messages sent by carrier pigeon. *Manashir* was used for sending letters of reprimand or satisfaction; in this case tails were added to the characters. *Ḥurūf tāj*, as its name implies (*tāj* = crown), was written in the form of a crown. *Ḥilali* used one or several crescent-shaped strokes. This name alone refers to the natural

TAŪS

RIḤANI

HILALI

SHAKY SCRIPT

symbolism in Islamic scripts. But perhaps the most moving style is in some ways the *'shaky' script*, which was formed by tracing the characters of any script in saw-tooth fashion. Here, one can still discern the essence of the Arabic language retained within the ragged borders of its departed elegance.

A multitude of schools and styles developed in the course of the history of calligraphy. In each country there emerged and grew – or sometimes soon disappeared – a particular way of writing. The material upon which the calligraphy was inscribed also contributed to an original and fresh rendering of certain letters, so that a given style may be found on, say, wood rather than on ceramic, stone or parchment. It was also considered proper to use the style of calligraphy appropriate to the subject in hand – Qur'āns, poems, official documents, love letters, etc.

To make a definitive list of all the different styles would seem impossible. We have therefore restricted ourselves to a selection which is representative, though incomplete by reason of the obstacles in the way of achieving it. The object of this list is therefore to provide examples of the richness and variety of styles rather than an exhaustive inventory of them.

MOU INÉ

MANĀSHIR

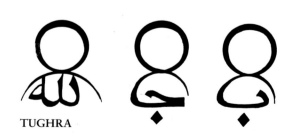

TUGHRA

MUHAQQAQ

ZOULFI AROUS

BIHAR

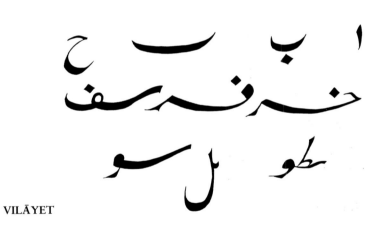

VILĀYET

GULZAR

TĀJ

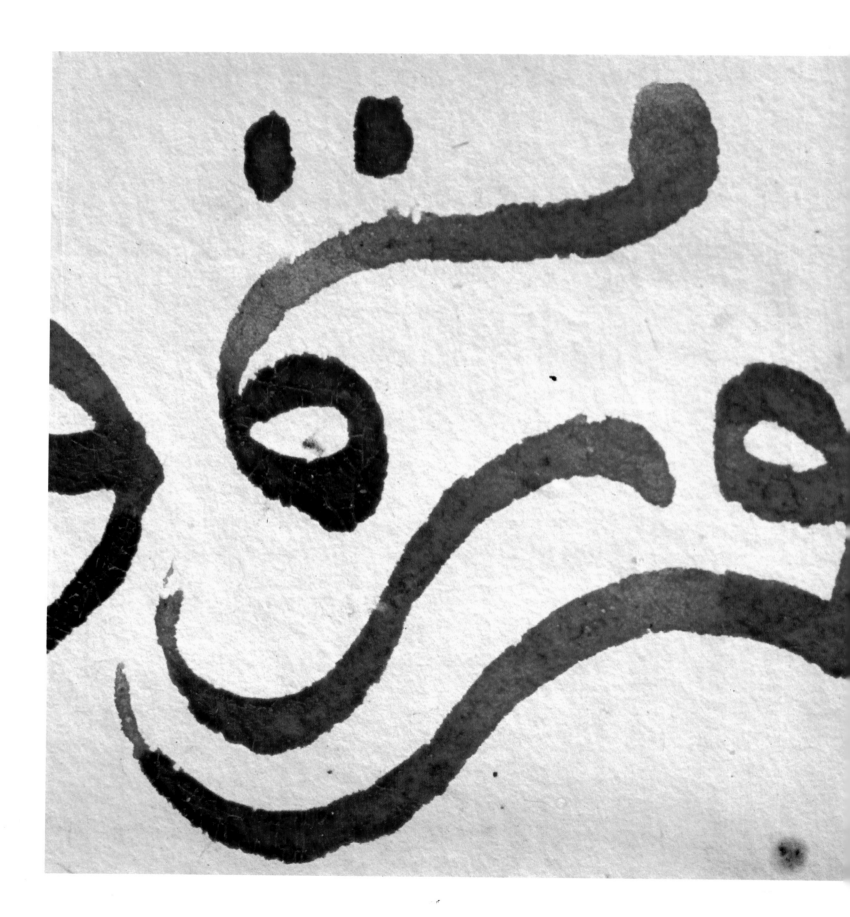

The word 'sura' (chapter) by al-Qandūsi (19th century).

اب ث ج ح ح خ خ د ر ز ر
س ش ض ط ع ف ق
ك ك ل م م ن و
ه ه لا ى ى

ديوان الخط العربي

ديوان الخط العربي

THULUTH

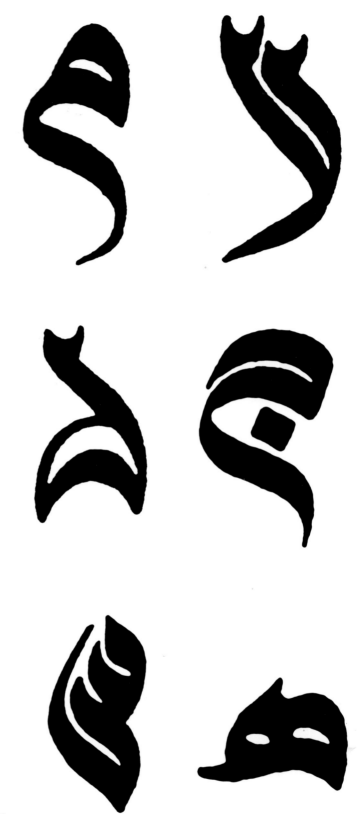

Sumbuli script. *Various monogram letters.*

MEANING AND THE WRITTEN WORD

The sovereignty of Divine Glory has shone forth.
Thus the pen survives, but the writer has
vanished.

[S.M.H. Gīsūdarāz
(15th-century Indian Sufi)]

What is the relation between language and calligraphy? The art of calligraphy is in no sense simple decoration; its germination is encoded and takes form in the singular structure of a language. it is this singularity, constantly under review here, which governs the force, rhythm and chromatic design of the script. Calligraphy relates to the total organization of language and writing in the form of *image*. In Islam, it glorifies the unseen face of Allah. We will consider later the consequences of this and the mirror games relating to the Name of God and, in general terms, the Sufic symbolism associated with the concepts of *zāhir* (manifest) and *bāṭin* (hidden).

The consonantal frame is set along a horizontal line, on each side of which come and go – in chromatic and musical interplay – the vowel triangle, the diacritical signs, and the other special signs. This establishes a mode at many different levels, departing from, but connected to, a firm rhythm. According to L. Massignon, who was much struck by this division, the consonantal line (the 'literal skeleton' and the 'corpse') contrasts with the vowels (the 'life-giving soul' or the 'spirit of life and voice'). Such a hypothesis takes us straight back to the ancient metaphysical ideas of form and substance, or matter and spirit. It is interesting to note that classical Arab philology, which is closely connected to theology, supports such an opposition, calling the consonants

ṣawāmit (mute letters) and the vowels *ḥarakāt* (symbols of movement). Moreover, Massignon puts his explanation in the form of a general principle: 'The triple vowel', he writes, 'is the basis of Arabic grammar, the I'*rāb*, and it is the basis of Semitic musical theory.'[1] In this sense orientalists interpret Islam according to Greek metaphysics, reconciled here with the monotheism of Abraham, in Massignon's enthusiastic synthesis.

Nonetheless, an examination of Arabic script must take into account the totality of verbal signs (vowels, consonants, diacritical signs, etc.) and the point which emerges – apart from this contrast – is the generative or creative movement of phonemes and script in their separate development, a development not reducible to the domination of the vowel. The point of it is the imagery of the written sign, any script being, within its limits, part of the province of poetry.[2]

Let us consider a simple example (see the illustration opposite). How is this square kufic calligraphy to be read? The reader will immediately note the sign ﻻ, on the right, which introduces the *shahada*, one of the key phrases in Muslim belief: 'There is no God but Allah, and Muhammad is His Prophet.'

Recognizing this statement, the reader will next try to discover the arrangement of the letters. This is a work of

Rectangular kufic script
(Samarqand): 'There is no God but God'.

Left. Calligraphic exercises in various scripts (after M.B. Yazir; see bibliography).

recognition which, to be done properly, requires the deciphering of a number of rhetorical figures such as inversion, reversal of characters, and their rearrangement. Reading is thus not a matter of following a single line of text, for here it can in fact be recognized by any permutation of its letters.

Antecedent to the calligraphic line, the expression of a sentence from some other source (here the Qur'ān) requires to be *spelled*, to be re-articulated according to calligraphic requirements. This makes it irreconcilably different from the process of linear reading: the text is presented first, then gradually withdrawn, like musical variations on a theme. The effect of calligraphy is to disturb the course of the text. It emanates from language and returns to it, coming and going, as it were, at one remove from it. The mind takes pleasure in this paradoxical approach to the written line: in this calligraphic is rendering one reads only what one *already knows*. But perhaps this is the principle behind all imaginative language in its written form, such that the meaning is a sort of optical illusion, skimming across a celestial prism. Calligraphy alters the lighting effects, so to speak, removing preconceptions and reiterations from the linguistic base, and highlighting its tremulous symbolism. This is what the calligraphic line brings out for us, like an echo without an ultimate destiny.

DIACRITICAL SIGNS

We must now define the position of diacritical signs and vowel accents, a subject of particular fascination in Arabic writing and one which, in the wider sense, points up, marks and punctuates Arab thought. Here our purpose is simply to summarize the variations and the points of impact and of delight.

It is a strange fact that the Arabic language did not achieve its *scriptio plena* until the middle of the third/ninth century. The official reform began in the reign of the Caliph Abdelmalek (685/705), who made Arabic the official language. History has recorded the resistance of purists, who were averse to any interference with the language of Allah. The debate was stormy, but major political considerations carried the day. The establishment of a united empire required the formation of a class of scribes using a carefully executed and legible script. For how could an empire be administered without written documents in a generally understood script?

At first the Arabs used the vernacular languages of conquered nations, in view of the necessities of state, but this was only a temporary expedient. Ultimately they wanted to unite their empire through Islam and the universal use of Arabic. In the intellectual field this intention took form through philology and other linguistic disciplines. First of all, an authorized version of the Qur'ān was needed. The system of diacritical signs and vowel marks is usually attributed to the well-known lexicographer from Basra, al-Khalil ibn Ahmed (d. 170/786).

According to the most 'probable' hypothesis, the Arabs adopted their alphabet from the Syriac, adding diacritical signs to certain letters in order to differentiate them. This theory is supported by evidence from coins and papyri, dating from the first century of the Hegira. In Qur'āns written in kufic script, these marks took the form of oblique strokes.

One point of confusion, the accenting of ﻑ (*f*) and ﻕ (*q*), has never been resolved. The earliest punctuation consisted of a dot over the '*q*', while the '*f*' had no mark. This was the most economical form, but the diacritical system has its own development. Later the '*q*' gained a second dot above it, and the '*f*' a dot below, as is still used in the Mahgreb, but it tends to disappear or to co-exist with the last modification, which has remained constant: '*q*' retains the two dots above and '*f*' the one. The reform dates from the second century of the Hegira.

The gradualness of the reforms was due to political considerations (the need to compromise with local languages in conquered lands), and to a tendency in Arabic towards a *general diacritical system*. In the reign of Abdelmalek the vowel '*a*' was shown by a dot above the letter, the vowel '*u*' by a dot inside, and '*i*' by a dot below the line. Nunnation was indicated by double dots. To avoid confusion between dots marking vowels and those marking consonants, a system of colours was used, especially in Qur'āns. The diacritical signs were written in black, and vowel accents were shown in red, yellow or sometimes, though rarely, in green.

The introduction of complementary signs and the transformation of vowel signs into the now established vowel triangle were the final stages. The remarkable fact about this reform is that it established from the outset a relationship between writing and phonetics. For example, the sign ء (*hamza*) is a ع (*'ayn*) without its tail; similarly, the sign ﻭ (*shadda*) is a constituent of ﺱ, likewise without its tail. Alterations in the written form were made by taking the terminations from (phonetic) speech.

The system is not only a matter of vowels and diacritical signs; it is also a matter of phraseology: thus, the ends of verses were indicated by strokes, or by letters such as ﻩ, or by small circles with or without a dot in the middle. Finally, an entire decorative system of floral and vegetal motifs constituted the divisions, within the Qur'ānic text, between verses or chapters (Suras), together with the enumeration inscribed in the margin.

In addition to consonants (with or without diacritical signs) and the complicated interplay of arabesques, to which we will return, let us now consider, first, the vowel triangle; secondly, the complementary signs (inflection, lengthening, nunnation); thirdly, the decorative signs invented by calligraphers which, belonging as they did to an uncodified system, were originally displayed in the style of each artist. They included letters in miniature, either consonants or long vowels, which may or may not have been repeated in the letters of the text; and also, occasionally, whole words appeared in miniature, repeating or extending the text.

In fact, these techniques represent a whole, meticulous system of expression, employing the full range of written signs, and combining them according to the style of the artist. In some examples, the diacritical signs disappear completely or become lines indicating, as we have seen, short vowels. In another example (pp. 50, 51), the dot acting as module goes beyond its geometric function and itself becomes a massive partition.

Furthermore, the situation becomes highly complicated in the Persian script known as *shikesté*, which does without all vowel and diacritical signs by extending the consonantal line obliquely from top to bottom. The outline can be developed and folded in various directions, so that in practice it seems actually to encroach on the principles of painting and calligraphy. We will return to this subject in the final chapter.

لنّاسِ عَفْــوًا وَالمَهْدِيّ مَحَمَّد بِنُعَبْدِ اللّه
الّذِي بِينَ بِنّـَـنَا لَمّ يِسَـنّنَها خَلِيفَه تَبْــلَه
وَ لّا عَجَبَــنّي عَطَايّا لَمّ يَعْطِ جِصْما لّا جِمّ
وَ بِّدَّة المَظَـالِمَ لّا قِيّسَمَ يَ لّا هُــل
اَلّامّصَاربِه لّا شِرّاؤُهمّ وَ ـلّـيبّا بِهمّ
وَ لّا عَجَبَني لّاهلِ الجأجِه وَ قَيّدّصَ للعُجَّه مِينَ
وَالمَنـّـبُوذِنّ وَلَمّ يَقِّرّضَ لَهمّ لّا جِمّ
قَبْــلَه . وَ الهَــأجِّ وَ البِرّ سِيهِ
كّـأنّ أذّخّـرَ النّاسَ فِي الإمّأجِ وَ الجِيّمّ
نَفّسِيل
وَ لّا جّـيبُ النّاسَ يِنَفَقَه فِيهِما جّا فَـمّ
بِنَفّسِيهِ وَ لّا نّفَـــقَ مّا لَمّ يَجِيبُ بِهِ نَفّسِيّ
لّأجِمّ قَبْــلَه وَ لَمّ يَـلّ خّلِيفَهُ مِنّذُ كّأنّ
الّا هّــلّامّ مِنّلّ و لّا بِتِه وَ لِي لّا كّـتّرّ

Writing of North Arabian origin.

Left. **Archaic kufic**, *typically made up of letters with a rigid verticality and squat, rounded letters with a downwards emphasis unified by the horizontality of the base-line.*

KUFIC AND NASKHI

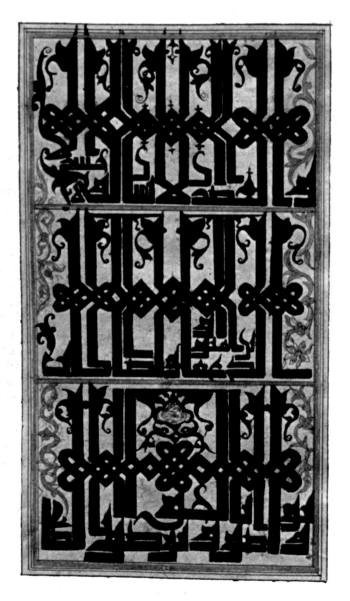

As documents dating from the beginning of Islam have confirmed, the origin of calligraphy must have been two-fold: an angular, geometric script of a hieratic and monumental nature, used originally to transcribe the Qur'ān or texts of great religious or literary value; and a rounded cursive script employed by scribes for everyday documents.

It now became customary to designate the early script as 'kufic' the cursive type as 'naskhi'. However, the two classifications have led to contradictory results and explanations; by this we mean that they have not been thought out, or, if they have, then it is according to a principle, already discussed, which is based on the premise that the whole history of Arabic writing relates to an original, lost prototype. But we should keep in mind the hypothesis of a dual origin, for this is all-important in our thesis. Methodologically, the route is labyrinthine since, in order to define the scripts, the Arab chroniclers and scholars used varied and differing registers: a nomenclature referring to the inventors of calligraphic styles, as for example in the case of riḥāni, yāgūt; a geometric or arithmetical typology (e.g. thuluth); a regional toponymy (e.g. kufic, andalusi).

The chroniclers combined these registers together, so making an interpretation of their texts extremely difficult, particularly since these works frequently do not include any useful graphic indications. Orientalist epigraphy often goes astray here.

Arab historiography and orientalist epigraphy must be briefly examined in relation to each other in order to corroborate certain facts, but we should ignore the confused explanations which proliferate in the works of most of the chroniclers. It was this atomistic erudition that partly provided the Argentinian writer Borges with his metaphysical vision of the Secret Book – that which is absolutely undiscoverable. The Arabs usually distinguish four types of pre-Islamic script: *al-ḥiri* (from Hira), *al-anbāri* (from Anbār),

Naskhi script. *'Thou hast destroyed them'. This style includes both full-bodied and slender letters, linked by sinuous ligatures which provide the sense of flow.*

Facing page.
Floral kufic script. *Note the rigidity of the base-line and the mid-point knots and floral ornamentation at the top of the letters.*

al-maqqi (from Mecca) and *al-madani* (from Medina). The famous author of *Fihrist*, Ibn Nadim (died *c*. 390/999) was the first to use the word 'kufic', deriving it from the *ḥiri* script. However, kufic script cannot have originated in Kufa, since that city was founded in 17/638, and the kufic script is known to have existed before that date, but this great intellectual centre did enable calligraphy to be developed and perfected aesthetically from the pre-Islamic scripts.

A later author, Ibn Khaldūn, agrees with this hypothesis, stressing the change of calligraphic styles: 'When . . . the Arabs founded their empire, they conquered towns and provinces. They settled at Basra and Kufa and their government had need of handwriting. Thus they began to learn it, and it came into current practice, developing rapidly till it reached, at Basra and Kufa, a high degree of accuracy, though it was not yet perfected. And today kufic script is well known. Afterwards, Arab conquests and expansion covered Ifriqiyya and Spain. The Abbasids founded Baghdad, where calligraphy was perfected as a result of the development of the civilization in that city, the capital of Islam and centre of the Arab dynasty. The script of Baghdad differs from kufic in the way that the letters are fully formed, and presented in an elegant and distinguished style. The difference increased under the Vezir (Abu) Ali ibn Muqla and his secretary, Ali ibn Hilāl, called Ibn al-Bawwāb. But the tradition of the calligraphy of Baghdad and Kufa disappeared with him after the tenth century. The principles and characters of the one differed to such an extent from the other that there was, as it were, an abyss between them.'[3]

Other Arab sources claim that the word 'naskhi' was invented by Ibn Muqla, but the point is that, following on this cursive style, the great calligrapher established a geometric codification which was to inspire subsequent schools (after the tenth century), and that he established it according to Euclidean theory, with which he was certainly famil-iar – but at second hand, so to speak. We use the phrase by no means in its figurative sense alone, for his right hand was in truth cut off. In a celebration of Arabic calligraphy it is only proper to make reference to the tragic fate of that hand.

Orientalists have deduced some of their postulates from these sources, and allowed their own intuitions, together with epigraphical researches, based on the scientific rationalism of the eighteenth century, to be their guide. According to them, it has been confirmed that the two scripts (angular and cursive) co-existed both before and after the coming of Islam. So be it. How can this original duality be explained? B. Moritz[4] has provided a simple answer: it was due to the difference between the materials used, in the sense that kufic (angular) is a hieratical and monumental script suitable for inscriptions on masonry or coins, whereas naskhi (cursive) is better adapted for use on parchment. But this proposition will not bear close scrutiny, for the history of calligraphy has clearly demonstrated that it is the materials which are adapted to the driving impulse of calligraphy, and not the reverse. The solid mass of stone yields to the controlling action of man, by virtue of the power of his will that extracts from the rock its latent quality. Under the hand of man, nature reveals the completeness of its inner potential.

The written word inscribes the estranged, ephemeral symbolism of the separated being, whose double nature Arabic calligraphy expresses. It would be rash to say that materials used neither retain their form nor influence its expression, but they certainly cannot turn aside the extractive, expressive impulse.

In any event, Moritz's explanation is proved wrong in historic and epigraphic fact. Theoretically, it reduces the distinction between scripts to one of technique, a view that would justify a vision of cultural archaicism. Such a distinction is certainly something to be considered, given the

complicated series of factors: phonetic, geometric, semantic, metaphysical, etc. Technique presumably operates in relation to all these aspects.

In short, this idea of technique is an element in the orientalist theory which again brings up the original duality of Arabic writing by the antithesis of sacred and profane: the contrast of religious morality secularized in the rationalism of epigraphy. J. Sourdel-Thomine[5] attempted to rephrase the issue of duality by suggesting that there was initially a fundamental unity in Arabic writing, and that duality in fact occurred only later. But this writer merely covers up the orientalist theory, which ultimately finds its metaphysical ground, as well it might, in the fall of the early empires.

It is the view of ourselves and others that writing, calligraphic or not, is dual, and always dual in all its instances. There is no point in reiterating the irretrievable nature of the split, evidence of which can be seen on the page, for all time. Naskhi and kufic scripts are used to express the same theme in the context of Islam.

According to this proposition, we can state that *the two scripts evolved in parallel*. And through the codification of the *khaṭ al-mansūb* (proportioned writing), Ibn Muqla reformed Arabic calligraphy from naskhi and not from kufic. The predominance of the former never led to the elimination of the latter. The remarkable continuity of their coexistence is rooted in the culture of Islam, in its different manifestations.

A Moroccan manuscript. Exegesis of the Qur'ān by al-Thalabi Abu Ishaq Ahmed b. Muhammad. In this detail of a chapter opening the lettering is framed in yellow to provide added contrast and improve the legibility of the text. 19th century.

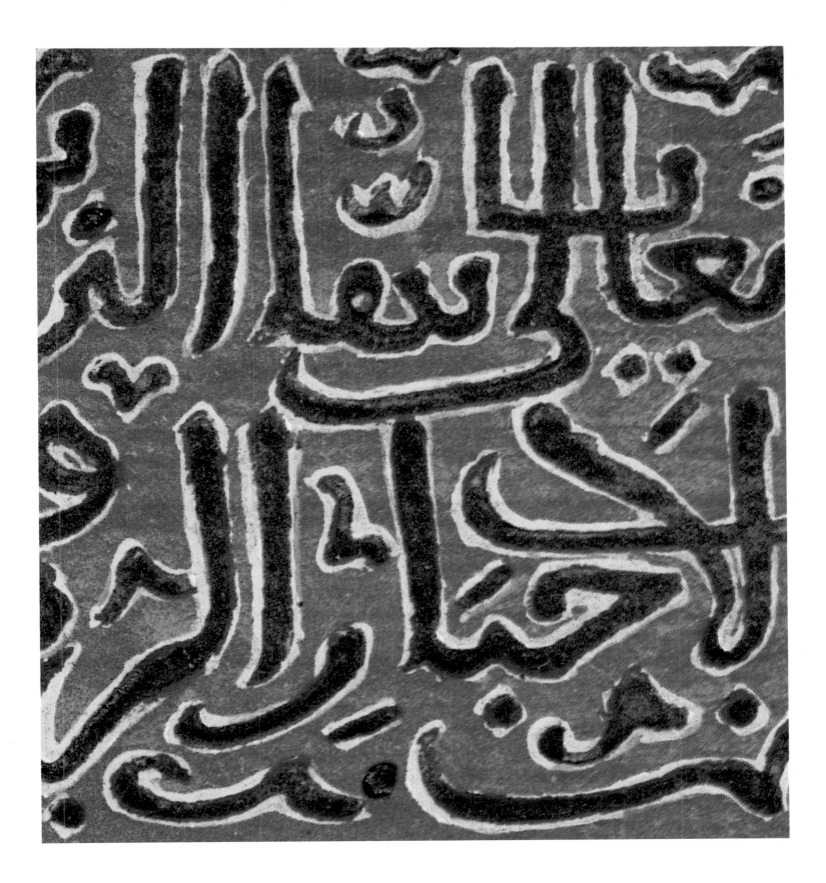

IBN MUQLA

(272/886–328/940)

The haunting memory of the thrice-buried body of Ibn Muqla remains with us. What can one say about the fate of this calligrapher, whose severed hand still affects and influences the world of Muslim art?

Not one manuscript page written by him appears to have survived, though certain texts, which are in fact skilful forgeries, were formerly attributed to him in an attempt to cash in on his fame. It was the custom of the times; even the great Jāḥiẓ confessed to having signed some of his books with famous names in order to get his own work read as it were by proxy. The marvellous image has disappeared, to be propagated today according to a genealogy carefully established and fiercely guarded, not least by devoted humanists of every breed.

Many poems and tributes bear witness to and celebrate the talent of Ibn Muqla. Abdullah ibn al-Zariji wrote in the tenth century: 'Ibn Muqla is a prophet in the art of calligraphy. His gift is comparable to the inspiration of bees as they build their cells.' According to the Arabs, Ibn Muqla was without any doubt the man who codified calligraphy, using the circle as the module for each of the characters, according to a measured proportion. This technique, already described in detail, makes use of the dot as the standard unit to establish the basic code, starting with the first letter of the alphabet.

In his *Epistle*,[6] Ibn Muqla defines the general principles of this discipline: round off the shape of the characters; observe the laws of proportion; clearly distinguish the geo-

There are no extant samples of the calligraphy of Ibn Muqla. This sample comes from the hand of Ibn al-Bawwāb, a pupil of Ibn Muqla. These two men are regarded as the 'fathers' of Arabic calligraphy. They laid down the rules which are still in use today.

Left. Extract from a Qur'ān dated 391 of the Hegira (AD 1000–1), with enlarged detail opposite.

metric forms according to their movement, horizontal, vertical, oblique and curved; observe carefully the thickness and thinness of the line; keep the hand steady but relaxed when handling the pen, so that the line shows no sign of wavering. These principles were to give harmonious form to the art of calligraphy.

Together with the theory, as it has come down to us, there is evidence of his very intense political life, the repercussions of which led to the severance of his hand. This hand secretly wrote, as it were, an invisible secular manuscript, perhaps the reason for Ibn Muqla's father describing him as 'son of the white of the eye', or 'of the pupil'. Once again we are met with silence, for not a single text of his is extant for us to admire. Mallarmé wrote – 'As there is no escape, once having entered the domain of art, under whichever sky it chooses to settle, from the ineluctable Myth; so may it be better to start with this knowledge and make use of the treasure-house, whether for document or pure divination', or dream, or fleeting fantasy. . . .

Ideologically a Sunni, the calligrapher-Vezir, like many Chinese or Arab princes, led a very unsettled life during the Abbasid era. His mortal battles with authority are renowned, in particular with the Caliph Rādi billāh and his rival the Vezir Rā'iq. Ibn Muqla plotted against the Caliph, to whom Rā'iq showed his confidential letters. As a result, Ibn Muqla's right hand was struck off. But, invincible, he took up his pen in his left hand and continued to write. With the Caliph's authority, Rā'iq had his tongue cut out.

The Arabs say, 'The pen is one of the two tongues'. In all senses of the word.

Finally, Ibn Muqla was sentenced to life imprisonment and died in jail, his corpse being moved twice thereafter. It is also said – according to legend – that his generosity was inexhaustible and his art was Paradisal. Let us imagine, then, a sumptuous garden, drawn by an infallible hand; plants so rare that they summon to the page every kind of arabesque; not forgetting the song birds and the miraculous fountains. Let us linger here and meditate on the calligraphy, recalling that the Vezir particularly loved the grace and delicacy of birds, hanging silken threads in his garden to serve as nests.

Imagine this entire scene and be a guest at the house of Emblematic Death. Ibn al-Bawwāb ('the janitor's son') will close the garden by another gate, taking up the work left by that severed hand.

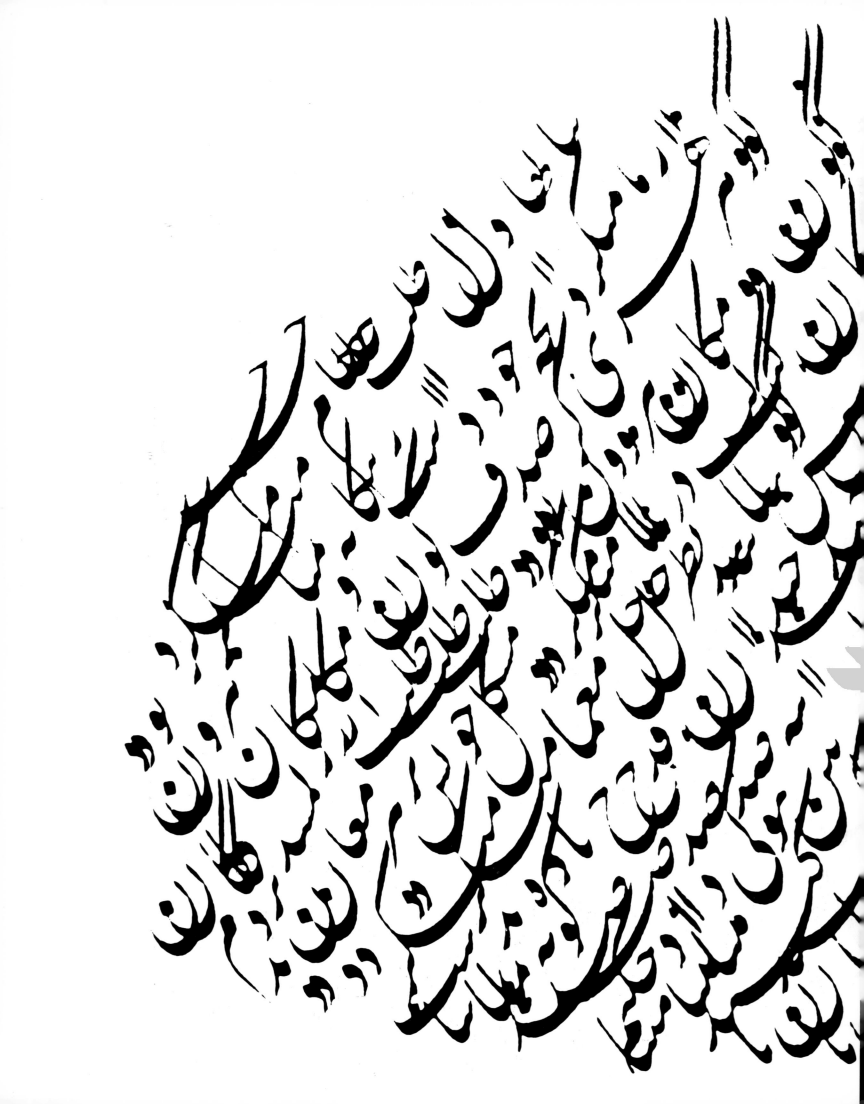

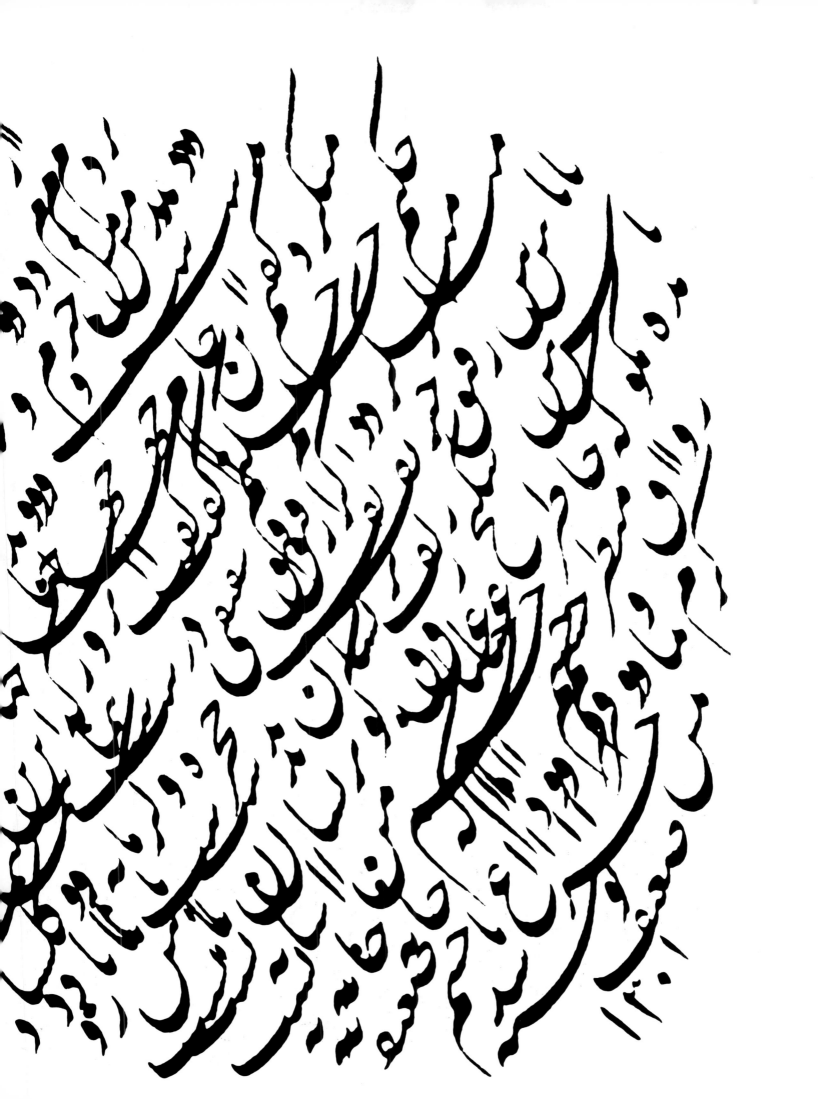

From left to right.
Shikesté script. *A poem by Hāfiz copied by Mahmūd Khan Saba (1812–93), Iran.*

Shikesté script. *A poem transcribed by Muhammad Bāgher Ghertas, Iran (19th century).*

Shikesté script. *An example dating from the early 20th century.*

Below.
Diwāni script *by Iraq's best-known contemporary calligrapher, Hāqim Muhammad al-Khattāb (1919–70).*

Pages 102–3
Shikesté script. *A poem written in 1883 transcribed by Mahmūd Khan, Iran.*

مقتضی با

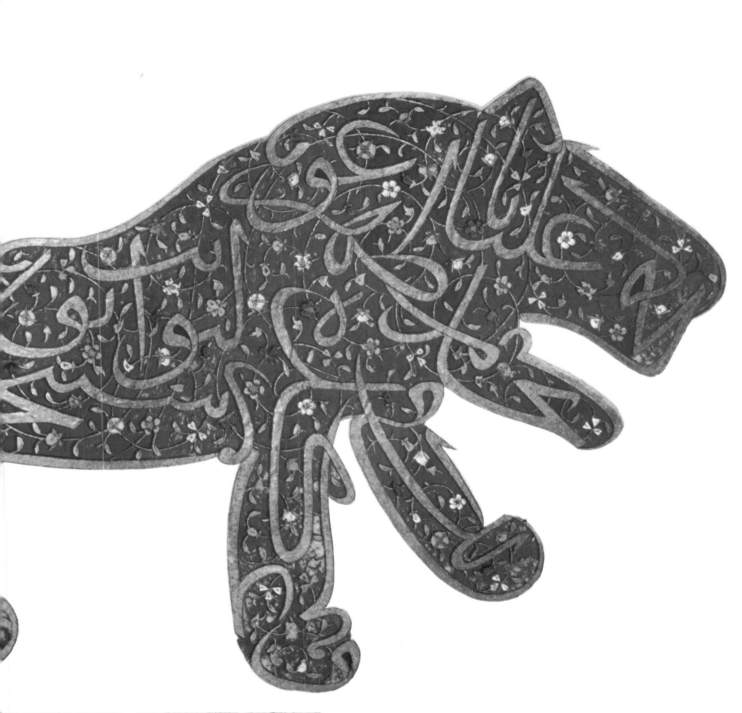

Above. **Thuluth script.**
A lion calligram by Shah Mahmūd Nisabūri (16th century).

Left. **Anthropomorphic script**
used as decoration on a copper object, attributed to a Persian workshop.

Far left. **Late Ta'liq script.**
A poem probably transcribed by the Iranian calligrapher Abdullah Farādi, late 19th-early 20th century.

Preceding pages.
A diagonal composition in **ta'liq script.**

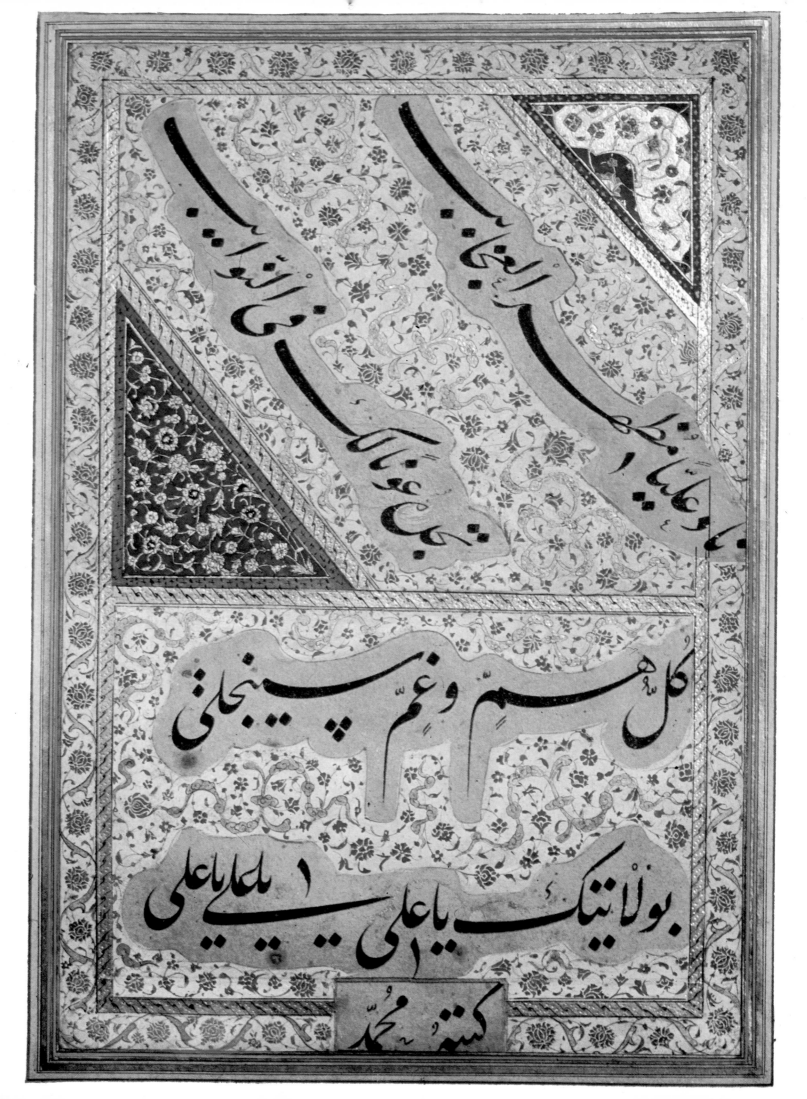

بسم الله الرحمن الرحيم

Ta'liq bismillah, *early 20th century.*

Ta'liq. *A page by Shah Mahmūd Nisabūri (16th century).*

Left. Ta'liq script.
An Ottoman manuscript.

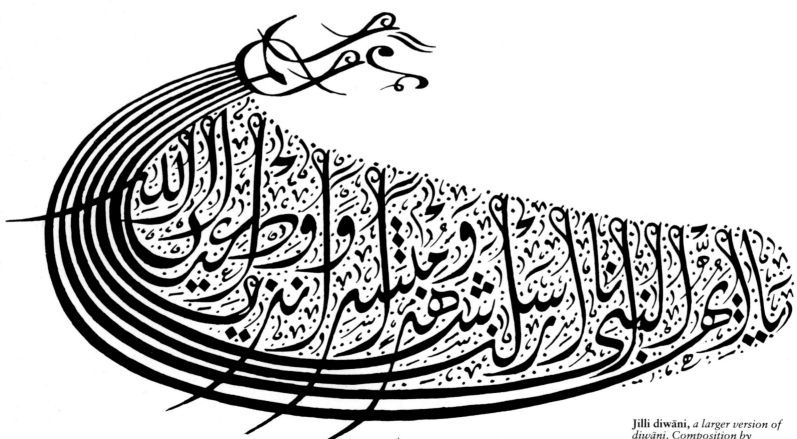

Jilli diwāni, *a larger version of* diwāni. *Composition by Muhammad ʿizzat al-Karkūki.*

Right. A firman tughra *of the Ottoman Sultan Süleyman II (reigned 1687–91).*

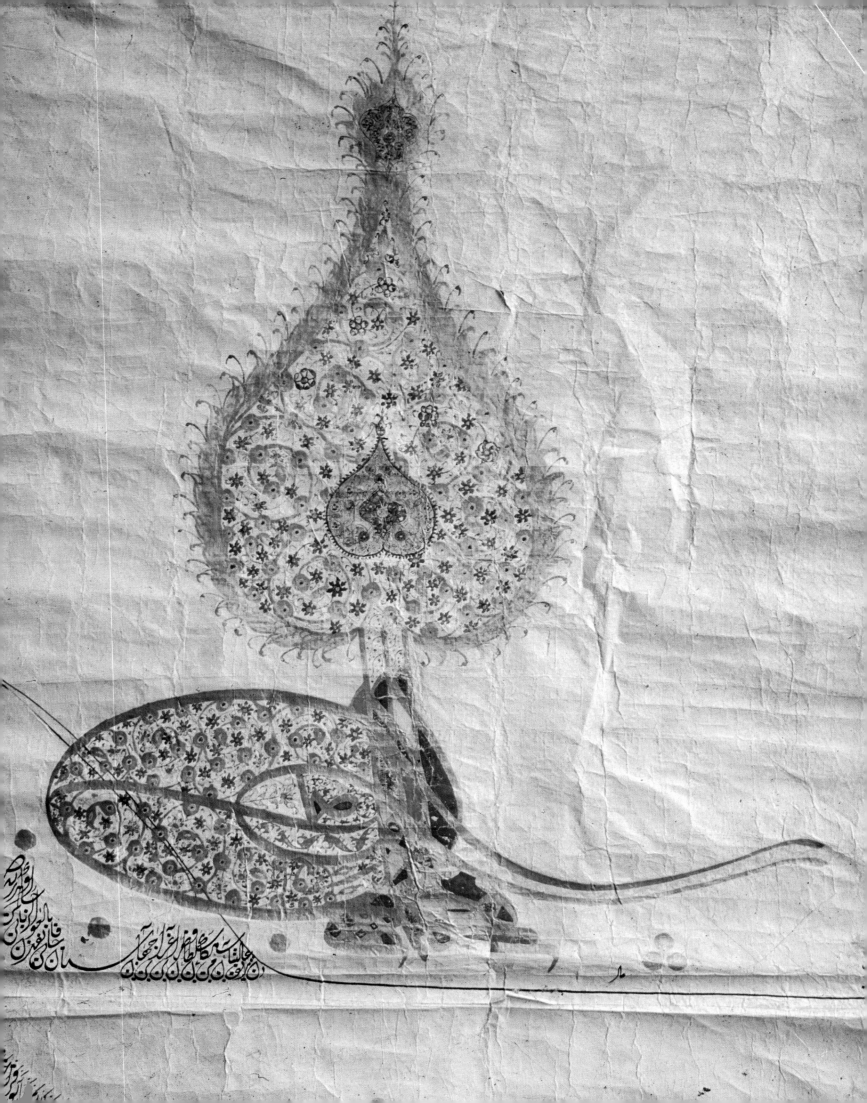

Right. **Maghribi script.** *Title page of the Dalīl al-Khayrat (Prayer Book).*

Left. **Thuluth** *composition executed in boustrophedon style, changing direction in successive lines.*

IBN AL-BAWWĀB

(Abu l' Ḥasan ʿAli B. Hilāl, d. 413/1022)

Opposite. A bismillah by Ibn al-Bawwāb, with enlarged detail above.

The work of Ibn Muqla has passed beyond our reach following his death, the mysterious nature of which is discernible only in the traces of legend. Thus we must turn our attention to his disciples, in particular to Ibn al-Bawwāb, who made a definitive impact on Arab calligraphy and whose script is still in use today.

Ibn al-Bawwāb was by profession a calligrapher and illuminator in the Buwayid period. Known for his Qur'ān (399/1000–1), as well as for apocryphal texts, he is said – according to Arab sources – to have invented the riḥani and muḥaqqaq scripts. He made sixty-four manuscript copies of the Qur'ān in his own hand, and was also able to imitate to perfection the writing of Ibn Muqla.

In 1955, D.S. Rice published Ibn al-Bawwāb's single surviving manuscript, together with a well-documented and detailed analysis.[7] While paying due respect to this work, its limitations should also be noted. At the outset, Rice reduces

calligraphy to a geometric description and to a formalist value, even as he reviews its incomparable beauty – an approach consistent with the pictorial aesthetic of the nineteenth century; in reality, however, calligraphy is rooted in a sacred text, a celebration of the divine. This is not the place to survey in detail the relationship between calligraphy and its many points of reference in theology, politics, etc. What we should mention is the power of the sacred text in its chanted form, as recited in the incantation. By marking the vowels throughout the text, Ibn al-Bawwāb was enunciating this chant. The *bismillah* (*above*) is the principal formula introducing each Sura. The script builds up along a cursive line, accentuated by the use of oblique accents for diacritical signs and vowels. This asymmetry is pointed up by the slight inclination of the letters to the right and the elongation of the semicircles. The line is positive, necessary for instant legibility, delicately modulated by thin curves and flourishes flowing over the entire page; a disciplined excess and a golden serenity. The whole is written in gold with arabesques in the margin and in the midst of the text. There is surely an analogy with Arab music, but here it follows a literal inspiration, and not a simple correspondence between musical rhythm and graphic movement, so that the 'music' emerges through the interstices of the text.

These observations apart, Rice's study does make a useful contribution, and the annotated Qur'ān (M5.K16 in the Chester Beatty collection) constitutes a fundamental corpus for the study of calligraphy. Ibn al-Bawwāb uses a cursive naskhi script which is precise and regular, following the principles of the theory of proportion. But does such a regular script come from the bored impulse of a scribe obliged to earn his living, or from the extreme sobriety of repressed desire?

Left. Maghribi
cursive script.

Right. Andalusian
cursive script.

As Rice points out,[8] Ibn al-Bawwāb organizes his use of
scripts according to the divisions of the Qur'ān: naskhi, in
black (consonants, vowels and diacritical signs), serves as
the principal script for the body of the text, while decorative
scripts in colours emphasize the headings together with
palmettes in the margin, and all kinds of chromatic varia-
tion punctuating the text.

The punctuation in its formal sense is marked by three
dots in a triangle between every two verses. Every fifth verse
is marked by a golden *khamisa* (a final *ha*, whose numerical
value is five), every tenth verse by an *'achira*, a medallion in
kufic script indicating the appropriate multiple of ten – *ya*
for ten, *kaf* for twenty, and so on.

This division of the line has been modified. Nowadays,
the verses are numbered one by one and not in groups of five
and ten. In modern times, too, the Qur'ān has been divided
into 60 *aḥzab* which are themselves subdivided.

What is equally remarkable in the manuscript of Ibn al-
Bawwāb is the absence of any recitation marks, which are a
customary feature of contemporary Qur'āns, and indicate
with a small *sah* (silence) the moment for the pause. And
each school naturally expresses the pauses according to its
particular style.

Among the later disciples of Ibn al-Bawwāb was the
celebrated Yaqūt al-Musta'simi (d. 698/1298), who was the
calligrapher of the last Abbasid Caliph. He gave the thuluth
script its prominence and excelled in the other styles, but he
could not match Ibn al-Bawwāb. He cut his reed obliquely,
to introduce a line expressing finesse with slender upstrokes.
In this book he is not accorded the importance which he
generally commands, for Ibn al-Bawwāb is undeniably the
source of his inspiration.

118

سيم السماء ولاح وأعجابه مسقط العقر وبيده المملوك

مثل البهيم بن جث تحببثبه نحو السطو وقبله النبرينا

يقول أنا ربك ظار والظأمه اكلعثم وأذوبه رغبة وأكلا

ومن لا تبرد كبروط أله بل تبشرح الراعي ولعك موونها

على الراعي قالوا الخصوم من راع ظار ما بن أنه ينعابها ونغلبه

فيقر عنها والنعبة مؤجوه بشأثراها ل دوأيم ومن اكل

من الكثثر وابن مك اكل من المرتدون وقيل لا تعبلت لبدالرواب

اكل فلاك مرتدوه رعون فإذا كانت المرتدونه اكل الدواب بعلى

حساب ذاك بزيبه اكلها إذاا أرضعيم وبعلم انه بوجيج اكل المراه

من عثروه إن النبل كان أكثر من عدا الرجل وعثمابه هكذا

تكون نحو وأكثر النساء ومن نمسع من مغزوه إن النبل وكراله

للحبر والعرس

ومن العرب أن معاد بن جبل قالوا وكان معاد امه وكان سمه

ابن هيم خليل الرحمن وكثوز السلف أخبيس حرده ولا انعم بزنا

مزمعاذ وسعل بن جبيف وقال النبي صلى الله عليه وسلم اترك

من معاذ حرخانه وكان بعر من ازهاد السنه وفرشهد

المسامدون للنب الولايات ومبنوا الصروأن وبعلم الناسلاعلم

وترسم العران ومعاد بن افل من بشر بن سنه وكان يعند

رسول الله وجيها وفي عنبور المسلمين عظما وقال البنم

انه إذا القهر بل بعثر بن معسم الكابد واضهاب له فقال بعث

CALLIGRAPHY AND HISTORY

Ibn Khaldūn pointed out that writing and calligraphy flourished when civilization was at its apogee, and decayed with its decline. This is no doubt true, but such a relation is always extremely subtle. Calligraphy has been influenced by many peoples and powers; it has accompanied, in its own way, the whole history of Islam. And wherever Islam triumphed, in war or religion, the indigenous culture would reinterpret calligraphy and re-establish it in the duality of its vision. The use of Arabic script in Afghanistan, in Persia, in Turkey, or even in China, bears witness to the power of this inspiration. The imagery of calligraphic art denies the integral nature of Islam and separates it from its total system. This imagery retains the movement of history within itself. Persian mysticism makes reference to the shattering instant when the written word is swallowed up in divine love; when ecstasy disrupts the continuity of history. This process accepts history, receives it, and moves within it. All calligraphy, all writing, advances when his-tory is idle.

The importance of Kufa and Basra since the first Arab empire is well known, and history has recorded the name of the first famous calligrapher, Khalid Abi Hayyz (seventh century). Gotba (eighth century) is said to have invented in the Umayyad epoch (660–750) the four calligraphic styles, which were named after the places where they were supposedly developed: Mecca, Medina, Basra and Kufa.

This kind of theory is unverifiable. It arose primarily from an ideological conflict between sects within Islam, each seeking by whatever means to prove its legitimacy.

Some historians choose to mention the calligraphy of Ali, Muhammad's son-in-law, traces of whose writing have supposedly been found, but according to the evidence of palaeography there is nothing to support this contention.

Since the Umayyad era, naskhi and kufic developed side by side, with kufic reserved in particular for hieratic inscriptions; it is worth repeating that kufic did not originate in Kufa. Under the Abbasid dynasty (750–1258) Baghdad became the centre for calligraphy. Kufic script was ousted from its primacy during the second century of the Hegira (eighth and ninth centuries AD) in favour of naskhi and its variants.

This change is explained historically by the centralization of the power of the caliphates. There grew up a caste of scribes (*Kuttāb*): secretaries, administrators, functionaries and calligraphers. Naskhi was a script suitable for use by clerks in a centralized bureaucracy extending westward as far as Spain as a model and unified system. The military class and the caste of scribes shared power at the head of government.

This world achieved its cultural sovereignty in the tenth century AD, a fabled sovereignty in Arab folk memory, when one considers the historic retreat which has since relegated this period to the twilight of historical existence. Calligraphy has glorified this expansion and contraction, this back-and-forth between the crest and the trough. Thus one can discern in calligraphy a faint and subtly drawn sense of the futility of life; perhaps it was in this context

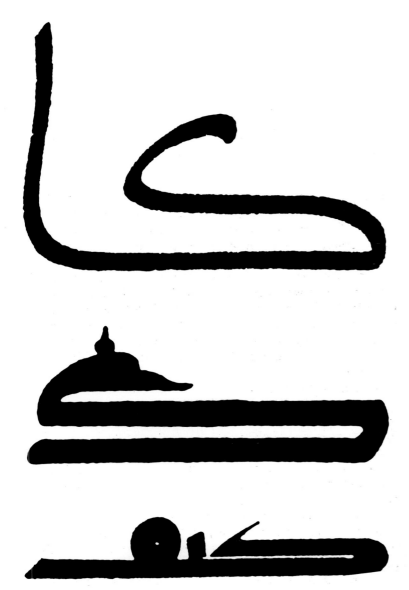

Various renderings of the letter kāf *(k):*
(top) **thuluth;** *(centre)* **stylized kufic;**
(below) **archaic kufic.**

that Ibn al-Bawwāb decorated the margins of the Qur'ān – to keep it safe within pure imagination.

Historians proudly record this upsurge of learning and ability which achieved a unique synthesis between Islam, Hellenism and the Persian world. They speak of the growth of schools and universities, of the insatiable accumulation of manuscripts and the growth of libraries. Scribes and calligraphers, paid by the state, directed and codified this traffic of ideas.

This is where the three great schools of Ibn Muqla, Ibn al-Bawwāb and Yaqūt really belong, historically. Not simply because these calligraphers had elucidated the formal theory of the written sign, but because, in an elegantly disturbing form, they projected onto this profusion of images the shadow of their ultimate futility. Classical Arab art is aristocratic: its tendency is towards something outside history. And its concern with the sacramental maintains its imagery at the highest plane.

The centres of this profusion shift and multiply in the Arab and Muslim world. They mark the different poles of the hegemony, and calligraphy became, in institutional terms, at the service of the imperial bureaucracy and its religious ideology.

121

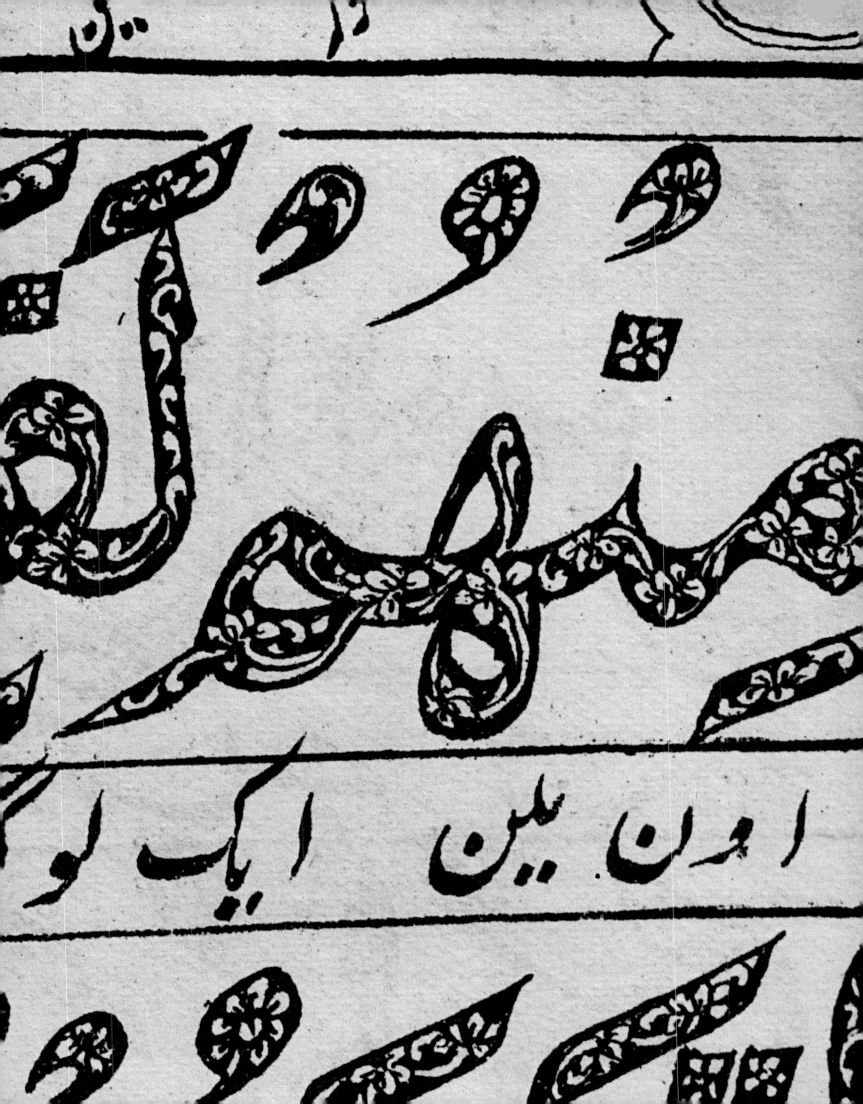

Maghribi scripts.
Pages from manuscripts written in a variety of calligraphic styles: cursive maghribi, or mabsut; precious maghribi or muhawhar; administrative maghribi known as zemami or musnad; maghribi mustashrik or orientalized kufic which, unusually for kufic, features diacriticals.

Pages 125–5. Text written in Arabic (large letters) and Persian.

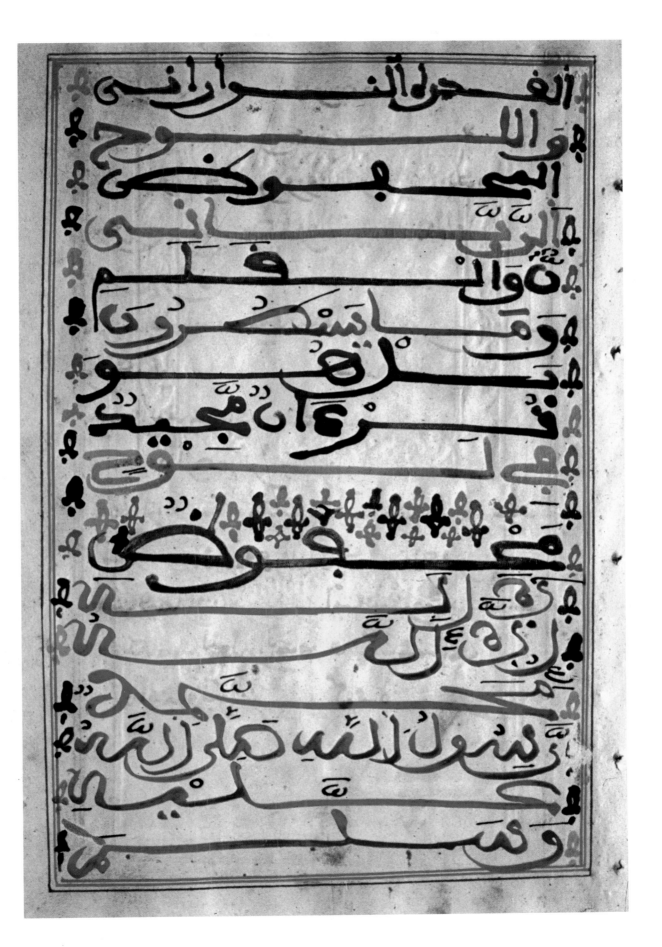

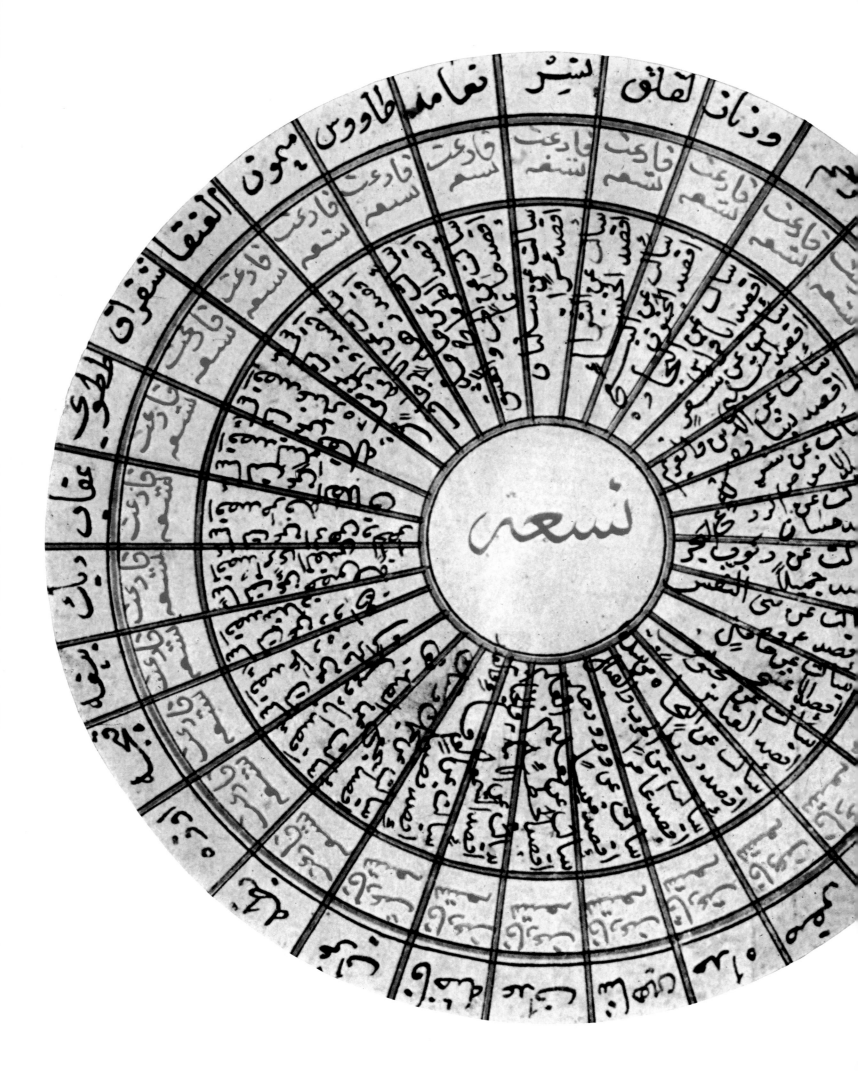

SYMBOLISM
OF THE PAGE

THE SPELL
OF THE FACE

It is a common mistake to suppose that Arab graphic art is characterized by a strongly abstract quality, in contrast to the representational and figurative nature of Western art.

First, the Qur'ān does not expressly forbid the representation of the human form. In fact, the subject is not mentioned anywhere. The *fuqaha* and the orthodox have twisted the allegorical meaning of the Qur'ān the better to impose rules and prohibitions. The task of theology lies in circumscribing the edges of symbolism and making an enclosure of it. We have seen how, in writing, the reform of diacritical signs and vowels was strongly contested. For theologians the text of the Qur'ān – the word of God – had to remain just as it was in its first and incorruptible revelation. Later, the introduction of floral and geometric decoration into the Qur'ānic text was to meet with the same hostility.

A *hadith* cited by al-Bukhari expresses the prohibition on figurative art straightforwardly: when he makes an image, man sins unless he can breathe life into it. Since the authenticity of the *hadith* (sayings of the Prophet) is unver-

ifiable, one may discreetly recall that this alleged prohibition was directed against contemporary forms of totemism which were anathema to Islam, but could conceivably re-infiltrate it in the guise of art. The principle of the invisible face of God could be breached by such an image. In one sense, theology was right to be watchful; it had to keep an eye on its irrepressible enemy – art. The absolute aim of art is, specifically, to endow with soul – a wandering soul which reveals itself in the field of existence only to show the impossibility of a sojourn there.

Another Muslim tradition states that, on the contrary, Muhammad permitted one of his daughters to play with dolls, which are of course derived from totemic objects of worship. Moreover, there are numerous examples of figurative sculpture in Muslim art, as well as drawings of animals and humans. The Caliph al-Mansūr (eighth century) had a sculpture carved in his palace. There are a number of well-known manuscripts (narratives, medical treatises, etc.) illustrated with miniature figurative drawings. Coins were stamped with the heads of monarchs.

Repetition of the letter 'w' in the phrase Huwwa llah *('It is God himself').*

Preceding pages.
Nashki script. *A cosmogonic composition, 1819.*

Calligraphy itself imitates the forms of real objects and makes use of the shapes of men and animals.

On the other hand, the point to consider is not just the explicit prohibition itself, but the transfiguration of calligraphic script in terms of imagination and the erotic. In freeing art from theology, religion encroached on mysticism. *'Ichq, ḥbb, maḥabba:* the desire to merge oneself in the infinite presence of Allah. A giddiness took the soul – here conceived as ecstatic thought – and sent it on a double journey involving both body and mind. 'I journey towards Mecca and Mecca comes towards me,' cried the great *rabi'a.* A separate existence in the spark of the divine presence, as fire catches the breath of the mystic: chanting, echo of the void, abyss of the corporeal body. Sufism acquired an invocation beyond compare. Therein lies a consideration which must be cleared up to permit a better reading of calligraphy.

Understanding of the nature of this physical impulse may emerge as the result of an examination of classical Arab lore, as expressed by the mysterious *Ikhwān as-Safa* (the Honourable Brethren), a secret sect of the fourth/tenth century. This spiritual group sought to establish a relation between the mysticism of Ismail and the doctrine of Pythagoras as part of a universal language, in which script expressed the rhythm of the world's separate creation. Adam was created in the form of a being who spoke. Allah taught him letters and numbers, the alphabet then consisting of only nine characters. With the increase of mankind, and its dispersal, this number grew to twenty-eight – the precise number of characters in the Arabic alphabet. Other forms of writing were imperfect through having either too many or too few letters. Arabic writing symbolized cosmic harmony, the perfection of Allah. This number expressed both the rhythm of the stars and the form of man. At the same time, the movement of the universe followed a duality ordained by Allah – as in the duality of the straight line and the curve. The image of man was equivalent to the straight line, that of the animal to the curve. Similarly with writing, the *alif* constituted the first letter, and it was upright.

Can the human countenance be studied like a Qur'ān? According to the Ḥurūfi, a cabalistic sect, the invisible beauty of God vibrates in the body of each prophet and is extended to the human countenance. The divine aura surrounding the beauty of the loved one or the Cupbearer has been a theme which major Muslim poets have developed in terms of intoxicated abandon. Certain sects met together expressly to contemplate the countenance, and as part of the novice's initiation into the emotional meaning of the mystery he was required to submit to the ordeal of the intense gaze of the master, *his* master. Through the impact of this spell, the word of Allah resounded deep within before appearing exoterically in the written word.

As a microcosmic expression – a calligram – of the hidden beauty of Allah, the human face has a powerful quality of fascination. As in script, the face can bring out the spiritual vibration of the divine injunction, the *fiat*. To read thus is to arouse the erotic in the field of existence. It is a flight across the mirror of Allah dividing form into its two aspects: the hidden and the manifest. Or, more precisely, the Ḥurūfi believe that there is a 'mute' Qur'ān and a manifested Qur'ān, which is revealed in the human face. They endow this face with the symbol of the number seven, which is that of the *Fātiḥa* or the first Sura of the Qur'ān: seven lines – two pairs of eyelashes (4), the eyebrows (2), and the hairline. A seemingly eccentric choice of number, but the number of the seven maternal (and therefore feminine) lines indicates, for the Ḥurūfi, the charm of the androgynous form, wherein is reflected the inaccessible being of Allah. And it is always divided into two.

Above. **Kufic script.** *The name of Allah. Detail of a mosaic inscription from a mosque in Samarqand.*

Facing page. **Maghribi script.** *'The Beloved' by al-Qandūsi.*

JAFR,
OR THE SCIENCE
OF LETTERS

Thus the compound organization of letters has a lively significance for spiritual or mystical speculation, which seeks to reveal, through the veil of appearances, the hidden reality in terms of intelligible form. In the field of classical Arab knowledge it is grammar, as well as Jafr (the science of letters) or alchemy, which symbolizes the desire for a 'geometry' of the soul, achieved by spiritual exercises based on a combining of numbers and letters. Everything unfolds, according to this view, in the indivisible unity of Allah. For example, the 'science of balance' of Jabir ibn Ḥayyān, known as Geber in the medieval West, relies on traces of the universal transformation of one form into another, matter into matter, symbol into symbol. Such development of the cosmic scripture is encoded in the structure of the Arabic language. From the root of a word, an extensive growth proliferates, a blossom of number and of rhetoric. These forms are, so to speak, poems dedicated to the glory of God.

This sort of theory (beyond the reach, perhaps, of archaeology) has pervaded the metaphysic of symbol from East to West, in every sense, and still survives in certain simplified stories used by the *fuqaḥa* in popular medicine (organic and psychosomatic).

Left. Marginal figure from a cosmogonic treatise: The Stars Explained so as to Harmonize the Namer and the Named *(1812).*

Right. A bird bringing a message to the mystic Abdelqadar Jilāli, known as the 'White Hawk'. Calligram in relief on an unidentifiable ground.

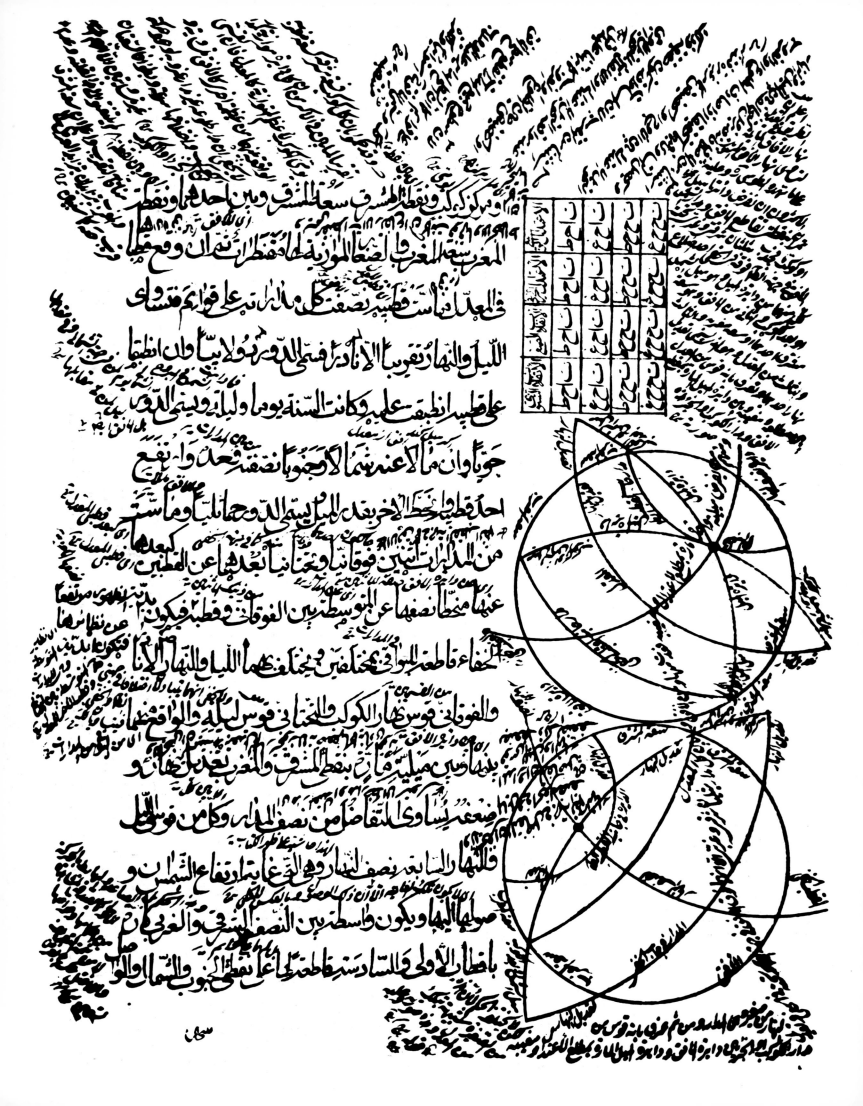

Right. Liturgical formulas
framed in circles.

Left. A cosmogonic
representation.

Preceding pages.
A composition taken from the
Garden of Eternity *by Abdallah
bnū Sayyid ʿAli al-Husayni
(completed 1819).*

Futuḥat,
or Isolated
Letters

In the Qur'ān one finds, at the beginning of certain Suras, *futuḥāt* (isolated letters) which have defied every attempt at explanation. They belong to the Arabic script, yet they are totally arbitrary. These letters have provided material for much mystical speculation. According to legend, they are the initials of the first copyists to record the text of the Qur'ān, and it is also hinted that they mark a break in the recitation between one Sura and the next, but the *futuḥāt* are not systematically arranged. However, legend thrives on inconsistency – in the statement, for instance, that the arrangement of these letters is a cunning trick played by Allah to confound unbelievers. Tradition says that in every revealed book there lies a secret, and the secret of the Qur'ān is hidden in the *futuḥāt*.

The legend conceals a theory, namely that the combination of these signs somehow crystallizes the symbolism of the Name of Allah. This may be elaborated into an arrangement of anagrams but is easily disproved.

The mystical view sees in the *futuḥāt* a kind of sublime signal, a wink of the eye, a tip of divine intuition penetrating the cycle of existence, granting pause for meditation on these crystalline letters where meaning is dissolved. Then the letters may combine, according to the power of the mystic's insight, to reimpose meaning upon the random and arbitrary nature of their dispersal. But perhaps one should consider how Allah has sanctioned this random quality of chance. It is chance itself.

Archaic kufic script. *A letter* fa *('f')*.

Stylized kufic. *Fragment of letter* fa *('f')*.

Facing page.
Maghribi script. *The double letter* lām *and* alif.

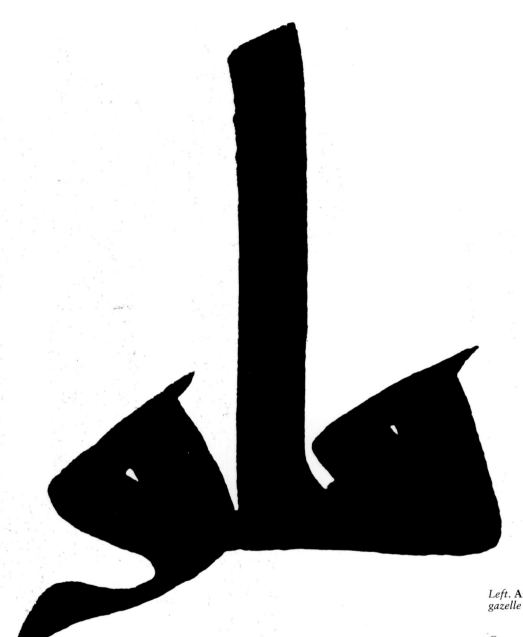

Left. **Archaic kufic script** *on gazelle skin.*

Opposite (from top left to bottom right).
Shikesté script. *Repetition of the letter 'l'.*

Shikesté script. *Repetition and superposition of the letter fa ('f').*

A letter 's' in exaggerated **kufic script.**

THE BISMILLAH

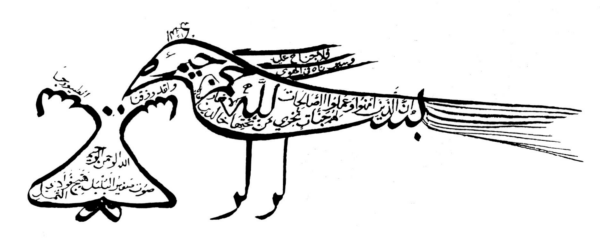

As I think of rhymes and verses, my beloved says:
Think only of my form.
I answer: Will you not sit beside me and rejoice,
O Rhyme of my thought? . . .
Then what are these letters that they should absorb your mind,
 what are they?
Why, they are the thorns which surround the wine.
Yes, I shall annul the letter by means of voice and language.
And I shall hold with you a converse beyond all letters,
Beyond all voice and language.

[Jalal ad-Din Rūmī]

A bismillah *in the form of a bird appearing to drink.*

'In the name of God, the Merciful, the Compassionate', is the traditional translation of this formula, which opens each Sura of the Qur'ān and punctuates the recitation. Like the right hand, which is for regulating physical movement, according to the *hadith* every important action undertaken by a Muslim should be preceded by a *bismillah*. This theme in a sense complements the spirituality of the believer, since it immerses him at the outset in the blessing of Allah. This formula is also the subject of extremely varied decoration and of a richness of calligraphic treatment which would alone be enough to 'transmute' the Arabic language.

Each script extols the form of the *bismillah* in its own way. The codified models are very precisely laid down. For example, with Ibn al-Bawwāb the character س (*s*) simultaneously contains the formula in its extension and projects it forward.

How are the attributes of Allah to be set out in terms of the graphic line? In this kind of formula, it is the whole entity of the godhead which is involved, the whole metaphysical range, in its symbolic aspect. For centuries Arab philosophy has been considering the question of its attribution: a strict monotheism must be maintained, while taking into account the many attributes of God mentioned in the Qur'ān. Can God be said to possess the attributes of created form? Can one behold him in Paradise? A series of questions relating to the nature of God and of his Name are repeated in the field of calligraphy, where the imagery is well equipped to express the modification of the hidden face of Allah by means of arabesques which sing out in their divine intoxication. This is in the margin, and it is the nature of the margin which now requires a brief consideration from another aspect of the Islamic text.

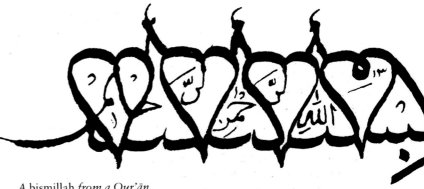

A bismillah *from a Qur'ān, Afghanistan, 18th century.*

Top. A bismillah *in the form of a hawk.*

143

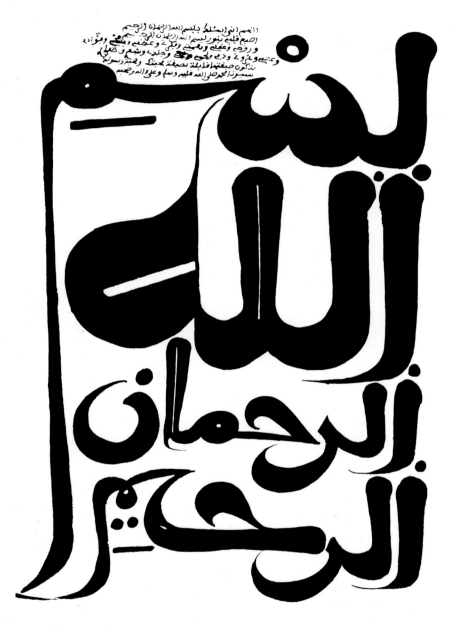

A bismillah *by al-Qandūsi, from his remarkable 12-volume Qur'ān (completed 1849).*

Opposite. The opening of the sura Maryam (Mary), from al-Qandūsi's Qur'ān.

Following pages. **Maghribi script.** *'In the name of Allah', from a Qur'ān copied by Ahmed Malūsh al-Hadrami (1886).*

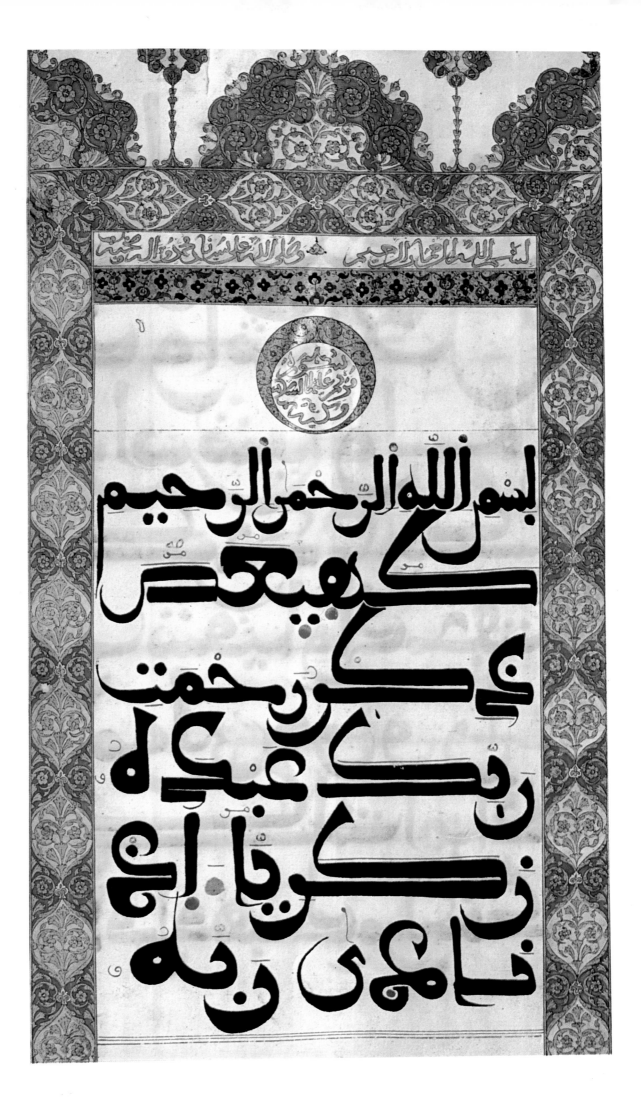

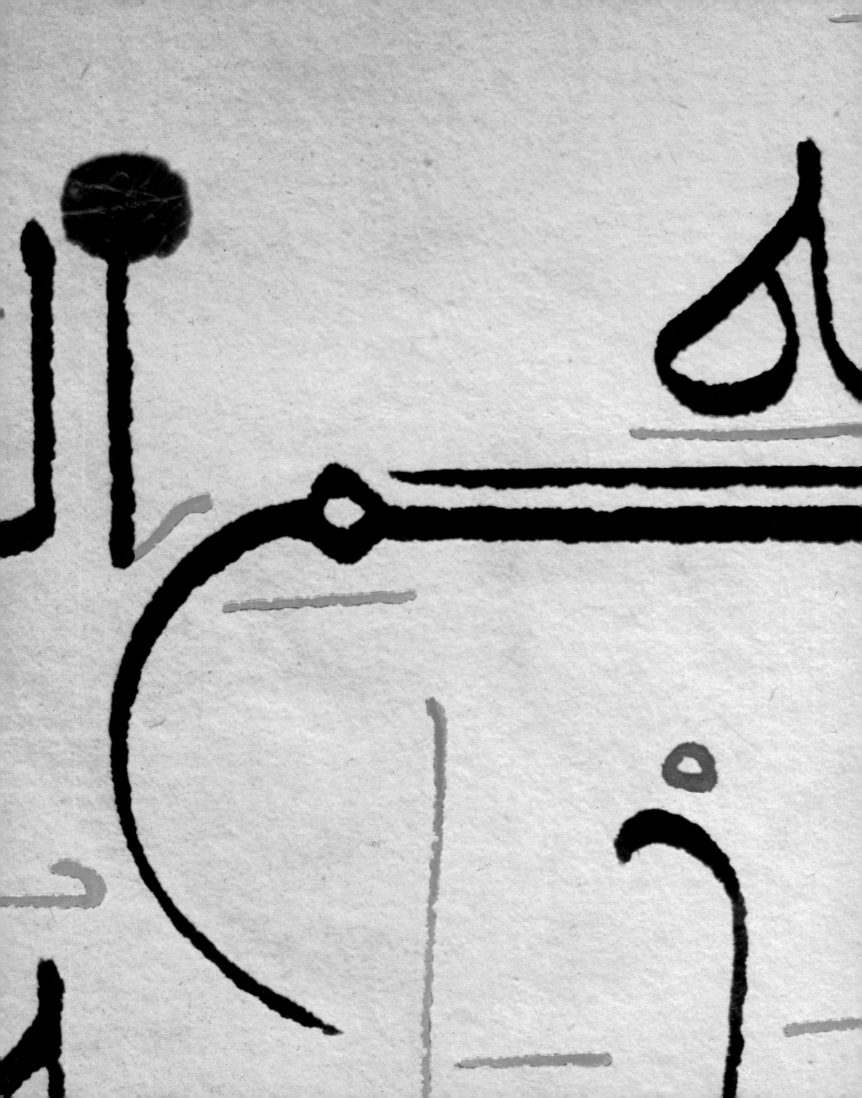

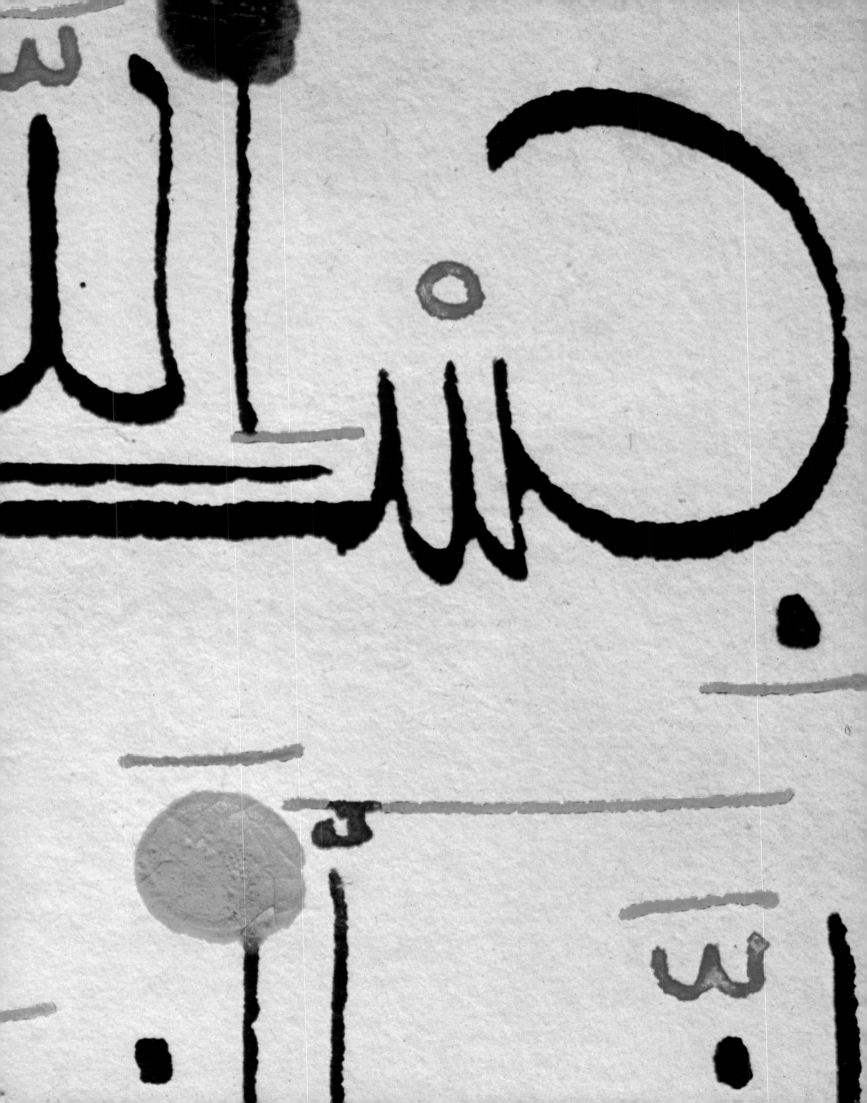

THE MARGIN

A margin may perhaps be defined as something totally outside the law and statutes of the text. Totally, because the margin breaks all the rules and all the limits of authority. In vain does the writer put a frame round his text, protecting it from harm with vigilant ceremonial: the margin breaks through the frame, goes through the looking-glass and creates a general scandal. Thus we can talk about a certain script's passionate and 'prideful' will.

First there is the conventional margin. Here the margin of the text is either left blank or contains a commentary. In calligraphy the margin can be decorated. Its conventional quality consists of the degree to which it is based on a central unity, a central principle around which revolves the margin, here regarded as an unnecessary accompaniment to the text.

But in the art of Arab calligraphy the margin may include alongside the actual text a parallel text; or marginal motifs may be transplanted into the text; or the reader's attention may be diverted by making the margin easy to read and the text very difficult. Or the margin may rob the text of its central position by framing it with script on all sides.

In the last case, so beautifully done in certain Turkish and Persian books, the marginal commentary may consist of a word or phrase belonging to the body of the text, put in so that this commentary breaks the line of the script and gives it an unsuspected drift. The book then has to be turned around in all directions so as to follow the line of the script. Thus, too, the body turns with the book, joining in a little dance.

But in its absolute sense (no longer controlled by official convention) the margin is active in the whole field of calligraphy. It is active there as the inexpressible which may yet be expressed. From the smallest diacritical sign to the clearly written heading, the mystery is always in the reflec-

tion of what is actually there. It is in the winding paths of this uncertainty that the genius or the talent of the calligrapher makes its uncertain way. For instance, the Moroccan al-Qandūsi gave his margins an insistent, powerful symmetry. The unity of the page is punctured by this unexpected element, and the resulting dislocation gradually breaks down the central principle until the margin becomes a text within the text.

Above. Pages written in **naskhi** *with marginal commentaries.*

Right. Text written in ta 'liq with marginal notes and interlinear commentary in **naskhi.**

ولا يغلب على ظنه وان غلب اخذ الاقل وقعد في كل موضعه

باب صلاة المريض لا يعذر

ضنه لا وصلوته

القيام لمرض حدث قبل الصلوة او فيها صلى قاعدا يركع و
يسجد وان تعذرا اوماء برأسه قاعدا وجعل سجوده اخفض
من ركوعه ولا يرفع اليه شيئا للسجود وان تعذرا ومى متلقيا القعود صح

ورجلاه الى القبلة او مظطجعا ووجهه اليها والاول اولى

اذا تعذرا الايماء اخرت ولا يومى بعينه وحاجبه وقلبه ان
تعذر الركوع و ... قعد اوماء وهو افضل من الايماء

قايما وموما حقق الصلوة استأنف وقاعدا يركع ويسجد صح

فيها بنى ... قايما صلى قاعدا فيها قدر جالسا بلا عذر صح وفي المربوط لا

بعذر جرح او اغمى عليه يوما وليلة قضى ماماته وان زاد لا

باب سجود التلاوة بها سجدة بين

... تكبيرتين بشروط الصلوة بلا دفع يد وتشهد وسلام وفيها

٣٢٣

Left. Text with marginal and interlinear commentary.

Right. A text written by al-Qandūsī with marginal notes in **maghribi script.**

THE SIGNATURE

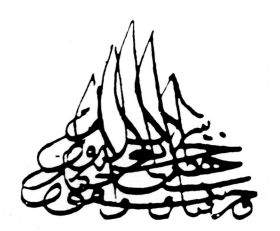 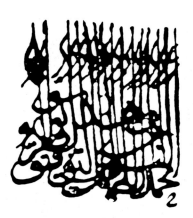 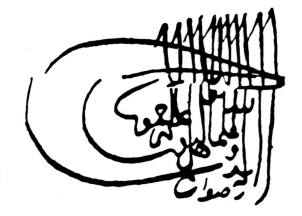

Some Moroccan *fuqaha* recite a religious invocation as they make their signature, speaking the first word as they write the first letter, and ending with the last movement of the hand. This is a mnemonic device which was called *bakhucha* (scarab) as a reference to the stick-like antennae of this little creature.

Signing the name was an art in itself, the act of putting down the proper name according to its divine and historic stock: thus the *tughra* is a royal signature signifying a transcendental order and meant to be impossible to imitate. Then official scribes became entitled to copy the image, with the result that the ritual value of the gesture was destroyed: a king without a signature, and a signature without a crown.

In the *tughra*, which is a sort of cipher, sometimes impenetrable, the first letters are particularly prominent and form a compact base from which certain appendices project forcefully upwards. The higher these letters reach, the harder they are to read; the vertical is caught in cursive loops on the right. The proper name resumes the rightward

momentum by overlapping it. In certain calligrams two signatures co-exist: the calligrapher inscribes his own name (which is not necessarily readable) to the left of the royal signature. Sometimes the calligrapher may displace the royal signature with a *bismillah* or a quotation from the Qur'ān.

To take another example, one can be surprised by the severe monotony of calligraphic phrases which are variations of Qur'ānic phrases, or the names of Allah, or those of Muhammad or the first Caliphs. But this limitation must be put in its historical context, when each Muslim sect introduced a hierarchy among the successors of the Prophet.

Ali is pre-eminent among the Shi'ite Sufis, who mourn his murder and that of his two children, a murder still commemorated at Karbela in Iraq. With prayer and lamentation the faithful strike their foreheads constantly and with increasing force against a small calligraphed stone placed on the ground. There, the calligraphy is a signature of the mystic blood.

Tughras, *or signatures of Ottoman sultans, including a firman in* **diwāni script,** *the monogram of Osman III (reigned 1754–57).*

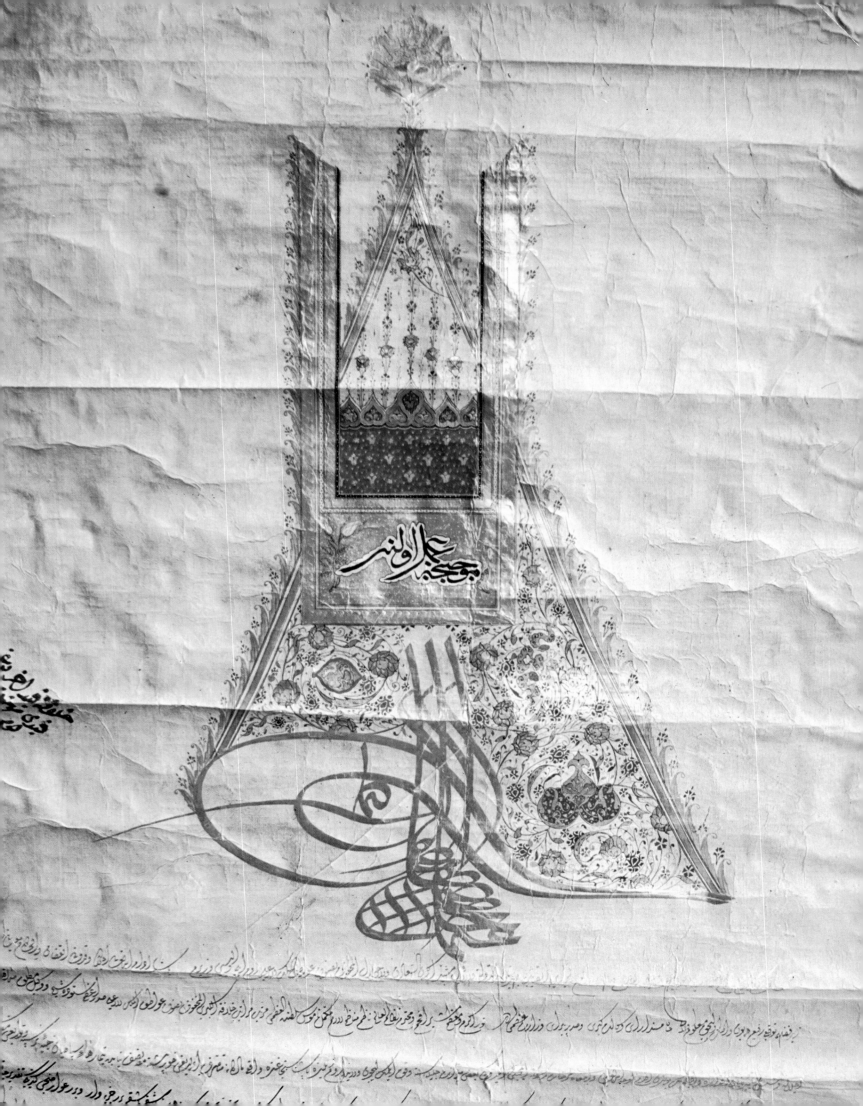

A calligram in praise of a
Mamluk sultan, with his name –
'Husayn bnū Sha'ban' –
suspended in a grille formed by
the long uprights. The address is
accompanied by accounts of his
fame (1362).

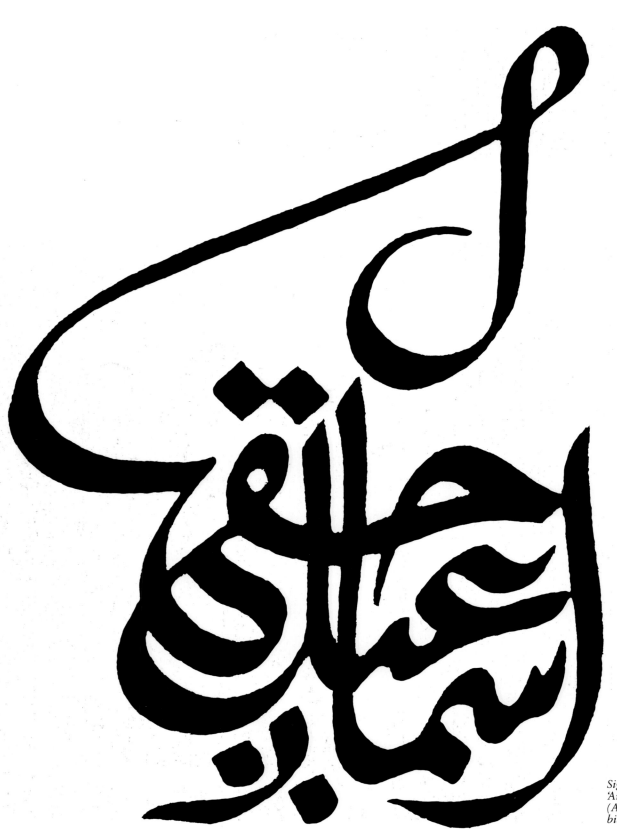

Signature in **sumbuli script** *by 'Arif Hikmat (After Zayn al-Din Nāji; see bibliography).*

A calligram written in the normal direction.

Below. The same calligram written in reverse. Composed by Yahya (19th century).

A complex arrangement of
thuluth script. *The text can be
read vertically as well as from
right to left. Calligraphy by
'Uthmān al-Ḥāfiz.*

Extracts from a Turkish film, with calligraphy by Amentü Gemisi. A love story in which a male figure fires an arrow at wild animals. The animals avoid the arrow, which eventually wounds the man's beloved.

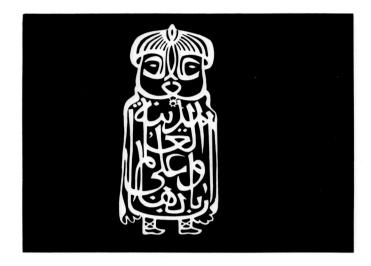

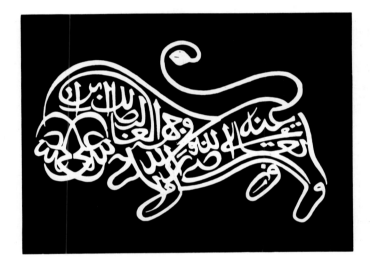

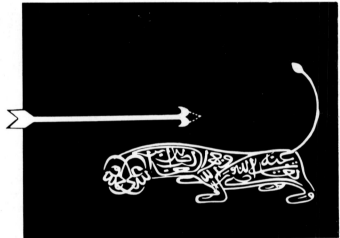

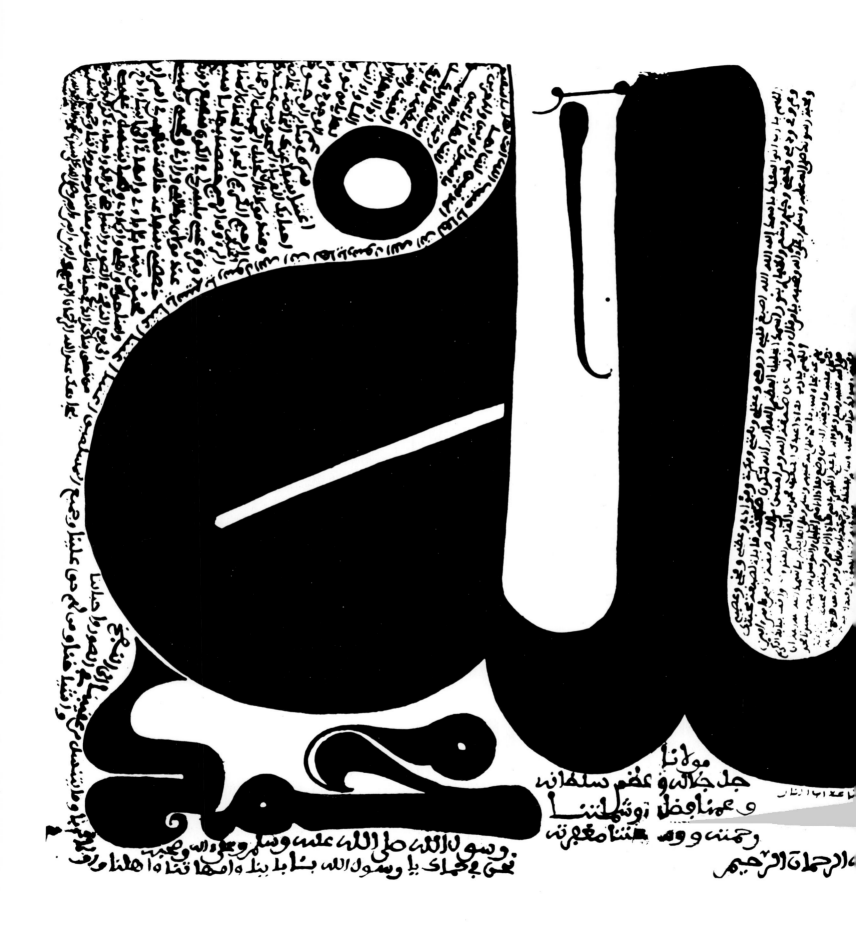

IN THE SIGHT
OF ALLAH

We have emphasized the sacred character of calligraphy, as well as its divine associations. We now need to outline the connecting links which, from several points of view, place the principle of calligraphy within 'the sight of Allah'. Later we will briefly discuss the way in which calligraphy was involved in other aspects of Islamic art, particularly architecture, and how, even today, it challenges the graphic arts throughout the Arab world. In order to escape the grasp of technology, Arab, Turkish and Persian painters are now seeking to establish new roots in their work. We shall attempt to discover the form which this reappraisal is taking.

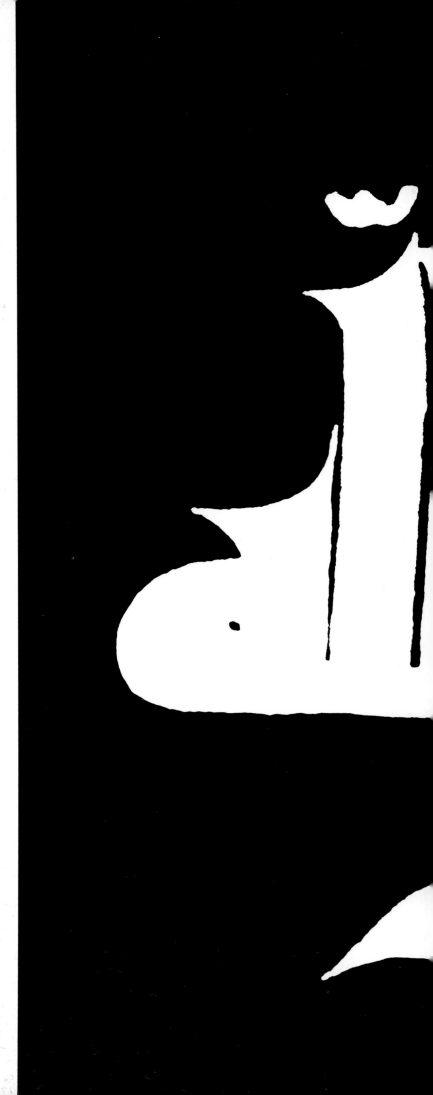

Kufic script *written on gazelle skin (14th century).*

Preceding pages. The name of Allah as transcribed by al-Qandūsi. Extracts from 'A Miscellany of Quotations and Liturgies' (1828).

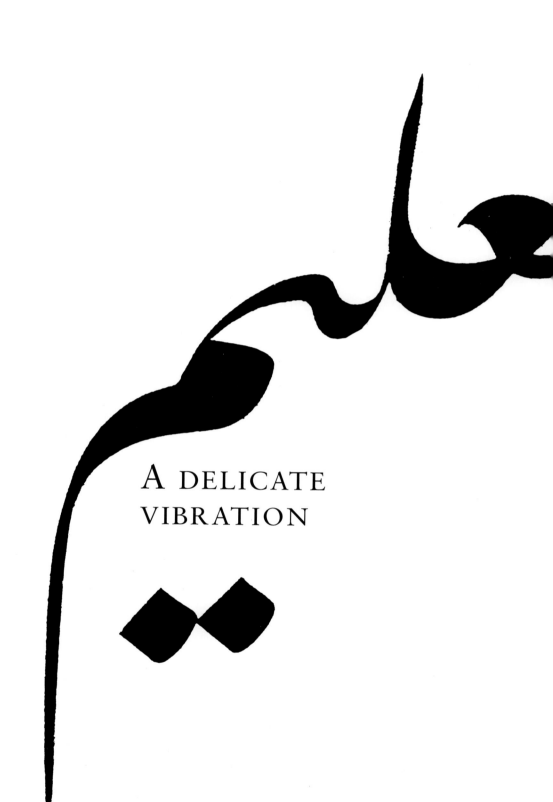

A DELICATE
VIBRATION

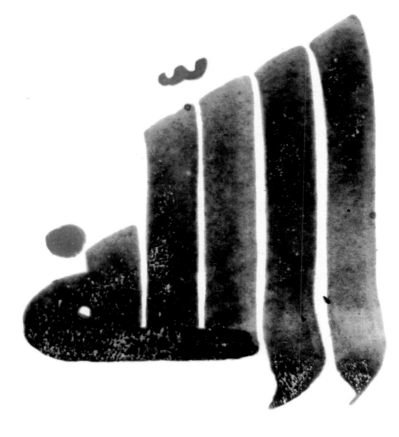

For the Muslim, the world bears witness to the divine omnipresence. How can such a thing-in-itself be translated? What emerges here, on the plane of transcendental existence, is not simply the effect of an image or symbol concealing the human countenance, but the whole body contained in its sacred envelope. Man is a symbol, a name stamped with the seal of Allah. This is the body, screened from itself, and as it were detached from motion in the sight of God. Inserted into this body, at the divine command, is a depiction of the soul released into the realm of heaven. In its way, calligraphy contains this depiction of the soul. It reveals the path of revelation.

Of course, the history of the written word is in a sense the whole history of Islam. Calligraphy must be given its due as a universal feature in the arts of Islam: architecture, mosaic, arabesque, etc.

Muslim art obviously did not arise, whole and entire, in some miraculous transmutation. A survey of its full extent reveals metaphysical and cultural influences which are necessarily diverse and numerous. The art of Islam is by no means centred on any one place, be it Mecca or Timbuktu; it presents a varied landscape, without any precise centre. Take the Arabic calligraphy written by Chinese Muslims.

Such a script is Arabic to excess, overflowing its own origins. A cursive ideogram twists the Arabic letter, turning it upon itself as if to test its plasticity. Each culture has its own particular joys, and artistic creativity flourishes when the seeds are scattered far and wide.

Two prejudices which are commonly held with respect to Islamic art are its aversion to empty space on the one hand and, on the other, the completely gratuitous nature of its use of geometry. We need to understand that these two prejudices, rooted as they are in Christian theology, presuppose that it is figural art which witnesses to the divine incarnation in human form. Religious art in the West – in its Byzantine form, for instance – has symbolized the equation of painting, in the depiction of Christ, with representation: the bodily form of God presupposes a transfigured concept of painting or sculpture. These arts may be likened to the rays of a sun resuscitating the spiritual bloodstream.

The Christian artist may be said to contemplate himself lovingly in the eye of God, the self-contemplation of a spirit troubled and tempted by the desire, the suffering and the sin of looking. Such an artist, one imagines, must re-create himself through the substance of the Holy Trinity to let his vision roam free in the sensual world. Resurrection

Left. The phrase 'The Omniscient', one of the names of Allah, written in **ta 'liq.**

Above. **Maghribi kufic** *with diacriticals in red, written on gazelle skin (14th century).*

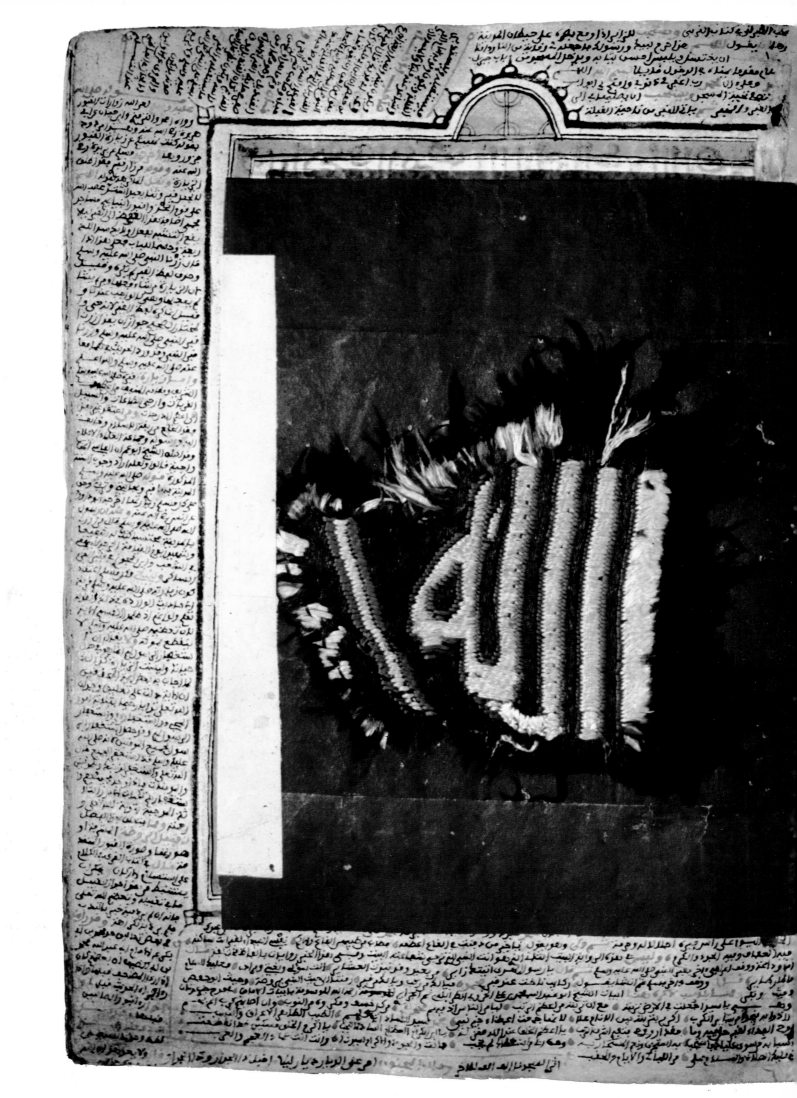

Interwoven floral kufic script. *The name of Allah.*

Left. The word 'Allah' embroidered in silk thread on leather in a book of quotations and prayers composed by al-Qandūsi.

through art thus irradiates the perceptual order, where the fusion of God and man is reflected.

By contrast, a Muslim artist – constrained as he is by a general prohibition preventing any figural treatment of the divine or human countenance – must return to the fundamental theory which asserts that everything must pass through the sacred text, and return to it again: the sacred text and the central principle. The Muslim artist constructs the semblance of an object (for only God can *create*) relating to something already inscribed on the Sacred Table. By this action he expresses the essence of art: to bring out in infinite variety what is already there. By this action he initiates an esoteric spiritual art which fills the void and expresses itself in terms of outlines of gnomic import: calligraphy of the absolute, symbols in monogram, parabolic geometry of the divine. Hence the thrilling example of the arabesque. In the alternation of geometric and floral motifs, what the eyes sees through the clarification of form is marked out in the main outline of the script, surrounded by blank space, emptiness, and the decoration in the margins. Then, when this has been noted, one sees a mosaic of illumination setting off, with exquisite grace, a central line of calligraphy – central, though not

Illuminations from the Dalīl al-Khayrat.

Following pages.
Illumination from the start of a chapter in a manuscript by al-Qandūsi, executed in a highly personal style (19th century).

centred on the page. Between the calligraphic elements and the mosaic one sees (*right*) the emergent interaction of a delicate, elegant vibration.

This leads to the general conclusion that the significant factor in Islamic art is neither aversion to empty space nor a gratuitous use of geometric design, but a drive towards absolute sanctification. The superabundance of the sacred is such that it contains its own void. Muslim art moves onwards in a secret, veiled anguish which harbours in itself a mystical experience. Hence the arabesque, which expresses this anguish in decorative form. It holds the balance of line and colour to a point where they begin to waver and vibrate in an interlaced tracery, and epigraphy and natural or geometric decoration are combined. This tracery holds the superabundance in check, yet marks a secret desire to lose itself. Epigraphy tells the word of God. Geometry and nature bear witness to His omnipotent presence. And on this voyage of celebration, the world delivers the soul of the believer to the anguish of the Invisible.

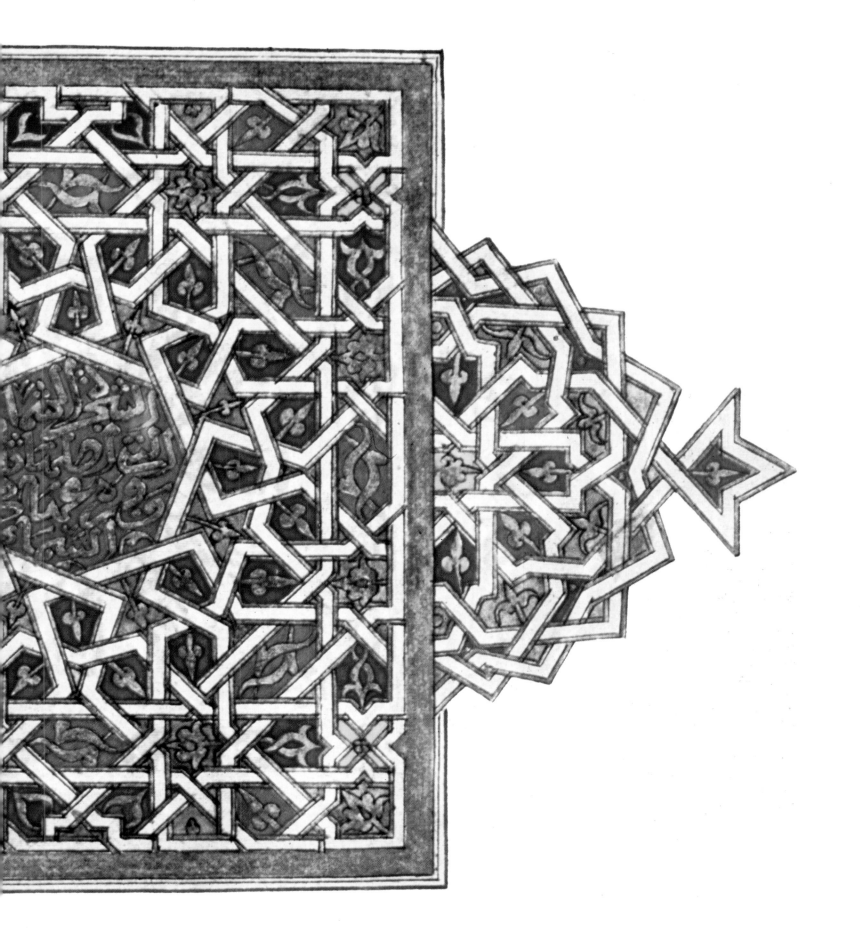

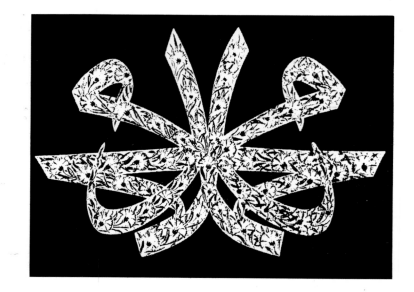

The name of the Prophet
Muhammad in mirror image, by
Suhaïl Anwar, Istanbul.

Below. An example of the style
known as tomar (after al-
Qalqashandi; see bibliography).

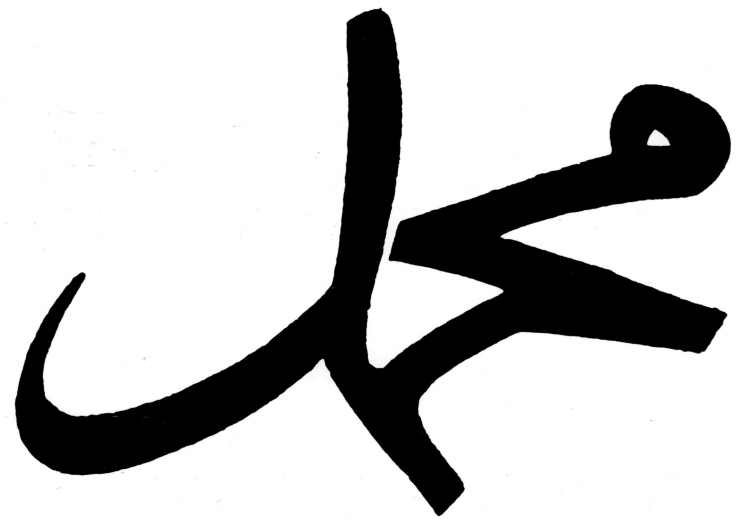

Left. The word 'Paradise' by al-Qandūsi. Within the one word there is a contrast between the rectilinear and curvilinear styles (1850).

Below. The name of the Prophet Muhammad as composed by al-Qandūsi.

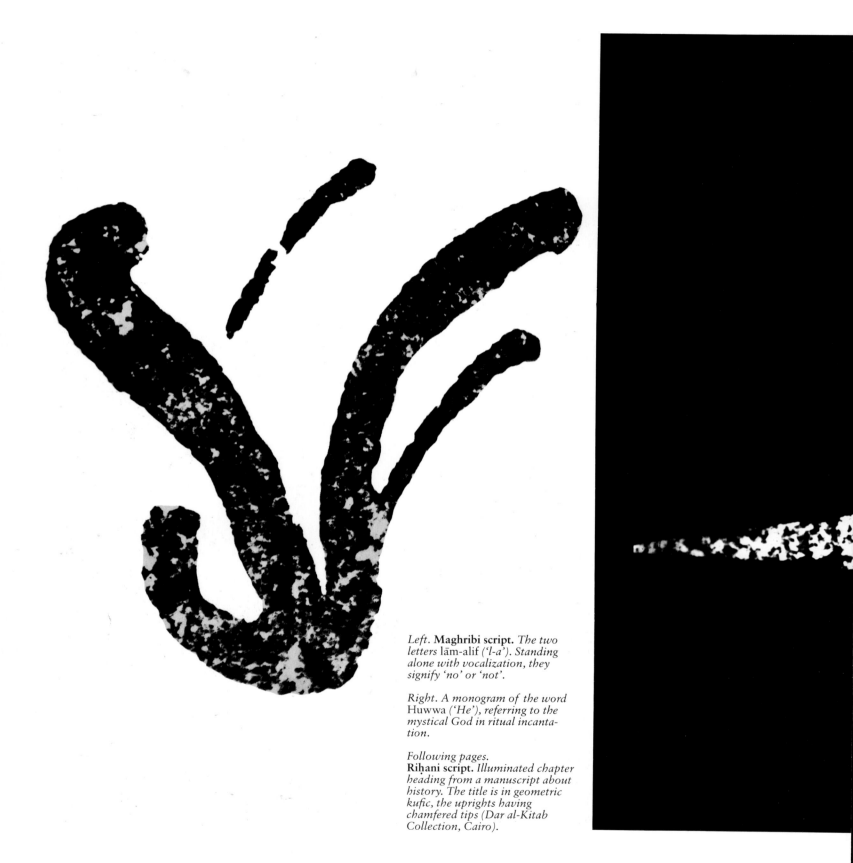

Left. **Maghribi script.** *The two letters* lām-alif *('l-a'). Standing alone with vocalization, they signify 'no' or 'not'.*

Right. A monogram of the word Huwwa *('He'), referring to the mystical God in ritual incantation.*

Following pages.
Riḥani script. *Illuminated chapter heading from a manuscript about history. The title is in geometric kufic, the uprights having chamfered tips (Dar al-Kitab Collection, Cairo).*

The Prophet Muhammad's
footprint.

Right. The Prophet's footprint
(from the Dakhira of the
Sharqāwa, a Moroccan
brotherhood).

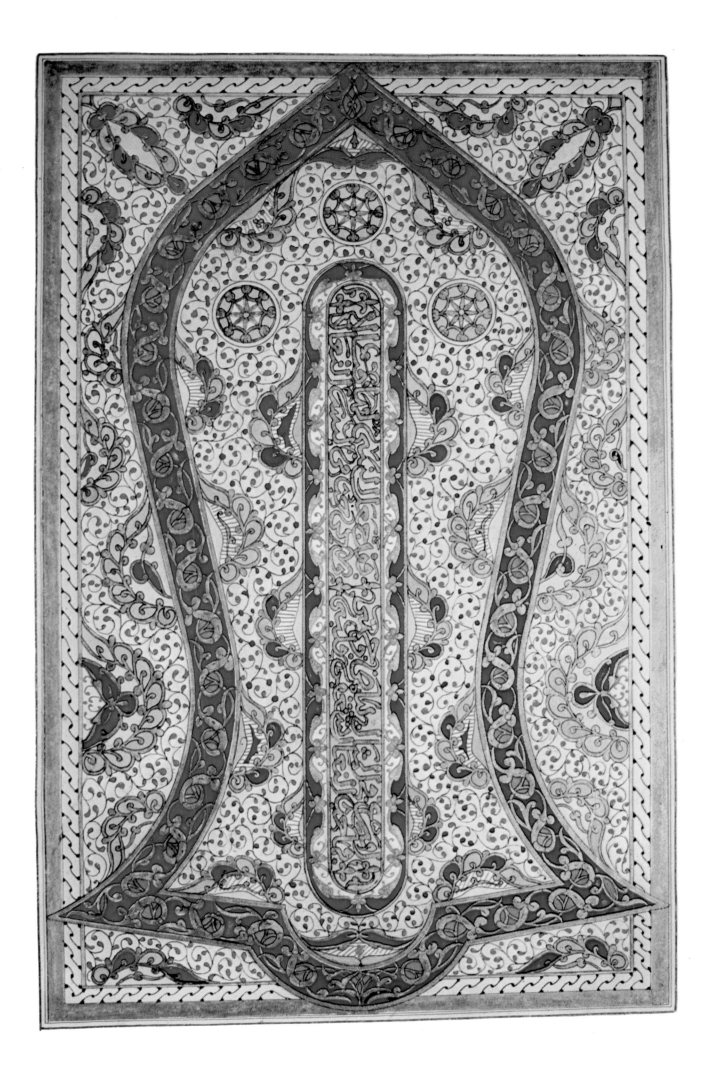

ORNAMENTATION
OF BUILDINGS

Kufic *(in red) and* **thuluth** *– interplay between two scripts.*

In the context of architecture, calligraphy plays an ambiguous role. On the one hand, it is projected from the manuscript page onto the monument, to decorate mosques, palaces, *madrasas*, tombs and any place with religious associations.

On the other hand, calligraphy becomes a veritable iconography of the written word. Qur'ānic manuscripts or liturgical texts may be ornamented with an assemblage of architectural themes: minarets, the holy sites of Mecca, the tombs of Muhammad and the four Orthodox Caliphs. No human features are depicted on these simply constructed shrine-pictures. Their purpose is simply to prompt the believer to meditate on the sacred, on an imagined pilgrimage to Mecca. The icon is there to symbolize the return to the source of Muslim belief.

But most often decoration takes the form of illumination and arabesque, which are inspired in equal measure by Byzantine, Greek or Persian art. The themes are well known: rosettes, flowers, palmettes, vines, garlands – a development of stylized forms following precise rules, and having as its function the revelation of God's omnipresence. Floral decoration, for example, is not in fact a pure abstrac-

tion. As a thing, and a thing in bloom, the floral subject contains, beneath its apparent emptiness, the fragrance of our being.

What is an arabesque? G. Marçais has written of this art form (in *L'art musulman*): 'The essential element, which may itself alone constitute the whole decoration, and which controls the design and the rhythm, is the band, the ribbon of constant width. To trace the design which the band is to follow, to compose it as a whole, simultaneously intricate and balanced, luxuriant and coherent, a design in which the eye can willingly lose itself and find itself again – that is the primary concern of the creator of the arabesque.'

What then is the essential meaning of this design? No doubt one can concentrate, as we have seen, on the geometric interweaving, and trace the combinations of letters and their stems in relation to geometric and natural ornamentation. Or, better still, one can try to work out the connections between decorative epigraphy and architecture as properly defined. But the real question remains unanswered, and it concerns the nature of the thing which graces Islamic art with its special quality. What is this quality to be called?

To be sure, historians have studied the development of Islamic art in relation to the triple influence of Greek, Byzantine and Persian art, a development which occurred from the tenth century onwards. Certainly, these historians have identified – insofar as it concerns our approach – the particular nature of decorative epigraphy. But these erudite and useful studies tend to give rise to a misleading oversimplification.

If Islamic art is to reveal itself to us, we must look into the philosophical heart in which it resides. In that heart, it lives unknown. Thus the simple example of the arabesque can still surprise us because of its refusal to be fitted into any of the accepted artistic categories.

Calligraphy, as we have said, is projected from the page onto the monument. It decorates the surfaces of mosques, palaces and tombs, emerging from a background of marble, stucco or wood, or indeed from any material imaginable. Mosaics, too, are included in this grand display of script. An impression of sumptuous magnificence is the immediate effect produced by these subtly fashioned garlands. But where does this genius of fantasy lead, this reordering of the stone between heaven and earth? One could even imagine

Left. **Ta'liq script:** *'The Hearer' (one of the names of Allah).*

Tāj *(a script invented by Muhammad Mahfud al-Misri, 1930): the word* jalāl *('majesty').*

that the walls, columns, cupolas and domes might easily uproot themselves and rise towards heaven!

Multifarious calligraphic designs envelop these buildings. Extended quotations from the Qur'ān are inscribed on some surfaces, imitating the illuminated pages of manuscripts, often in kufic and/or thuluth script. As for the friezes carved with arabesques, they release a universal visual energy. But those familiar with Muslim art know that these arabesques serve as a subtle and evanescent initiation into Arab philosophy, and into the philosophy of Islam.

Calligraphy and the arabesque cover a vast range of sites and materials: monuments, miniatures, sculptures, carpets, fabrics, jewels, coins, flags, mosaics, ceramics, enamelling – a harmony of luxurious forms to mark the divine presence or the power of aking. And because the use of calligraphy serves as an illumination of the sacred, it manifests itself everywhere, with scripts adapted to every material and every form. It holds within it an essential measure of the nature of being.

One should not assume, however, that all Muslim architecture is necessarily inspired by luxury. A mosque, for example, need be nothing more than a walled enclosure, or,

185

in the desert, just two or three stones piled together and aligned towards Mecca. Islam should be seen in terms of its sacred hierarchy. Luxury marks the worldly power of a king, a governor, an empire. Each dynasty developed and fostered a particular artistic style which was intended to establish its legitimacy and its political power in the eyes of man and of God. In its essence, calligraphy is an aristocratic art. Its use elevated the governing class above the common run, between heaven and earth, in the eyes of God.

Now that the Arab world has embraced modern technology, the art of calligraphy is yelding to typography and the keyboard, but it has not yet disappeared from books or from journals, where it is generally displayed in headings. Nor has it disappeared from the streets, where one can buy poster cheaply. In these places of refuge, calligraphy survives in a marginal and subtly decadent form.

Now, exponents of Arab, Turkish and Persian painting and graphic arts are looking at calligraphy afresh. This is by no means surprising, for modern art may be a search for the pure symbol, the intrinsic truth, of script. Yet such a meeting may give rise to an ambiguous dialogue. The West arrived at abstract art after centuries of figural representation, and the Arab painting did so by means of a doubtful short cut. This style of painting harks back to its origins in calligraphy and the popular arts, adopting a new way of combining signs which itself runs the risk of falling into the clutches of technology. But for as long as writing is able to exist over and above technology, so long will calligraphy remain a subject for poetry and meditation. Let us pay attention to messengers from the distant past.

Collage. Arches surrounding inscriptions in **thuluth** *script. Extract from the* Dakhira *of the Sharqāwa.*

THE
ARCHITECTURAL
CONTEXT

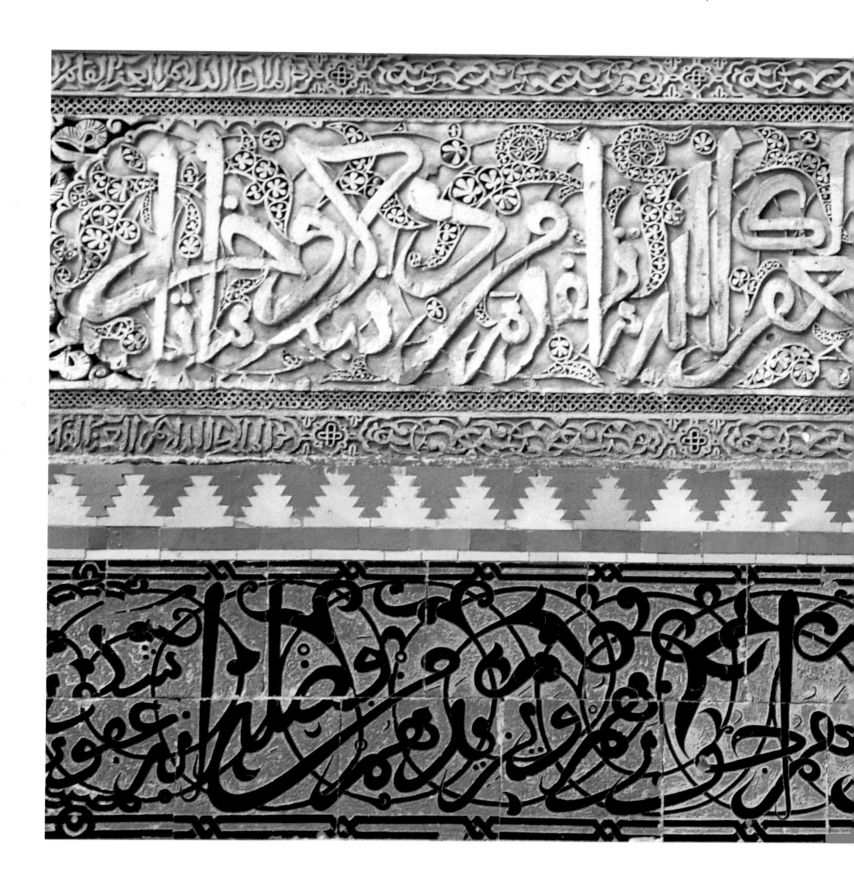

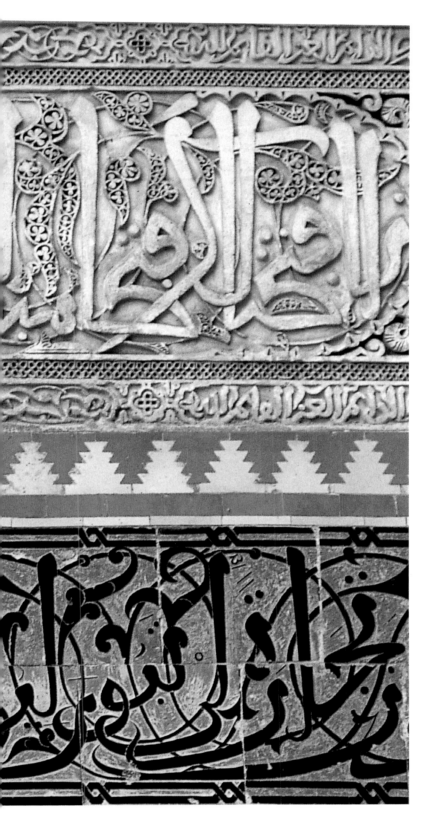

One of the more striking aspects of the architecture of Muslim countries is the way in which calligraphy serves as a key element of the decor in most of the monuments built in the period since the beginning of Islam up to the present day. Skilful arrangements of floral arabesque and geometric infills enable the artist to produce compositions which create a dialogue between light and shade, while at the same time highlighting subtleties of colour and form.

The malleable quality of the letters of the Arabic alphabet, the rhythmic movement of the way in which letters are joined and the harmonious nature of their forms combine to confer a sense of strength and elegance upon the buildings. Column capitals, arches, pillars, walls, doors and windows are enhanced by the presence of this lettered art form, which may be executed by painting, carving or incising, and which produces visual effects that are often arresting and act as an invitation to meditation.

Royal palaces, mausoleums, princely residences, town houses, public and private fountains, courtyards and garden kiosks, the tombs of caliphs, princes and dignitaries – wherever men have striven to build on a monumental scale, and wherever they have sought to glorify God and the Prophet Muhammad, the splendours of calligraphy were utilized to provide the final touch of grandeur and to impart the added lustre that would also serve to enhance the prestige of the building's patron.

Two friezes in Andalusian maghribi style (variant of thuluth), one (above) in carved plaster, the other in ceramic tiles with black-glazed letterring. Both are set against a background of spirals and double spirals. Madrasa al Attarin, Fez (14th century).

Preceding pages. Sculpted stucco medallion: Al Mulk Lillah ('Allah is great'), c. 1480 (Hashem Khosrovani collection).

LANDMARKS

The use of calligraphy in Muslim architecture can be said to date from the end of the seventh century AD. The earliest known inscription is to be found in Jerusalem, in the Al-Aqsa Mosque – near the Dome of the Rock – completed in 691. It consists of a verse of the Qur'ān incorporated into decorative friezes running along the south wall of the building. The text, rendered in archaic kufic script, is still readable in parts.

The second important inscription of this period is to be found in the Mosque of the Prophet at Medina. This building was begun in the lifetime of Muhammad, and was enlarged and rebuilt several times, before it was finally completed in AD 709. Here the calligraphic text, in archaic kufic script, is a verse from the Qur'ān. We know from the tenth-century author al-Nadim that the calligrapher Khalid ibn abu al-Sayyaj had first produced a full-size sketch in gold lettering before having the design reproduced on the wall of the mosque.

Subsequently the Medina mosque would serve as a model for places of worship all over the Islamic world. It provided the inspiration both for the architectural use of calligraphy and for the art of organizing the mosque's internal space. It was this building which gave the orientation for the *mihrab*, the niche indicating the direction of Mecca (*qibla*) which Muslims face when praying in a mosque.

In regions such as the Maghreb and al-Andalus builders were more inclined to take as their model the Al-Aqsa Mosque at Jerusalem, particularly during the Almohad dynasty (eleventh century). It was under this dynasty that the orientation of the *qibla* wall was established in the Qarawiyyin mosque in Fez and the Great Mosques in Cordoba and Seville.

As Muslim civilization spread further from its Arabian heartland, and as major works of architecture proliferated, rules began to be laid down governing the structure of

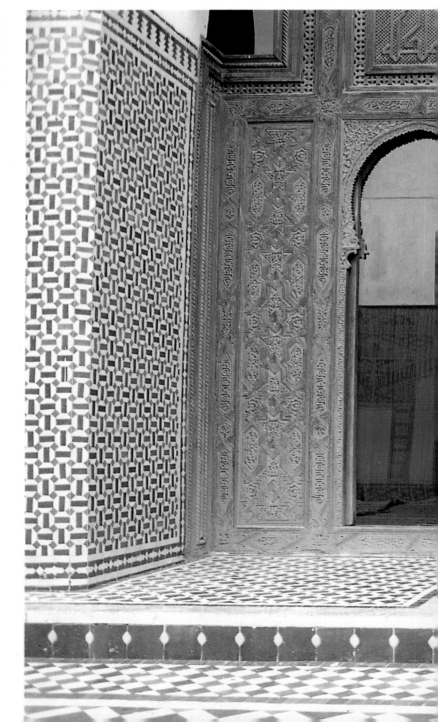

Interwoven floral maghribi kufic, in which the uprights of the letters turn back at right angles, creating knots and fill-in ornamentation. Carved plaster frieze (detail), Madrasa ben Youssef, Marrakesh (16th century).

Cedar-wood partition separating the mosque courtyard from the prayer-hall of the al-Kabir Mosque, Fez. Text carved in relief and surrounded by a frame with geometric ornamentation (13th century).

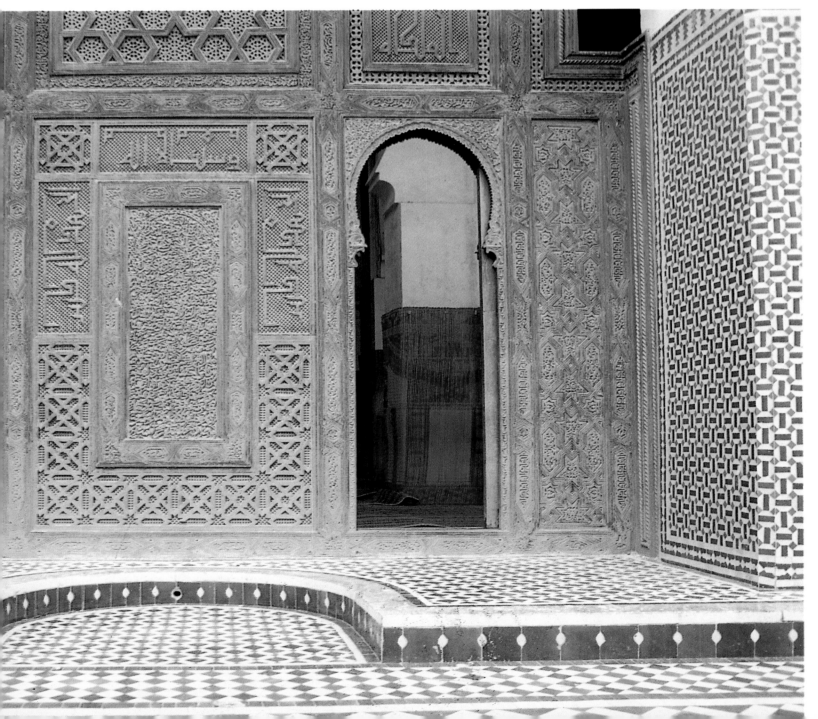

Ta'liq inscription carved in relief. Façade of the Yeni Valide Mosque (1710), Üsküdar, a suburb of Istanbul on the Asian side of the Bosphorus.

Detail of wood partition with carved and openwork decoration. An alternation of bands of geometric and floral ornamentation which highlight the sobriety of the kufic lettering carved in relief, Qarawiyyin Mosque, Fez (10th century).

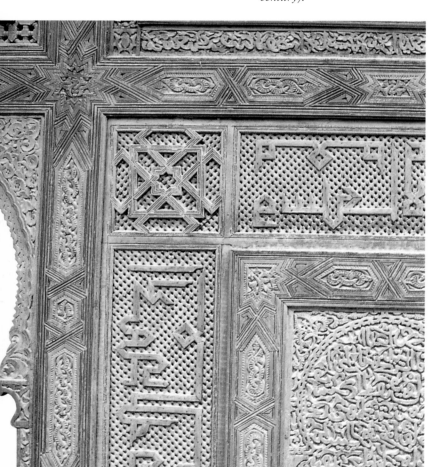

calligraphic texts, the manner of their arrangement, and their themes and contents.

Initially the subject matter consisted of short, unadorned phrases which were inscribed on friezes in particularly significant parts of the building. They later went on to become a regular feature of the decor, covering ceilings, columns, arches, doors, windows and whole stretches of walls.

The repertoire of calligraphic subject matter draws on quotations from the Qur'ān, phrases celebrating the glory of Islam, professions of faith, devotional invocation, exhortations, praise of sovereigns, philosophical maxims and mystical formulas.

To this body of subject matter can be added poetic texts, signature monograms (*tughras*), funerary inscriptions, information regarding the commissioning of the building in question, the names of caliphs, sultans, princes and high dignitaries, and details of the historical circumstances which a particular building was designed to commemorate. In addition, we find epitaphs and genealogies of famous public figures, and, in a later development, words which had no particular meaning and which were employed purely for decorative effect.

The names of the calligraphers and of the artisans who created and carried out the work are not generally given, any more than are the names of the architect or the builder, of whom one finds mention only later (and this only in some Ottoman and Persian buildings, but hardly ever in the monuments of the Maghreb).

The calligraphic texts as applied to architecture are, so to speak, a known quantity, given in advance, but they are nonetheless codified in the way they are presented, and there are rules governing their elaboration and execution.

However creative or competent the calligrapher who composes them, he has always been obliged to remain within the framework laid down by tradition, and was expected

to abide by the codes that govern each style. The specialist artisan working in any of the various different media – stone, marble, wood, stucco, ceramics, bronze etc. – was constantly subject to the control of his craft guild and its rules, even when his own individual inspiration was at its most creative and fanciful.

The text, which may be presented either raised in relief or incised, is always arranged within a framework defined by a line, 1 or 2 centimetres wide, which may likewise be either in relief or incised. This frame may take the form of a cartouche, a square, a rectangle, a circle or any of a variety of other regular geometric figures.

The dimensions of these frames vary according to a number of factors: the importance of the building; their position in relation to other elements of the decor; the degree of emphasis that the builder decides to give them; and the requirements of the artist's composition.

Mostly the framing devices are rectangular surfaces about 20 centimetres high and ranging between 1 metre and several metres in length. These friezes are used to frame large surfaces where a stylized vegetation and skilfully arranged geometric patterns create a dialogue that highlights the message conveyed in the text.

In other monuments these frames take the forms of squares and rectangles ranging from one to several metres long: the word Allah followed by one of his names, and the name of the Prophet or one of the first Caliphs are often created in a mirror calligraphy or by the use of interweaving lettering to give a labyrinthine effect. In some Ottoman buildings in particular, three or more rectangles may be superimposed, with each bearing calligraphic texts composed in a style different from the one immediately preceding it.

Building materials have played a determining role in deciding the form and arrangement of calligraphic lettering in architecture. They dictated the nature of the surface destined to receive the lettering and its accompanying arabesque – which may be flat, in relief or incised.

Colours tended to be reserved for wood, stucco and ceramics. They were generally of vegetable or mineral origin and the range was generally rather limited, in line with the technical possibilities available at the time. Gold and bright colours were applied to wood and stucco, while white, black, green and blue were generally reserved for tiles. Some of these colours have become famous – for example the turquoise blue associated with mosques at Samarqand and other sites in Central Asia.

The rules governing the use of calligraphy in architecture and the general principles that we have outlined are an integral part of the basic concepts and principles of Muslim aesthetics. While drawing on these principles, regional innovations and variants have provided new ideas, developing from one building to another while at the same time maintaining the overall image with which Islamic civilization has sought to endow its principal monuments.

Thus a large number of styles have been developed on the basis of scripts used in copying texts, and have been adapted to suit the monumental scale and the materials used in architecture. In the process the forms have been enhanced by various innovations regarding the body of the lettering, the tips and ends of letters and the manner in which they are linked. The original calligraphic styles have effectively been transformed by the nature of the materials used.

STYLES

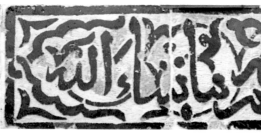

Kufic *and* **thuluth** *panels from left (black excised ceramic tiles) to right (relief carved plaster). The* **thuluth** *letters are against a background of spirals. The* **geometric** *kufic letters have verticals ending in chamfered tips and other ornamental elements characteristic of the style.*

Kufic was the predominant – in fact virtually the only – calligraphic style used in architecture until the eleventh century. It has two kinds of characters: long letters extending upwards, and squatter letters extending downwards or outwards. The former represent the vertical elements of tall letters, and the latter the curving lines of rounded letters and the shorter risers of the other vertical letters. Rigid horizontal lines provide the base line and link the letters in order to create words.

Thus a calligraphic phrase in kufic script consists of a succession of vertical letters with long or short uprights, and lower, squat, rounded letters, together with horizontal link lines. This all evolves within a space which is traversed by rectilinear outlines creating a geometric arrangement of empty spaces which are treated in various ways by calligraphers in order to bring the composition to life.

The tall and short letters, the linear link lines and the empty spaces provide the basic parameters within which the calligrapher organizes his work. The words themselves are arranged around a rigorously observed horizontal base line which is *de rigueur* for all calligraphic compositions executed in the kufic style.

The space within which the phrase is expressed consists of two zones, one above and one below the line, and a perfect equilibrium is maintained between these two parts. The upper area has an airy quality, and contains the verticals and the empty spaces, while the lower area is more densely packed. These are the two areas within which the calligrapher's imagination can work with the interplay of letters, the balance of their proportions and the organization of the empty spaces between the verticals. The resulting rhythm and harmony of a piece are derived from the subtle interplay of these parameters.

Subsequent calligraphic styles were created by transforming the structures of the letters, the proportions of

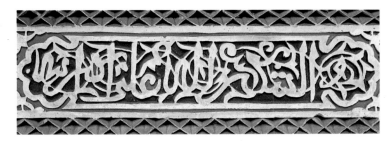

their verticals, the design of their tips and the treatment of the areas above and below the base line.

There were several types of kufic script to be found in Islamic architecture, each deriving from a given epoch or geographical region. Later they would be taken up by builders in other countries, who adapted and modified them with varying degrees of felicity.

The main stylistic variations are archaic kufic, which is the archetype of Arabic script, floral kufic, geometric kufic, interwoven kufic, Andalusian-maghribi kufic, braided kufic and bordered kufic.

In the era of the Umayyads (until the mid-eighth century) the only style in use was archaic kufic. This style, which was generally engraved, fast arrived at a degree of aesthetic perfection. It was characterized by lines of equal thickness and rigid appearance. There are few buildings extant from this period of the Arabs' early conquests and settlement, given that in that period they had not had the opportunity to build important monuments.

In al-Andalus and the Maghreb, the oldest surviving specimens of archaic kufic are to be found in the Great Mosque of Qayrawan and the former Great Mosque in Cordoba. The Qarawiyyin Mosque in Fez once had a number of inscriptions, but the only one extant is to be found carved in relief on a cedarwood beam dating from the ninth century and bearing the name of Daud ibn Idris, son of Idris II, the town's founder. It is preserved in the Dar Batha Museum in Fez.

The geometric structure of the lettering in archaic kufic is characterized by a regularity of layout and the rigidity of the base line. The empty spaces between verticals are not ornamented, and contain neither floral decoration nor geometric infills. There is also no letter-pointing using diacritical dots. The rhythmic effect of this style derives from the interplay between tall letters and short letters and the balance between their proportions. The interplay of light and shade created by the alternation between incised and flat-surface lettering accentuates this effect.

Under the Abbasids (ninth century) the development of science and knowledge went hand in hand with developments in manuscripts and architecture. This period saw the building of many mosques, *madrasas* and palaces. Now artists were brought in from all over the region to which Islam had spread, and they brought with them new ideas and new sensibilities which then influenced the evolution of calligraphic style.

There were important changes in various aspects of individual letters and the spaces created between them. Appendages in the form of flowers and flowery ornaments were added to the tips of certain letters, giving rise to floral kufic, which became the principal style in all provinces up to the eleventh century.

The kufic lettering of this era tends to be long and slender; the joining lines tend to be shorter, but are still straight. The tips of the letters take the form of an angular chamfer, where they had been somewhat thicker and concave in the earlier period. The bodies of the letters become thicker, as if better to support the enlargement of some of their parts. The spaces created by the uprights are filled by adding decorative elements such as stylized floral arabesques and complex geometric compositions.

These innovations went from strength to strength, sometimes ending by overstating the decorative aspect to the detriment of sensitivity and creativity, as can be seen in a number of monuments built in later periods.

The floral kufic style also introduced other transformations: the upright letters sometimes turn at right angles and join in knots or intricate patterns; the chamfered tips of the letters may take on ornamental elements typical of given regions, as for example the fine specimens of geometric

floral kufic to be found in the Alhambra, Granada, or in the mausoleum of Timur in Samarqand.

In some monuments the stylistic variants are so complex that it becomes hard to read the calligraphic text. On the other hand, in buildings such as the Qarawiyyin mosque in Fez or the Great Mosque in Tlemcen, the lettering itself remains sober, while the background is filled with flowers, rosettes, palm leaves and other stylized elements which serve to highlight the script.

The bordered kufic style developed principally in Iran. It consists of sober lettering with an independent decorative border, and in some monuments it includes geometric forms. The two elements stand out against a stylized floral composition which facilitates the readability of the inscription itself.

The so-called braided kufic style owes its name to the braided effect of the uprights of the letters. This style made its first appearance in Iran, and was then taken up in other countries, most notably al-Andalus and the Maghreb.

Persia, which saw the creation of several varieties of the kufic style, had a particularly inventive calligraphy because of its longstanding tradition of writing in other languages, of which the best known is *pahlavi*. The Arabic language, with its new characters, quickly took over, and became the preferred alphabet for all calligraphic texts on monuments, even when their original language was Persian or Turkish. The same thing occurred in Muslim India, where Urdu was written in Arabic lettering.

Other variations of the kufic style were applied to a wide range of building materials: carved or incised stone, stucco worked on several levels, brickwork arranged in relief in order to form words, engraved and painted wood, coloured tiles, and engraved or cast metals . . . These variants complemented by linear decoration of arabesques and infills are seen in numerous monumental graphic compositions which

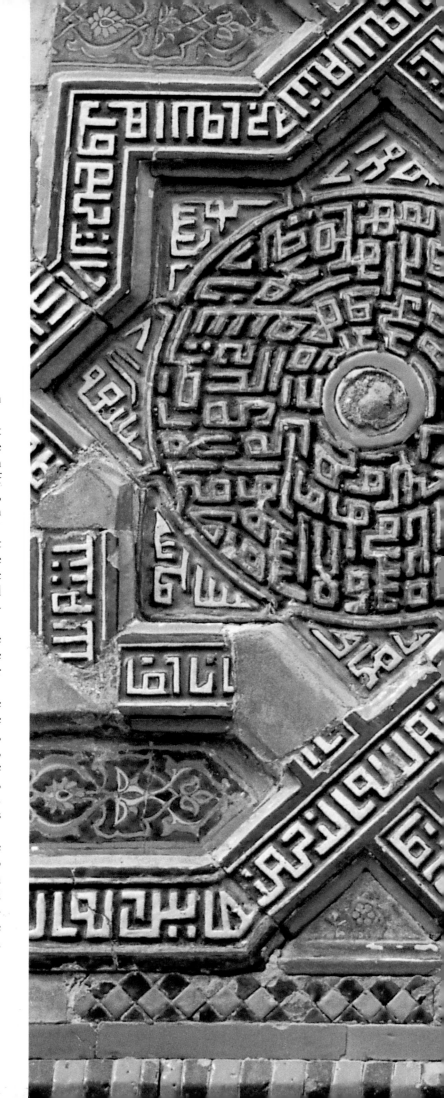

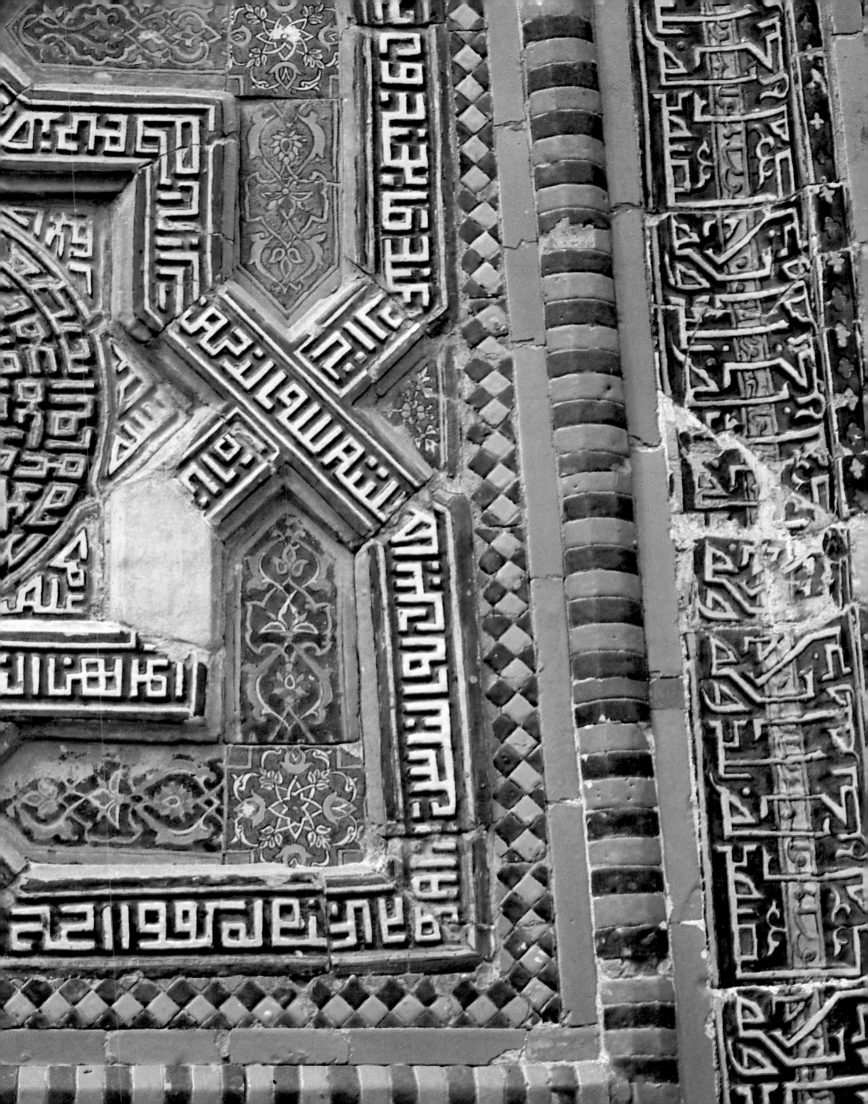

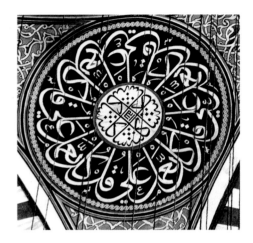

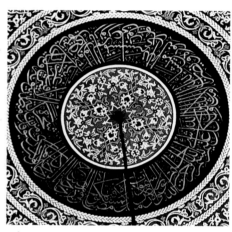

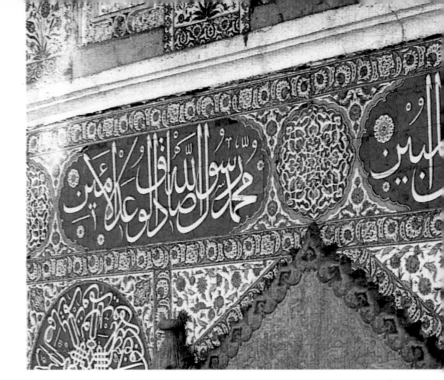

The interiors of many mosques in Iran and Turkey are ornamented with inscriptions. In the examples illustrated three circular compositions feature letters pointing towards the centre and arabesques providing framing elements. The main example (centre) shows a detail of the tile panels incorporating calligraphic inscriptions surrounding the mihrab of the Sokollu Mehmet Paşa Mosque, Istanbul (1571).
Preceding pages.
Archaic kufic script *in a geometric decorative scheme. A rare specimen of calligraphy in this style, characterized by horizontal and vertical elements of equal thickness and displaying a certain rigidity, highlighted by the spaces between the letters. Mausoleum of Jalal ad-Din Rūmī (interior), Konya, Turkey (1295).*

can be counted among the finest examples of Muslim architecture.

Naskhi script first appeared in the East in the tenth century, and by the eleventh century had been adopted in the majority of Muslim countries. Its cursive structure offered builders new decorative possibilities through the use of new combinations of calligraphic styles.

In Morocco and al-Andalus naskhi script was introduced under the Almoravids (eleventh century) and became widespread under the Almohads (eleventh and twelfth centuries) after the unification of the Maghreb under that dynasty. In Iran naskhi script first appeared in the eleventh century, whereas in Turkey it features in architecture only after the twelfth century, in the Seljuq era.

The naskhi script, codified by Ibn al-Muqla and his pupil Ibn al-Bawwāb, as noted earlier, developed in the East in the ninth century, in manuscripts and court correspondence, before arriving in the Maghreb and al-Andalus, where it was to be greatly transformed. It took a while before naskhi was adopted in the context of architecture, and it only became predominant in the first half of the twelfth century.

Given that the naskhi style has a supple, cursive script, it is easier to handle, inasmuch as its layout corresponds to the natural movements of the writer's hand. The creative options which it offers distinguish it from kufic, which is angular, rigid and difficult both to execute and to read.

Its lettering is sometimes continuous and sometimes detached, with supple rounded ligatures which often break the continuity. Here the base line loses its rigidity, and so we lose the rectangular aspect of the kufic style, which defines an upper area with an exuberant floral decor and a freer, more relaxed sublinear area. In naskhi inscriptions the calligraphy of both areas is animated by the suppleness of the bodies of the letters, and the varying directions taken by their terminal parts.

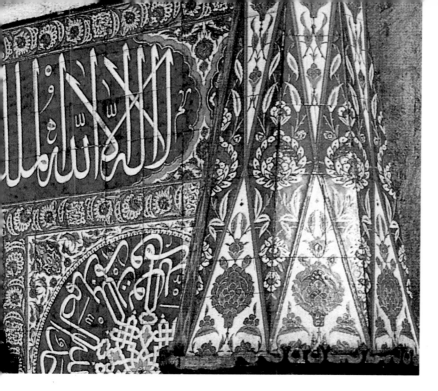

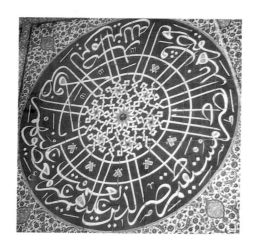

The supple way in which naskhi is written, with the continuous movement of the linking lines between letters, provides a direct contrast with the earlier rectilinear spatial organization of calligraphic lettering, as well as a means of setting off the essentially rectilinear aspect of most buildings. It thus acts as a visual counterpoint to the mass of the built structure.

Naskhi's harmonious curves fit easily with the single and double spirals with which it is classically associated, with their wealth of foliage, flowers and assorted floral ornamentation. Over the centuries, and across the regions, calligraphers have introduced many stylistic variations into the naskhi script, creating local styles, some of which have been used exclusively in their own architectural contexts without ever being adopted elsewhere in the Muslim world.

The best-known variants of naskhi include, first and foremost, thuluth. Then, depending on the region, there are taliq, nastāliq, muhaqqaq, riq'a, rihani and, particularly worthy of note, the Andalusian-maghribi style, which can be located midway between kufic and naskhi

These different styles have led to some remarkable creations, which have enriched the architectural heritage of the Muslim world with new ways of combining lettering with floral and geometric arabesques.

Thus, in buildings in Iran one finds Persian and Arabic inscriptions where the monumental lettering of the naskhi script stands out prominently, producing a result that is a world away from some of the more floral compositions found elsewhere. These inscriptions provide the principal aesthetic element for the architectural decor within which they are featured.

In Turkey, on the other hand, decorative inscriptions tend to be enclosed within a large frame or cartouche which itself is likely to be subdivided by thin lines separating calligraphic texts executed in different styles.

In many Ottoman and Persian monuments the royal signatures (*tughras*) display their characteristic lettering in the shape of elongated, closely packed uprights that join at their tops to form an elegant mass with its own distinctive characteristics dictated by the style of the period in which it was created.

There are many variants of naskhi used in other forms of Islamic art which have not been adopted for architectural use, due to difficulties of execution when working with traditional building materials. However, the thuluth style has been the most popular variant throughout the Muslim world since the twelfth century, to such a point that kufic is now only used in certain parts of buildings where the inscriptions are short, repetitive and easy to read.

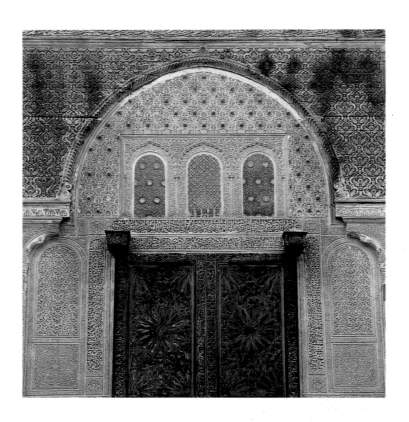

Various calligraphic styles employed in a single space, to stimulate the viewer and to facilitate a reading of the message.

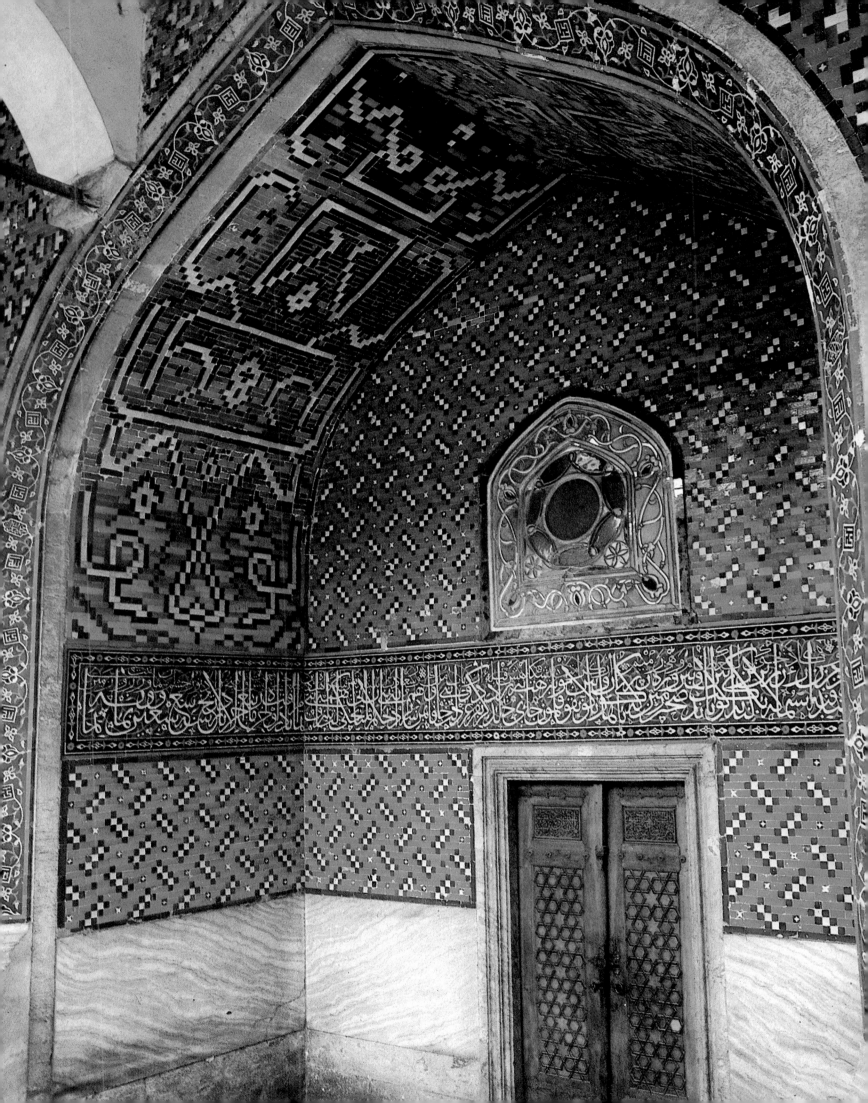

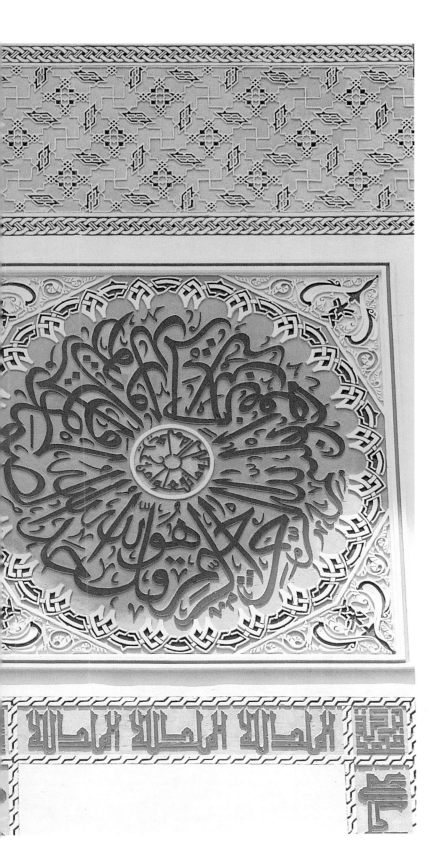

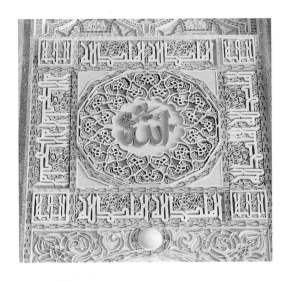

Alternation and juxtaposition of a supple, cursive style with rigid, angular **kufic** lettering. The combination of stylized floral ornamentation, geometric interlacing and the richness of the polychrome treatment highlight the individual words and invocations. Mosque of Hassan II, Casablanca (1993).

Overleaf. Rhythm, judicious positioning and movement are the criteria for beauty of execution in calligraphy. A good example of these qualities occurs in the dome of the Şehzade Camii, Istanbul (1548).

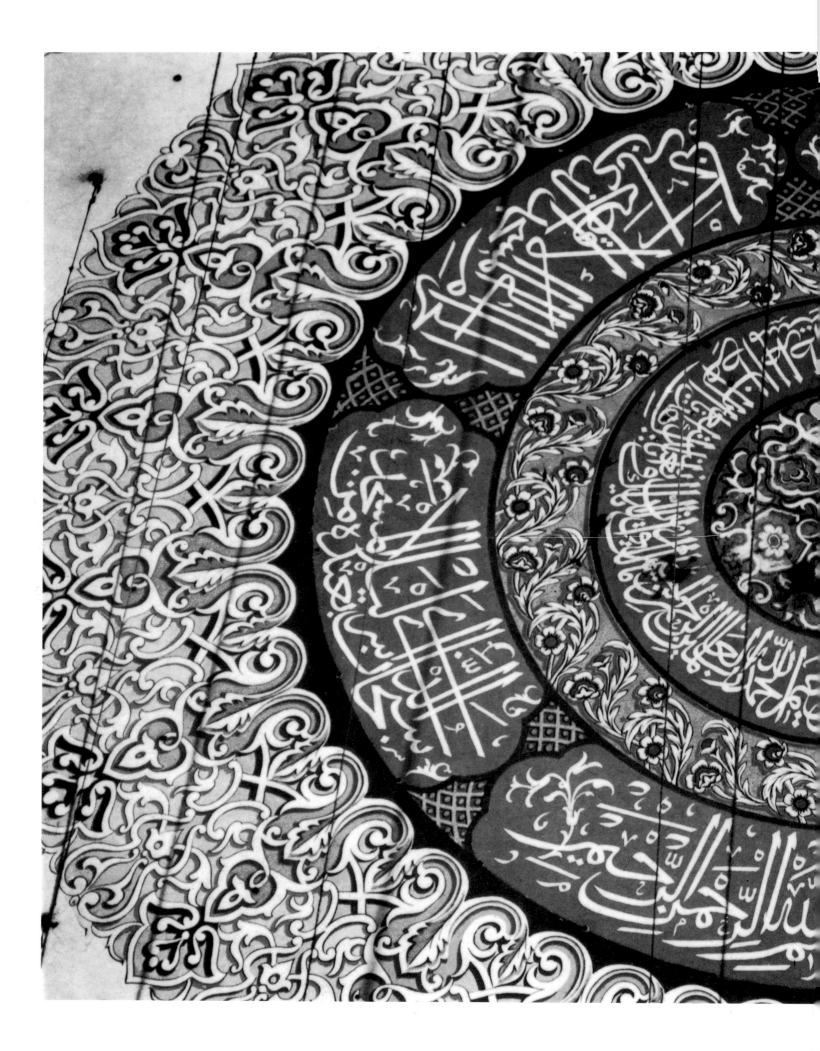

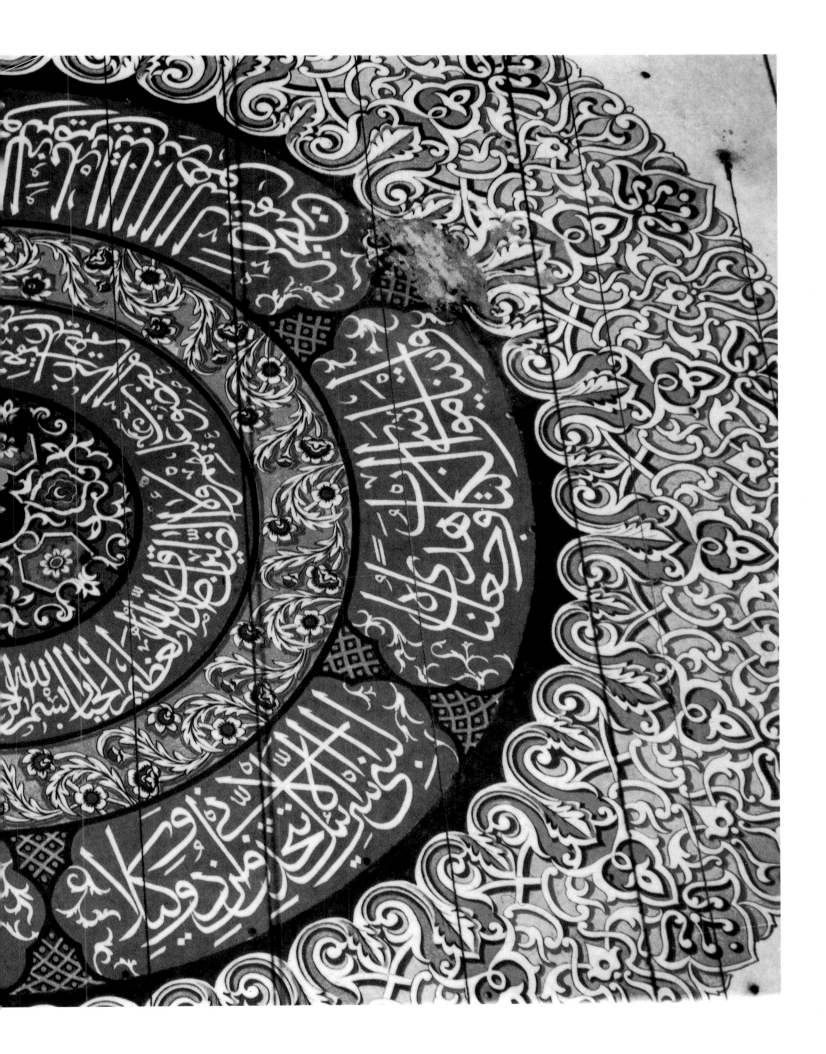

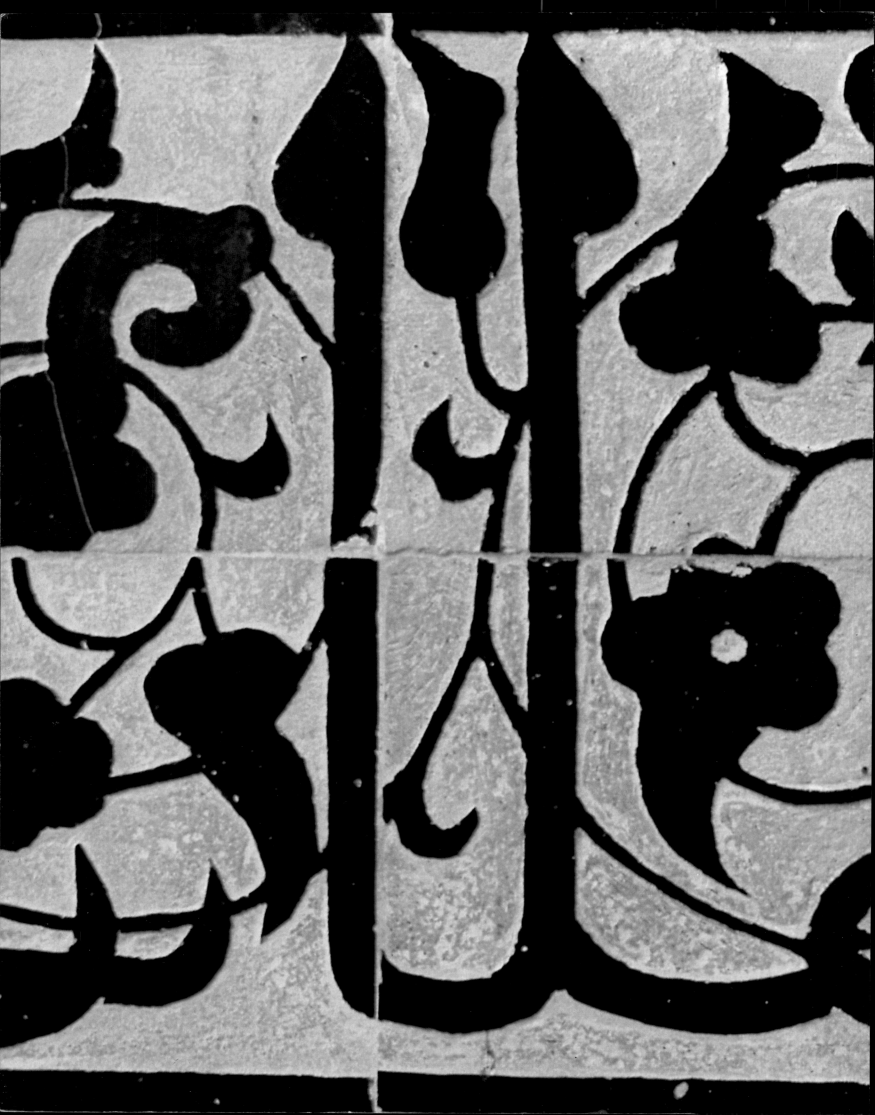

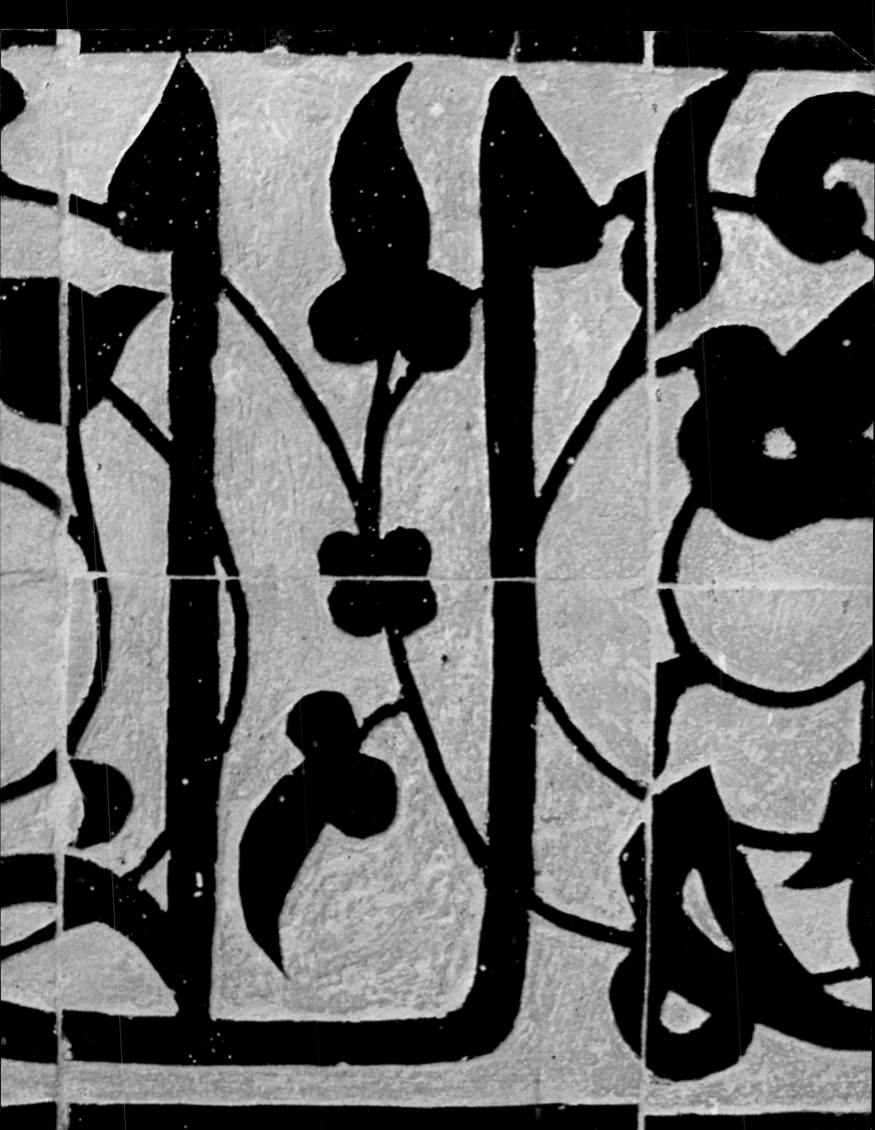

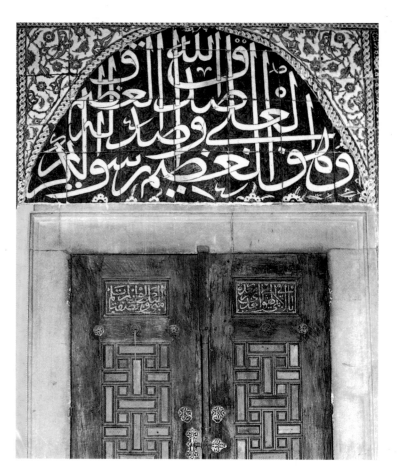

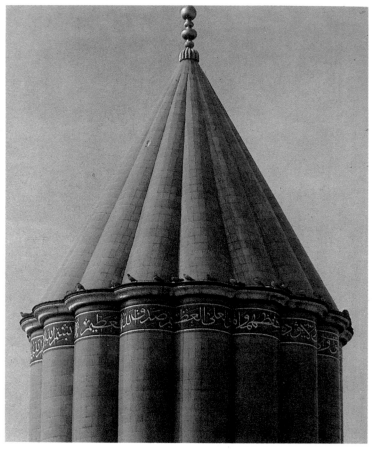

The repertoire of calligraphic
themes on monuments includes
quotations from the Qur'ān, pro-
fessions of faith, glorifications of
a sovereign and mystic sentences
or reflections. Çinili Camii,
Istanbul (1571), and the
Mausoleum of Jalal ad-Din
Rūmī, Konya (1295).

Preceding pages.
Enamelled ceramic tiles (detail)
featuring cursive calligraphy with
a background of single and
double spirals. Madrasa al-
Attarin, Fez (14th century).

Right. Materials play a key role
in deciding the form and arrange-
ment of calligraphic lettering in
an architectural context,
particularly whether the orna-
mentation will be flat, recessed or
in relief. Çinili Kösk, Istanbul
(1473).

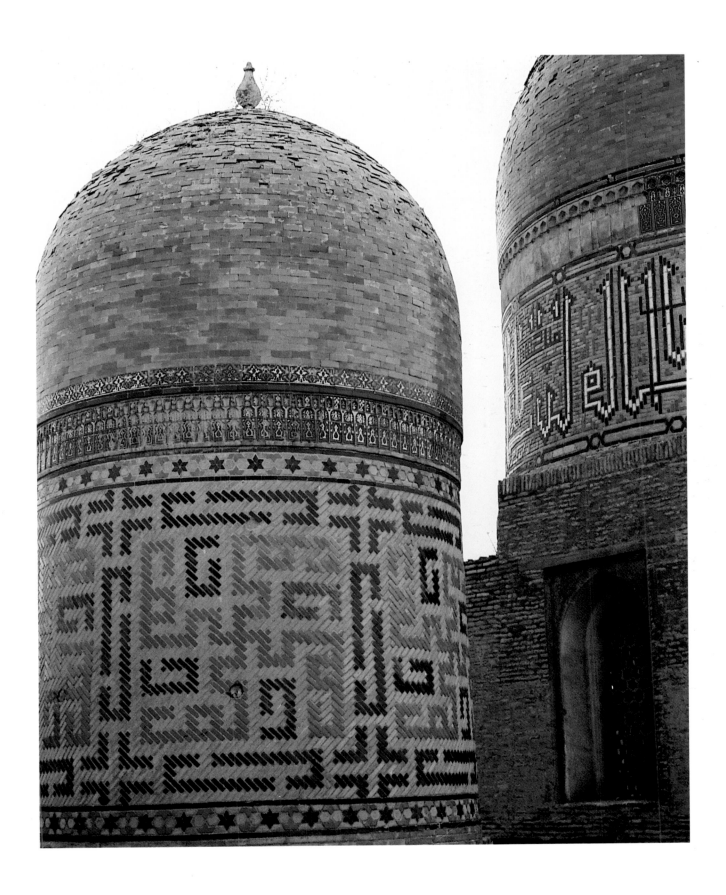

CONTEMPORARY
PAINTING

One can compare painting to calligraphy. We refer to them both as 'imprints of the heart'. Initially it is from the well-springs of the spirit that the activity of imagination draws the forms of shapes. Since these forms are in accord with the spirit, one is right in calling them 'imprints'. In calligraphy and painting, if the things that spring from the imagination to appear on paper or bare silk are not 'imprints', then what are they?

Kuo-Jo-Hiu (11th century)

At the beginning of this book we observed that one of the characteristics of Islamic civilization is the strength of the ornamental arts, in which the Book has pride of place. The initial reference point of this abstract art remains the use of written characters. In the opinion of the painter Kamal Boullata, the arabesque itself, with its geometric and floral motifs, embodies a systematic relationship to the forms of Arabic letters.

Since writing is part and parcel of the graphic arts, it is inextricably linked to other arts such as drawing, painting and architecture. It meets them on a common ground: the construction of shapes and their development in graphic form. One has only to study a fine mosque – in an appropriate spirit of meditation – to convince oneself of the coherence of this art. We prefer to say 'coherence' rather than 'unity', because unity is a concept, an ideal of perfection, whereas the artist stands always on the brink of failure to achieve what he has set out to do.

Although painting has developed along its own singularly independent track, one finds that it constantly returns to the written form and to the creative discoveries it embodies. Further more, whether realist or abstract, painting always remains somehow within the ambit of ornamental art, inasmuch as it depends on an integral interrelationship between matter, colour and symbols. The enigma of the arabesque, which inspired Western artists such as Paul Klee and Henri Matisse, resides not so much in its decorative qualities as in its variations of kinetic rhythm. Calligraphy derives its strength from the act of reading, and that of looking without reading. There is at all times an imbalance between the two, a displacement, a scansion and a loss of meaning. That is why a piece of calligraphy may be considered a picture in process of developing from its original conception. It opens the way to another stage of reading, that of the writer, who searches continually for an emotional and perceptional rhythm for the written structure that he strives to create. It is within the very syntax of a style that one senses this desire for rhythm and for ways of varying it: the variations of appearance, as Paul Valéry would say – the province of ornamental art. And that belongs us to modern art.

According to François Cheng (who has made important contributions to the study of calligraphy), the graphic arts provide a foundation not only for calligraphy as drawing, but also for the distribution of colours within the space occupied by any creative exercise. It was perhaps this quality which so captivated certain painters in North America (Kline, Tobey and Pollock) and Europe (Degottex and Michaux, to name but two) and encouraged them to turn for inspiration to the Far East and its civilizations, with particular reference to the calligraphy of China and Japan. In the words of Francine C. Legrand: 'If one simplifies things and overlooks the detail, one might conclude that the invasion of painting by writing takes place in successive waves, and that it becomes predominant in some of its phases: Cubism and its followers, Surrealism and its derivatives, abstract art and its later developments, and action painting.[1] Whenever painters direct their attention to abstract art, they come up against the centuries-old tradition of lettering as an art form, one which obviously is not merely the skill of knowing how to draw, but also involves the putting together of colours and the transformation of the matter of the composition by physical movement, as well as the use signs and symbols in an overall rhythm.

Among examples of painting inspired by Arabic scripts,

one finds calligraphy as such (or rather a false calligraphy, which is far more common), given that this is a form which continues to be practised in the Arab world, side by side with the use of functional lettering used to convey information. One also finds a number of distinctive strands within it:[2]

- A geometric treatment of letters in which the painter starts from a creative fragmentation and recomposition of the alphabet, and seems driven by a desire to melt into the talismanic magic of the language, as if seeking to translate into visual images passages from the Qur'ān. In a sense a chant (a litany) is visible in the treatment of line, the physical movement and the rhythm of the piece. The written text is inseparable from voice. This is the most common use of calligraphy, of which we could cite many examples: letters in the form of fountains, ruins, as well as a host of imaginative renderings.
- A process of abstraction of the painted letter: a letter which, in superimposing itself on a background of colours, somehow relates to the picture, by giving it a cultural identity, the stamp of a civilization and that civilization's invention of characteristic symbols (as seen, for example, in the work of the Iraqi Shakir Hassan, or that of Monir, a Bangladeshi painter and engraver living in Madrid).
- An emblematic use of lettering, in which the painting is saturated with signs that assume a mystical quality as talismans: Arabic letters, cabalistic ciphers, and, in the work of Rashid Koraishi, an intriguing interest in the distinctive qualities of Chinese and Japanese calligraphy.
- A decorative treatment of lettering, in which a word, a fragment of a word, a phrase or sometimes an entire text are presented in a calligraphic style which is clearly readable and representative of real letters, in a continuity deriving from the arabesque and kufic calligraphy in particular.

What we have here is often a form of decorative writing which mimics one or other of the styles of traditional calligraphy. Traditional calligraphy has its own aesthetic canon, its models and its proportions. It is learned by an arduous process of transmission from master to disciple, like a guild secret which is jealousy guarded, and which eventually enables the artist to earn his own place, and perhaps find his paradise, among the people of the Book (the *ahl al-kitab*).

We shall feature the work of four outstanding artists as we attempt to illustrate our ideas, while at the same time recognizing the contributions of others. The artists in question are : Hossein Zenderoudi, born in Tehran in 1937 and now living and working in Europe ; Kamal Boullata, born in Jerusalem in 1942 and living and working in France ; Rashid Koraishi, born at Ain Beida in Algeria in 1947 and living and working in Paris ; and Al-Said Hassan Shakir, born at Samawa in Iraq in 1925, and now living and working in Baghdad.

Pages 212–13
Shakir Hassan al-Saïd.
Al hassud la yassud, 1979.
Acrylic on wood,
84.5 × 123 cm.

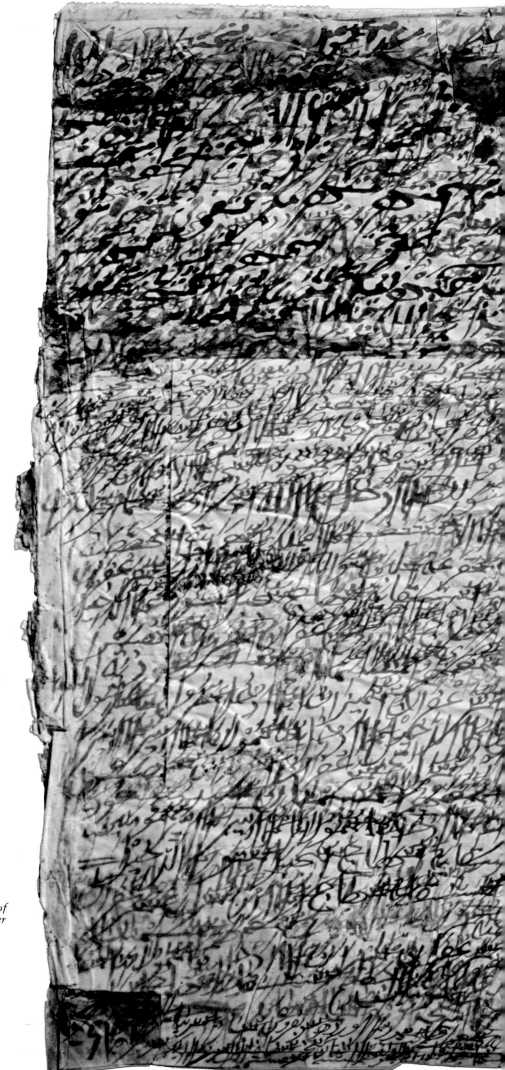

The highly personal writing of the Iranian Muhammad Saber Fiuzi (1909–73)

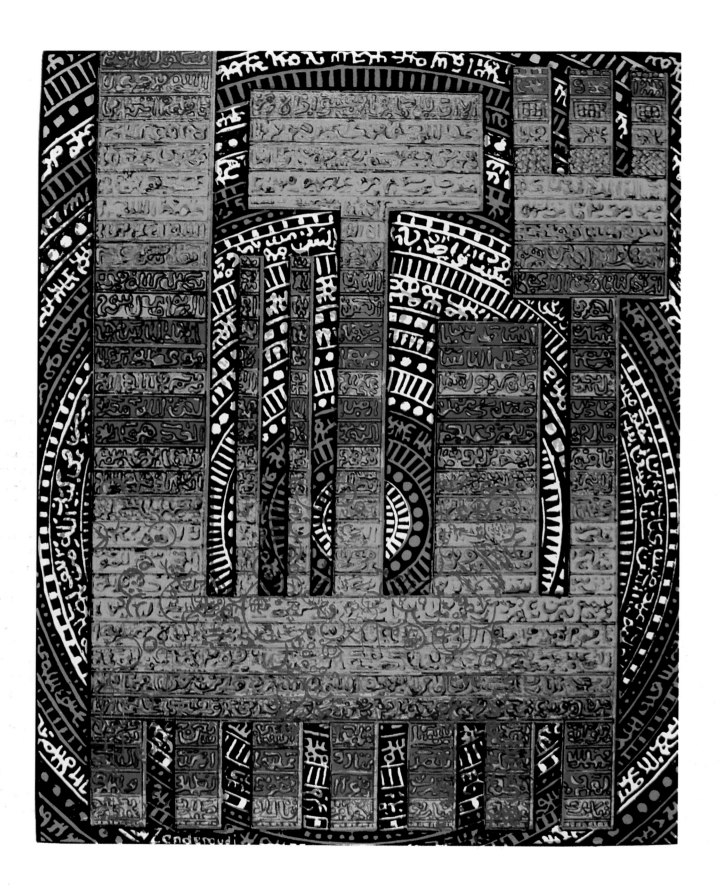

ZENDEROUDI

Hossein Zenderoudi is a versatile artist with a solid grounding in traditional calligraphy. After all, he comes from Iran, a country which, as well as producing superlative carpets, has also produced some of the most refined calligraphy to be found anywhere in the Islamic world. Following in this tradition, he has shown himself to be capable of building an entire composition – or a series of compositions – out of variations of a single letter.

Sometimes he will produce multiple series of labyrinths based on letters in a meaningful phrase which is more or less readable, building them up to the point of saturating – almost to bursting point – the entire space of his painting or drawing. However, he is also capable, in moments of meditation, of somehow emptying the letter of its original written form, retaining only its movement and essence. He knows that there exists a living force, a rhythm behind every successful example of calligraphy. In his work the calligrapher seeks to transmit this essence, this material life.

Sometimes the letter is presented in a variety of different ways (horizontal, vertical, slanting, reversed, or superimposed to give a palimpsest effect), so that the writing appears to walk and run and skip across the space. On another occasion, with a sustained energy that can sometimes be ferocious, the artist projects the viewer into a maze where one is liable to trip on the reading of a word and be thrown off balance.

In this work there is no longer any real difference between the painted picture and the page of a book, between painting and writing; what we have is a plastic treatment of letters which serves to unify all the movements within the graphic line.

One can almost sense the moment of something being about to happen at the tip of the artist's brush. If the eventual desire of the writer is to imagine the reader, in other words to set free a part of his own life that would otherwise remain inhibited, one can say that the desire of the painter-calligrapher is to invent a sort of image-maker reader, an artistically conscious viewer, capable of reading the letters both as signs and as images, with an equal intensity. Zenderoudi is heir to a great and magnificent graphic tradition in which the various arts of the book (calligraphy, miniature-painting and illumination) each contributed to the other's beauty. Here we have a feast of signs and symbols which the Persian carpet has, from time immemorial, raised to the highest levels of art. Thus, when one examines one of Zenderoudi's paintings closely, for example his *Rows of Numbers Replacing the 24* (1976), one is struck by the illusion of reversibility: this picture presents simultaneously the appearance of a manuscript and that of a talisman, a carpet or an arabesque.

The silkscreens which accompany the French translation of the Qur'ān[3] by the poet Jean Grosjean are the first works of this kind. They stand confidently opposite this sacred text which traditionally has always been accompanied by gilded illumination, in itself representing the yearning for Paradise. Now, Zenderoudi is a modern painter, an action painter and an artist of the letter, handling colour with great dexterity. Right at the start of Grosjean's translation

Page 218
Hossein Zenderoudi, The Prophet on the Flying White Horse. *Study for an illustration of the Qur'ān. Silkscreen, 24 × 18 cm. Editions Philippe Lebaud, Paris, 1972.*

Left. **Hossein Zenderoudi**, Homage to Nur Ali Elahi, Master, *1980. Acrylic on paper, 28 × 21 cm.*

Right. **Hossein Zenderoudi**, Rows of Numbers Replacing the 24, *1976. Acrylic on canvas, 162 × 130 cm.*

of the Qur'ān one comes upon a double page conceived as a mirror effect. Thus, the artist immediately distances himself from the traditional style of illumination, which is designed to frame headings, sub-headings and other sets of words which are readable and explicit. No mistaken reading here. In the traditional approach the letter was ornamented, whereas in these silkscreens the letter is treated as pure sign; it may be recognizable in its shapes, but it is devoid of real meaning. It is this absence of meaning which gives rise to the distinctive form of this calligraphy, transforming it into the realm of the mystical.

We might perhaps consider these silkscreens as the beginnings of the 'new arabesque', which in his time, Matisse attempted to create within a purity of creative space; in this process the relations between materials, colours and symbols are ordered within the rules of ornamental art. Perhaps we might also rethink Islamic art (as we shall see below in the case of Boullata) in its deeply rooted abstract coherence between the forms of Arabic letters and the variations of the arabesque, which thus becomes a paradigm of the imaginal. The French art critic and poet Jean-Clarence Lambert has observed:

> . . . the product of that faculty of imagination which is the creator of images and which, as Corbin says, 'should never be mistaken for the kind of imagination that modern man understands, which is "fantasy" and which secretes only the "imaginary". In the thinking of Ibn Arabi and the Iranians, the faculty of imagination is "accorded

as much importance as the intellect and the senses, as . . . an organ of perception which is matched to the world which it inhabits, and which enables one to understand it." And, later: 'The power of imagination has full entitlement to lay claim to real being.'[4]

Zenderoudi has drawn attention to the fact that, for him, Nur Ali Elahi (who died in Tehran in 1974) is an essential reference point for these concepts.

What is being done in these silkscreens by Zenderoudi? Since he is dealing with the Qur'ān, he geometricizes the name of Allah, but this geometricization no longer accords with the vision of Islamic theology. It brings in other figures with sacred associations: *mandalas*, in the form of wheels, circles, sundials, medallions and bands within which lettering runs off in all different directions.

In some of the silkscreens one has a calculated effect of palimpsest, of superimposition and jostling in which the writing – a writing that is deliberately designed to be unreadable – is superimposed on the serenity of a *mandala*, which gives a hint of the supernatural. He makes use of several kinds of unreadability, sometimes by cutting up a phrase and fragmenting it, or by piling letters together so that the writing is transformed into something else: it becomes a cipher, or map-making, or emblem, or talisman, as if the writing had – by a projection into a past that is in the process of developing – to traverse all the different strata of memory, in which the artist's first name (Hossein) provides a reminder of Husain, the son of Ali and a founding father of

Islam in Iran. The sign then takes on aspects of original myth.

Other artists working in a similar vein include M. Omar, M. Benbella, N. Mahdoui, E. Adnan and Mehdi Qotbi, who was born in Rabat in 1951 and now lives and works in Paris.

At first sight Qotbi's work is calligraphic painting. However, a phrase like that demands explanation. It suggests a continuous space within which each of the two arts (calligraphy and painting) enhances and accentuates the qualities of the other. Which is drawing which? Is the overall quality of the work created by the letters? Or by form? Or by colour? What is the particular putting together of imaginary structures that enables the letter to transform itself into painting?

Qotbi often works on the basis of a single phoneme (generally Arabic) in a deconstruction of the alphabet (or rather of the solitary nature of the letter) as if the whole meaning of the pictorial process is to enable the letter to become disengaged from meaningful language and its process of signification.

We do not see this painting as embodying a mystic experience, inasmuch as the mystic experience demands a sacred text as an initiation into the secrets of the invisible and the world beyond. However, the pulsations of the solitary letter in Qotbi's work, and its never-ending repetitions remind us of precisely that: there is a tradition in which, in the chanting of the Qur'ān, the mystics deconstruct the name of God (Allah). By the end the only sound which they make – and which then fades away to nothing – is a fragment of the phoneme 'h' that ends the name of Allah. This is the essence of mystic chant, to end with the sacred letter.

Qotbi works essentially as a painter of the letter. And he treats this letter (in every sense of the word) in the spirit of modern art. What preoccupies him – as we see in the restlessness of his paintings – is the idea of transforming his paintings into an image, an image which may be apparent to all. This explains why his paintings are open to two different readings: one by Arabic-speakers, another by non-Arabic-speakers. However, each of these readings exists symbiotically with the other. When you look at the artist's signature, you find that it appears in both Roman and Arabic letters. A signature in which the painter presents two aspects of his own identity.

This style of calligraphic painting has to be viewed in the context of the encounter between two civilizations, that of the sign (Arabic) and that of the (Western) image, both figurative and otherwise.

Qotbi. Star on the Threshold, 1984, *with enlarged detail above. Gouache on paper, 55 × 50 cm. Private collection, Paris.*

222

KORAISHI

Koraishi's curious fascination[5] with Chinese calligraphy has led him to attempt a dialogue between distinctive forms of writing coming from different origins, and taking in pictography on the way. However, his is not true Chinese calligraphy; it is more a semblance, an imitation of the ideographic act. For example, in the twenty engravings that he produced on the theme of Palestine, the most striking feature is the central monogram.

In order to appreciate the spatial directions in these engravings, one needs to be aware that Koraishi is left-handed, and that, in part, he works with the Arabic alphabet (which of course reads from right to left) and that he also works with made-up Chinese ideograms. Now, in the process of engraving the engraver must work on the plate in reverse, so that the printed image is seen the right way round. In Koraishi's work one also finds a number of architectural motifs, reminiscent of mosques, cupolas and religious locations, but this evocation soon evaporates in the face of this mobile topography of signs. The strength of these engravings lies in the fact that we do not know where the reading begins and where it ends, in other words where it is the writing that gives rise to the engraving, and where it is the other way round. It is as if, in the initial act of Koraishi's art there was no distinction between form and formlessness, structure and chaos – just an indeterminate quality. It is precisely this quality which is the delight of graphic art: it is from here that it draws its desire to re-invent and rebuild everything.

Earlier we referred to the encounter between Islamic art and the culture of other civilizations. In Koraishi's work it is represented in a dialogue between Arabic writing and painting (both Western and Far Eastern), particularly painting that is concerned with the search for pure signs. Each of Koraishi's engravings has this quality of a bridge between civilizations. But beyond this dialogue, what this artist has discovered is that each word is already inwardly written before actually being pronounced, before being written in any particular style. Every word represents the trace of a physical action. It is to this that the calligrapher's hand aspires. Even if a calligrapher's work were totally readable, it would still destabilize the habitual order of reading and its duration. Reading is not linear, even though it follows the rule of the line; it suspends duration, separating language from its immediate signification. Calligraphy realizes poetics in its most radical act; it is rooted precisely at the point where the word is a painting, a graphic form full of desire and energy. It is also rooted at the point where writing sculpts the meaning of language. As Mallarmé – an expert in the alchemy of

Rashid Koraishi, Untitled.
Engraving on paper, 105 × 85 cm.

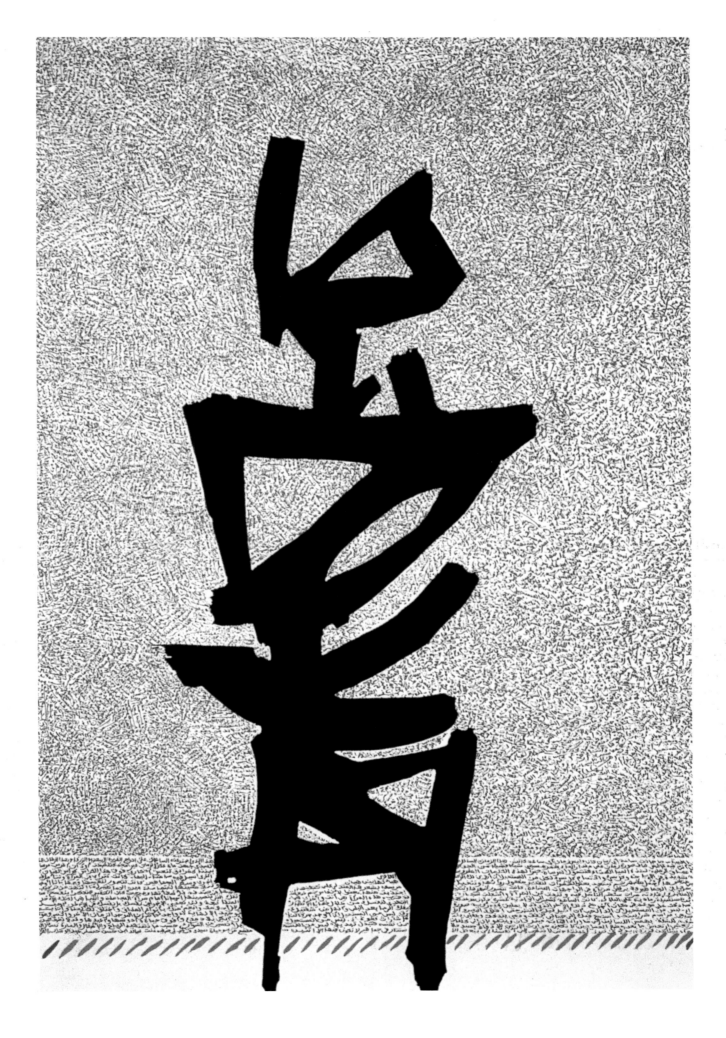

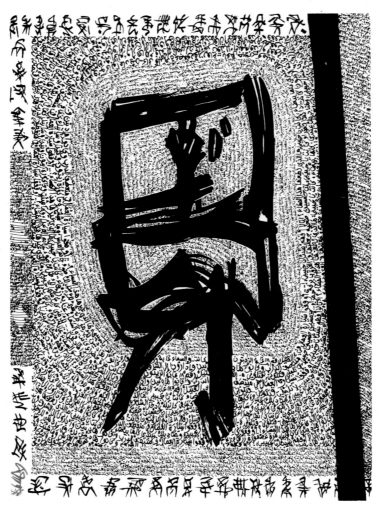

Combattant No. 18, 1984, *with enlarged detail (right). Engraving on Arche vellum, 77 × 57 cm.*

words – put it: 'My whole dream! A rarefaction of images into individual signs, rather in the same way that (you will smile at this) is done in divinatory Japanese art.' [Letter to E. de Roberty, November 1893].

How does Koraishi set about translating Mahmud Darwish's Palestine poems into engravings? He never writes them out in their entirety; he takes fragments, which he repeats, or reverses, or turns around. The words are there, but they are not totally readable. There is a tension, a violence, between the readable and the unreadable. We can read, but equally we cannot read: the itinerary of our reading is continually being broken off, continually setting off on voyages, journeys, going back through time. We might encounter *tifinagh* script (in the Berber alphabet) next to a cipher, which in turn is transformed by the presence of a densely-packed mass of phonemes. Viewed in detail, the reading has infinite possibilities.

The central monogram embodies the vibrations of this violence between the readable and the unreadable. Koraishi does not create calligraphy as such: he writes by drawing the pictorial movement of language. Try to read what he produces: one's attention is soon derailed by the pictorial strength of the piece. To a certain extent it does not even matter if you are not an Arabic-speaker! One begins to real-

ize that these writings are not there to be read, but to be viewed with a pictorial eye. They represent an encounter between different ways of seeing, between civilizations, between different ways of writing, between desires (of the letter desiring to be drawn; the act of drawing it).

Every work of art embodies its own theory to the extent that it is a creation of the mind in various aspects. In the case of painting one might argue that the theory is in fact produced by the act of painting, by the construction and rigour of the piece. In all instances where human imagination explores the unknown, it relies on a set of laws and internal conventions. Wherever it finishes up, it has to justify to the viewer's gaze the movement of a thought. One might well veer towards the notion of a graphic art made up of forces of the imagination that are productive of thought. Just as the dance step gives rhythm to a living thought (the body), the act of making a pictorial work of art fixes thought in a construction.

We have here a putting together of imaginary forms that is capable of having a wide appeal. We do not necessarily need to know the Chinese language in order to love Chinese painting, and, while loving it, to analyze it. We rely on our ability to span the world – in both the real and the imaginary sense. Nor do we need to know the Arabic language to

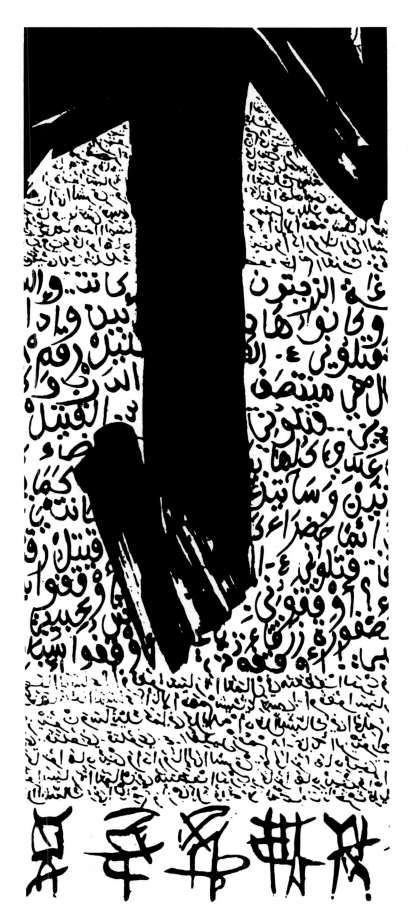

derive pleasure from its calligraphy. What we are invited to do is to explore the different places of language. Language is not the domain of a fixed set of meanings, but is like a laboratory of tongues. The artistic realities described here could be defined as intercultural. It is the experimental aspect that motivates the restless spirit of Rashid Koraishi.

SHAKIR HASSAN

An artist of the painted letter, of the letter as a drawn object, Hassan has developed a mystical and symbolic microtheory which presents painting – and his own in particular – as a workshop, a seat of civilization, an *aide-mémoire* in which signs construct the artistic identity of the Arab intellectual. In his search for what he calls the 'unidimensional' Hassan sees language as an 'open field in which all known aspects of contemporary Arab civilization are in operation.'[6] In his opinion, 'in a picture one can only achieve a logical complement if the letter loses all links with language.' But how does this happen? By decomposition and the destruction of meaning? By dislocation of the consonantal line? The shattering and violent juxtaposition of letters? Nothing is ruled out here; everything is possible. What the artist proposes is a transformation of calligraphy, writing and language into pure sign, into graphic line, in the midst of many other symbols – street graffiti, ideas borrowed here and there from Islamic imagery or from unknown sources. He liberates letters in order to cast them into the great adventure of abstract art, as elements of a new abstraction; or, more exactly, he integrates the violence of the act of doing within abstraction. Here we are no longer dealing with calligraphy, but with an extended spatial world in which the painted letter, whether recognizable or not, refers back to itself. The artist remembers himself, and his action bespeaks that remembering, that torn and lacerated nostalgia. One finds a similarly melancholic quest in Tapiés – a search for roots. In the case of Shakir Hassan, there is no sense of sacrifice: where calligraphy ends, painting begins.

Shakir Hassan al-Saïd,
Muhammad, *1975. Oil on wood,*
152 × 152 cm

BOULLATA

Boullata has followed a quite different path. In his work he goes to the linguistic and symbolic roots of calligraphy. Rather than chipping away at calligraphy and attempting to turn it into something else, he takes it as the central paradigm and foundation of Islamic art. In his view the arabesque is a geometric development of Arabic letter forms; the structures of letters provide the basis for its vegetal and floral motifs. Within classical Arab science, geometry, mathematics and the form of letters share an identical basic structure. The theory is difficult to demonstrate in all its dimensions, but it is rich in intuition. After all, one should not expect an artist to teach us the grammar of signs of science and history; the artist's job is to enable us to see ourselves. And furthermore, if one accepts the view of the poet Francis Ponge that the figures of rhetoric (ellipses, parables, hyperbole . . .) are related to Euclidean geometry, then one could justifiably join Boullata in asking oneself what is the topography and spatial logic to which the Arabic language relates.

Boullata provides a double answer to this question, as both painter and researcher. His work has been the most geometrical among the creations of modern Arab calligraphers, as exemplified in a fine group of silkscreens. His work is based on the kufic style, with a purity of line and a certain angular rigour, avoiding fanciful effect, as if by this transparent linearity he is attempting to uncover the secrets and the enigma of Arabic lettering.

The fact that all his work is inspired by classical calligraphy gives him an important status within contemporary art. His concern is to examine the kind of abstraction that characterizes the art of Islam, whether in its script, or the various arts of the book, or the arabesque, or mosaics. It is possible that his theory is merely intended to project his work (this is what we tend to think), but nonetheless it deserves our attention.

There is, in his opinion, a perfect correspondence between calligraphy and the arabesque.[7] The early origins of some of the letters in drawn forms is now accepted, and this applies to other Hamitic-Semitic languages. One can recognize this in the following pictographic remnants:

– ج (j): the camel
– ك (k): the hand, including the wrist
– ى (ya): the hand (*yad*)
– س (s): teeth
– ذن (n): fish.

In the first Arabic dictionary, compiled by Al-Khalil Bnu Ahmed in the eighth century, the character ع (meaning eye, spring) 'was the letter which, in the author's opinion, enabled letters to enter the throat'. Now, Boullata says that the appearance of diacritical dots led Arab mathematicians to transcribe their zero as a point or full stop, which then served to indicate vowels, as can be clearly seen in the older manuscripts of the Qur'ān written in kufic script. Learned people used a common code of transcription before each branch of the knowledge which concerns us, namely arithmetic and geometry, developed separately.

The ancient rhetoricians classified words according to whether they were two or three-letter roots. This typology of twos and threes, which one also finds in the allocation of diacriticals, represents the two principles of the arabesque and its geometric compositions. The very fact that letters vary according to whether they are at the start, the middle or the end of a word, gives each letter a particular form, in relation to the base line of the writing, which offers as many as seventy-three variants of the letter 'm'.

This phenomenon of variation has its counterpart in the arabesque. The grammarians' classification of words into biliterals and triliterals, and the way in which words are transformed by inversion, changes of letters and removal and addition of letters . . . this whole process involved in the structuring of language and the very body of Arabic linguistics, represents, in Boullata's opinion, the foundation of the arabesque. Its secret lies in the union between line and circle, which constitutes the correspondence between arabesque and calligraphy. The nature of this correspondence can be summarized as shown below and overleaf:

I CALLIGRAPHY

A The principal dualist oppositions

- Verticality/horizontality
- Letters extending above the base line/letters extending below the base line
- Words with no inner break/words with breaks
- Words with prefixes and suffixes/words without
- The principal visual counterposition: the circle/the dot

B The principal graphic contrasts of triliterality

- Three forms of the letter, depending on whether it is at the start, middle or end of a word
- Three forms of diacritical: one dot; two dots; three dots
- The writing of vowels in three forms, above and below the base line
- Words are recognized by whether they have diacriticals inserted above or below the base line, or whether they have none

II THE ARABESQUE

A The principal dual contrasts

- Contrast between circle and line
- Division of the line or the circle into equal surfaces
- The division of this contrast into a counterposing duplication, or lateral duplication, or both together

B The principal divisions into three

The arabesque is created in three stages:

- The drawing of the circle
- The division of the surface into equidistant parts
- The drawing of straight lines between the points thus arrived at.

Kamal Boullata,
Silkscreen, 1985.

Page 230.
Kamal Boullata,
Silkscreen, 1985.

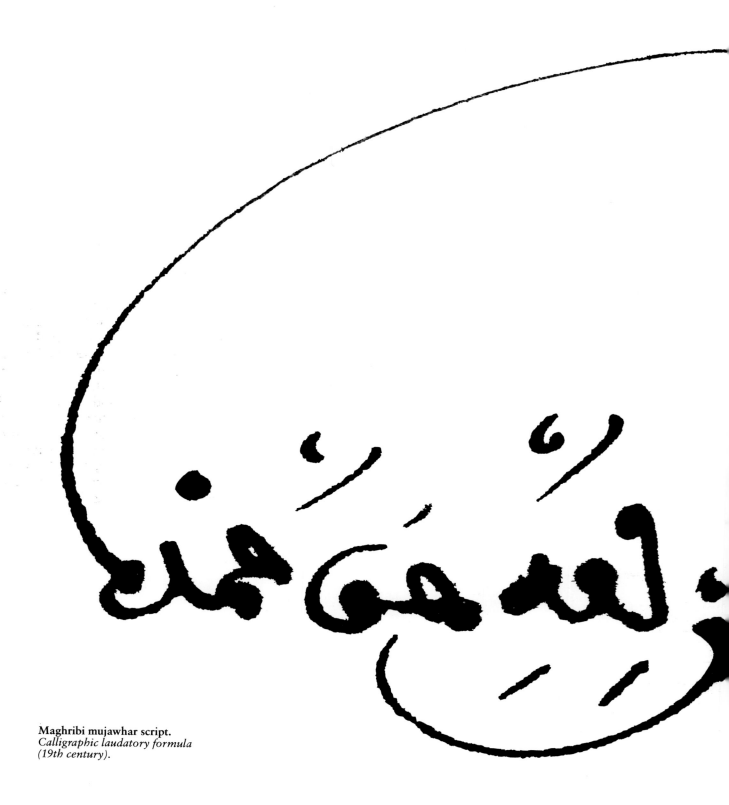

Maghribi mujawhar script.
*Calligraphic laudatory formula
(19th century).*

EPILOGUE

As the reader will have discovered in the course of this book, the letter has already been transformed, into an imagery, into a kind of fantasy world. We love calligraphy for its beauty, and its beauty – ornamented as it is with every kind of adornment – poses major questions for an understanding of art. We love this beauty, but at the same time it is a matter of concern, because how can one write about this art (which is by definition a writing in the second degree) without hesitating? What style would one have to bring into play to transcribe the discipline of the angular script, the subtle movement of the cursive, and all the other inventions of those oft-forgotten calligraphers, and those who are only known to us as names in history? It is as if, for history to be written, we were leaving our written heritage in the care of a child who is only just beginning to spell out words and given them meaning. This is the dawning moment from which the great adventure that is language begins.

NOTES ON THE TEXT

TRACING THE ORIGINS

1 A. Badawi, *Histoire de la philosophie en Islam*, vol. I, Paris, 1972.
2 Henri Loucel, 'L'origine du langage selon les grammairiens arabes', in *Arabica*, 1963 (pp. 188–208 and 281), 1964 (pp. 57–72 and 151–87).
3 H. Loucel, op. cit.
4 Roger Arnaldez, 'L'origine du langage' , in *Grammaire et théologie chez Ibn Ḥazm*, Paris, 1956.
5 H. Loucel, op. cit.
6 A. Badawi, op. cit., p. 80
7 Ibid. pp. 80–1.
8 Ibid. p. 82.
9 R. Arnaldez, op. cit., p. 45.
10 Ibid. pp. 81–82.
11 A. Badawi, op. cit., pp. 81–2.
12 *Iḥya"ulum ad-din*, IV, p. 316.
13 Ibn Khaldūn, *al-Muqaddima*, cf. section on 'Script and calligraphy', UNESCO, Beirut, 1968, vol. 2
14 J. Sourdal-Thomine, 'Les origines de l'écriture arabe . . . ', in *Revue des études islamiques*, Paris, 1967.
15 Vol. I, ed. by E. Combe, J. Sauvaget and G. Wiet, Cairo, 1931.
16 Article on Arabic script, in *Encyclopedia of Islam*, 1st ed., 1913.
17 J. G. Février, *Histoire de l'écriture*, Paris, 1959, p. 263.
18 J. Starkey, 'Petra et Nabataea', in *Dictionnaire de la Bible* (supplement), Paris, 1964.
19 Zayn al-Din Nāji, Atlas of Arabic Calligraphy (in Arabic), Baghdad, 1968.

SCHOOLS AND STYLES

1 L. Massignon, 'Voyelles sémitiques et sémantique musicale', in *Parole donnée,* coll. 10 18, Paris, 1962, p. 381.
2 See the important contribution by J. Derrida, *De la grammatologie*, Ed. de Minuit, 1967.
3 Ibn Khaldūn, *Al Muqaddima*, op. cit., pp. 852–3.
4 B. Moritz, 'Arabic Script', in *Encyclopedia of Islam*, 1st edition, 1913.
5 J. Sourdel-Thomine, loc. cit.
6 Letter preserved in the Dar al kutub al Misriyya, Cairo.

7 D. S. Rice, *The Unique Ibn al-Bawwab Manuscript in the Chester Beatty Library*, Dublin, 1955.
8 Rice, op. cit.

CONTEMPORARY PAINTING

1 *Quadrum*, no. 13, Brussels, 1962.
2 A Khatibi, 'Interférences' in *Croisement de signes* (exhibition catalogue), Institut du Monde Arabe, Paris, 1989.
3 French translation of the Qur'ān, Paris, 1972.
4 J.-C. Lambert, 'Le Règne imaginal', in *En Islam iranien*, III, 16, Paris, 1991.
5 Engravings accompanying a text by A. Khatibi (unpublished).
6 See article by Buland al-Haidan, 'La Lettre arabe dans l'art pictoral contemporain', in catalogue of the Institut du Monde Arabe, Paris, 1987.
7 See study (in Arabic) in *L'Islam et la modernité*, London, 1990.

BIBLIOGRAPHY

This bibliography is necessarily selective. We have therefore chosen those works on Islamic calligraphy which are basic and essential to the subject. Also included are several important books relating to the theory and analysis of writing, which have been mentioned in the text and footnotes. Major Arabic texts, such as the *Fihrist*, are too well known to require precise bibliographical documentation.

BIBLIOGRAPHY IN ARABIC

Epistles of *The Brothers in Integrity*, Cairo, 1928
Friḥa, A., *The Arabic Script*, Beirut, 1961
Ghazlan, L., *The Diwāni Script*, Cairo, 1934
'Ibada, A., *The Spread of Arabic Writing*, Cairo, 1915
Jahiz, *On Script and Writing*
Khaldūn (Ibn), *Al Muqaddima*
Muqla (Ibn), *On Calligraphy*, MS at Dar al Kitab, Cairo;
——, *On the Proportions of Calligraphy*, MS at the Bibliothèque 'Attarine, Tunis
Nadīm (Ibn), *Fihrist*
Nāji, Zayn al-Din, *Atlas of Arabic Calligraphy*, Baghdad, 1968
Qalqashandi (al), *Subḥ al'a 'sha*, vol. 3, Cairo, 1913
Tawhīdī (A), *On Calligraphy*, Damascus, 1951
Yāsin, S., *Arabic Script and its Development under the Abbasids*, Baghdad, 1962
Yussuf, A., *Kufic Script*, Cairo, 1933
Zaki, M. H., *Atlas of Islamic Ornamentation and Decoration*, Cairo, 1956

BIBLIOGRAPHY IN OTHER LANGUAGES

Abbott, N., 'Arabic paleography', in *Ars Islamica*, VIII, 1941;
——,*The Rise of the North Arabic Script*, Chicago, 1939
Alazard, J., *L'Orient et le peinture française au XIX siècle, d'Eugène Delacroix à Auguste Renoir*, Paris, 1940
Arnold, T., *Painting in Islam*, Oxford, 1928
Arnold, T. and Grohmann, A., *The Islamic Book*, London, 1929
Ars Islamica, quarterly review, Ann Arbor, Mich., 1934–51; followed by *Ars Orientalis*, Ann Arbor, Mich., 1951–
Berque, J., *Langages arabes du Présent*, Paris, 1974
Blachère, R., *Introduction au Coran*, Paris, 1947
Burckhardt, Titus, *Art of Islam: Language and Meaning*, London, 1976
Claudel, P., 'La philosophie du livre', iin *Œuvres de la prose*, Paris, 1965
Creswell, K. A. C., article on Architecture in *Encyclopedia of Islam*, 2nd ed.;
——, *Early Muslim Architecture* (2 vols.), Oxford, 1932/40 (revised ed., vol. I, Oxford, 1969); reprinted New York, 1978/9
Derrida, J., *De la grammatologie*, Paris, 1967
Diez, E., *Die Kunst der Islamischen Völker*, Berlin, 1915
Dodd, Erica Cruickshank, and Khairallah, Shereen, *The Image of the Word. A Study of Quranic Verses in Islamic Architecture* (2 vols.), Beirut, 1981
Ettinghausen, R., *Arab Painting*, London, 1962
Ettinghausen, R. and Grabar, O., *The Art and Architecture of Islam 650–1250*, New York and Harmondsworth, 1987; paperback ed., New Haven, Conn., and London, 1992
Farès, B., *Essai sur l'esprit de décoration*, Cairo, 1952
Février, J.G., *Histoire de l'écriture*, Paris, 1959
Gayot, H., *Le décor floral dans l'art de l'Islam occidental*, Rabat, 1955
Gelb, L.-J., *Pour une théorie de l'écriture*, Paris, 1973
Gluck, H. and Diez E., *Arte del Islam*, Madrid/Barcelona/Buenos Aires, 1932
Golvin, L., *Essai sur l'architecture religieuse musulmane*, Paris, 1970
Grabar, O., *The Formation of Islamic Art*, New Haven, 1973
Grabar, O. and Ettinghausen, R., 'Art and architecture', in *The Legacy of Islam*, Oxford, 1974;
——, *Islamic Architecture and its Decoration, A.D. 800–1500*, Chicago, 1964
Grohmann, A., *Arabische Paläographie*, Vienna, 1967
Houdas, P., 'L'écriture maghrébine', in *Nouveaux mélanges orientaux*, Paris, 1886
Huart, C., *Les calligraphes et les miniaturistes de l'Orient-musulman*, Paris, 1908
Kühnel, E., 'The Arabesque', in *Encyclopedia of Islam*, 2nd ed.;
——, *Die Arabeske: Sinn und Wandlung eines Ornaments*, Wiesbaden, 1949
Lings, Martin, *The Quranic art of calligraphy and illumination*, London, 1976
Lings, Martin and Safadi, Yasin Hamid, *The Qur'ān* (exhibition catalogue), London, 1976

Longperier, A., 'De l'emploi des caractères arabes dans l'ornementation chez les peuples chrétiens de l'Occident', in *Revue archéologique*, Paris, 1845

Marçais, G., *L'art musulman*, Paris, 1962;

——, *L'architecture musulmane d'Occident*, Paris, 1952

Massignon, L., *Parole donnée,* Paris, 1962

Mignon, G., *Manuel d'art musulman* (II), Paris, 1907

Moritz, B., article 'Arabic script' in *Encyclopedia of Islam*, 1st ed.;

——, *Arabic Palaeography*, Cairo, 1905

Otto-Dorn, K., *L'art de l'Islam*, Paris, 1967

Panofsky, E., *Studies in Iconology*, New York, 1939

Peignot, J., *De l'écriture à la typographie*, Paris, 1967

Répertoire chronologique d'épigraphie arabe, edited by E. Combe, J. Sauvaget and G. Wiet, vols. 1 and 4, Cairo, 1931

Rice, David Talbot, *Islamic Art*, London, 1965; paperback ed. 1975

Robertson, E., 'Muhammad ibn 'Abd ar-Raḥmān on calligraphy', in *Studia semitica et orientalia*, Glasgow, 1920

Safadi, Yasin Hamid, *Islamic Calligraphy*, London and New York, 1978

Schimmel, Annemarie, 'The Art of Calligraphy', in R. W. Ferrier (ed.), *The Arts of Persia*, New Haven, Conn., and London, 1989, pp. 306–14;

——, *Islamic Calligraphy*, Leiden, 1970

Soucek, P. P. (ed), *Content and Context of Visual Arts in the Islamic World*, University Park, Pa, 1988

Sourdel-Thomine, J., 'Les Origiines de l'écriture arabe à propos d'une hypothèse récente', in *Revue des études islamiques*, Paris, 1967

Vadja, G., *Album de paléographie arabe*, Paris, 1958

Yazan, Midhat Sertoğlu, *Tughra Osmanli Türklerinde*, Istanbul, 1975

Yazir, M. B., Calligraphy (in Turkish), Ankara, vol. I (1972) and vol. II (1974).

ACKNOWLEDGMENTS

The authors are grateful for having been allowed access to archives and libraries in Morocco, kindly arranged by the late Hadj M'hamed Bahrini, sometime Minister of Culture.

We wish to thank all those who permitted us to consult and to photograph manuscripts which are not generally accessible. They include: Farukh Hosni, the Egyptian Minister of Culture; the curators of the Topkapi Saray, the Süleymaniye, and Koprolü Libraries, all in Istanbul; the Bibliothèque Royale, Rabat, the University of Qarawiyyin, Fez, the General Library and Archives, Rabat, the National Library (Dar al-Kitab), Cairo, the National and Guilali Libraries, Baghdad, and the Razza Library, Rampur, India.

We are also indebted to Ahmed-Shawki Rafif, Yahia Fiüzi, Ferit Edgü, Dr Ekmeleddin Ihsanoglu, Qahtan al Madfaï, Abderrahman Tazi, Abdellatif Laraki, Brahim Alaoui of the Institut du Monde Arabe, Paris, the calligraphers Abdeslam Guenoun and Ghani Alani, and Kamal Boullata.

PHOTOGRAPHIC SOURCES

With the exception of the items noted below, all photographs were taken by Mohammed Sijelmassi:
Nuri Arlassez (IRCICA archives, Turkey) pp. 194 above, 198–202, 206–7, 210–11;
Yahia Fiüzi pp. 216–17;
Amentü Gemsi pp. 160–1;
Ara Güler pp. 8–9, 19, 28–9, 31, 34–5, 61, 108–9, 110–12, 153;
Musée d'Art et d'Histoire, Geneva, pp. 188–9.

Works by Hossein Zenderoudi reproduced on pp. 218, 220, 221
© 1994 SPADEM.